History of
WESTERN
AMERICAN
ART

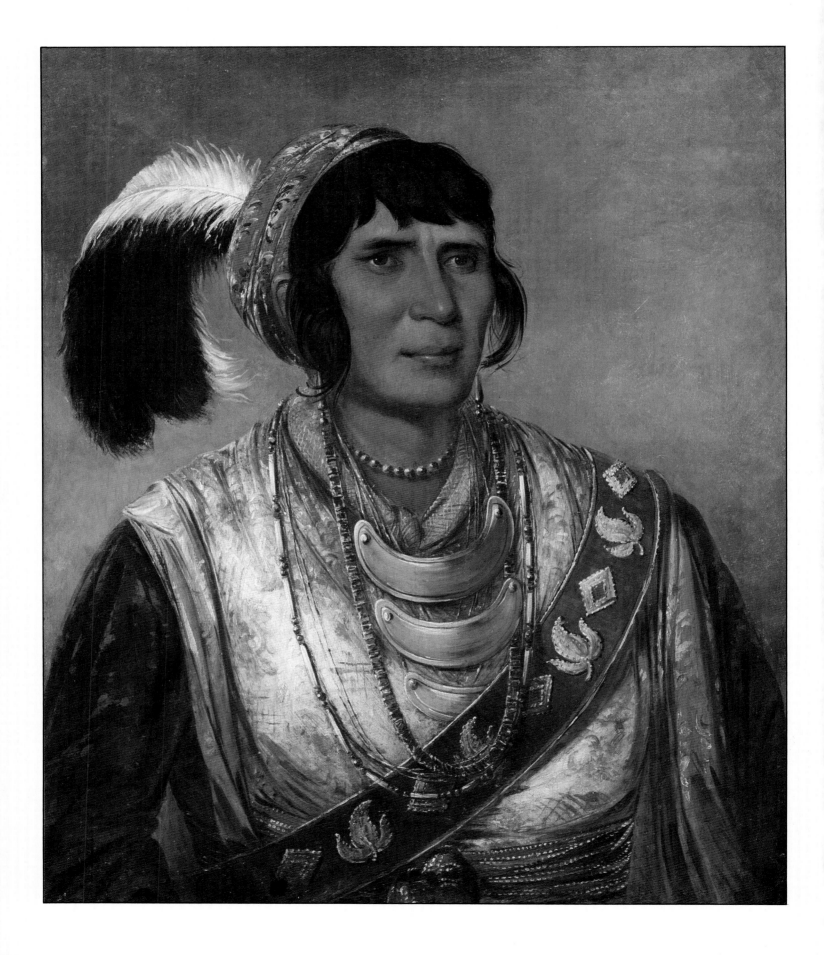

History of

WESTERN AMERICAN ART

Royal B. Hassrick

CHARTWELL
BOOKS, INC.

Page 2:
Osceola 1838) by George Catlin (1796-1872)
National Portrait Gallery, Smithsonian Institution
Oil on canvas, 30¾ × 25¾ inches
On loan from the National Museum of American
Art, Smithsonian Institution

Published by
CHARTWELL BOOKS, INC.
A Division of BOOK SALES, INC.
110 Enterprise Avenue
Secaucus, New Jersey 07094

Produced by
Brompton Books Corp.
15 Sherwood Place
Greenwich, CT 06830

ISBN 0-7858-0192-8

Printed in China

CONTENTS

INTRODUCTION

The American West – the West of the Great Plains, the Rocky Mountains, the arid deserts – began to exert its spell on the Nation's consciousness only after the Louisiana Purchase in 1803. It was Lewis and Clark's expedition up the Missouri River and across the Rockies to the Pacific Ocean that first brought word of the natural wonders and vast resources of this amazing region. The explorers returned with awe-inspiring tales of fantastically

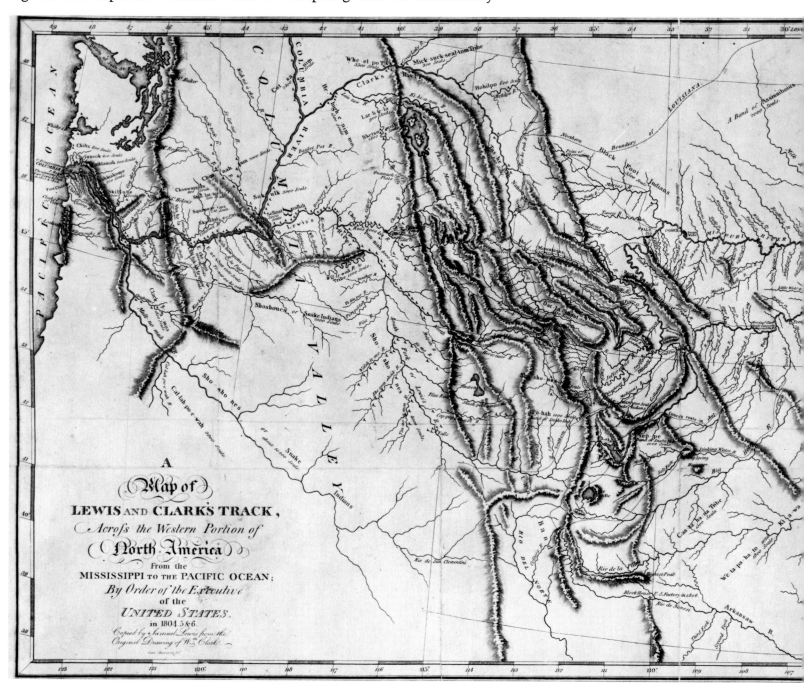

varied landscapes teeming with all manner of exotic wildlife – windswept plains containing immense herds of buffalo, wild, lofty mountains haunted by grizzly bear and bighorn sheep, far-western rivers choked with salmon, trackless deserts, gigantic forests . . . Reports of these marvels alone would have been enough to seize the imagination of young American and European artists, but even more fascinating to most were the Indians.

It soon became apparent that the western Indians were not only unlike their eastern counterparts, but that their cultural groupings were both diverse and exceptionally colorful. Artists found them so irresistible that Indian subjects virtually dominated Western art during the first half of the nineteenth century. The paintings and sketches that have come down to us from this period constitute, among other things, a priceless anthropological record, and in fact it is sometimes difficult to approach them as works of art without knowing something about the ethnological contexts which they were intended to illustrate.

The western Indian cultural groups were scattered over a huge geographic area. On the Plains were the nomadic and warlike buffalo-hunting Sioux and

A contemporary map of the route followed by Lewis and Clark based on drawings made by Clark.

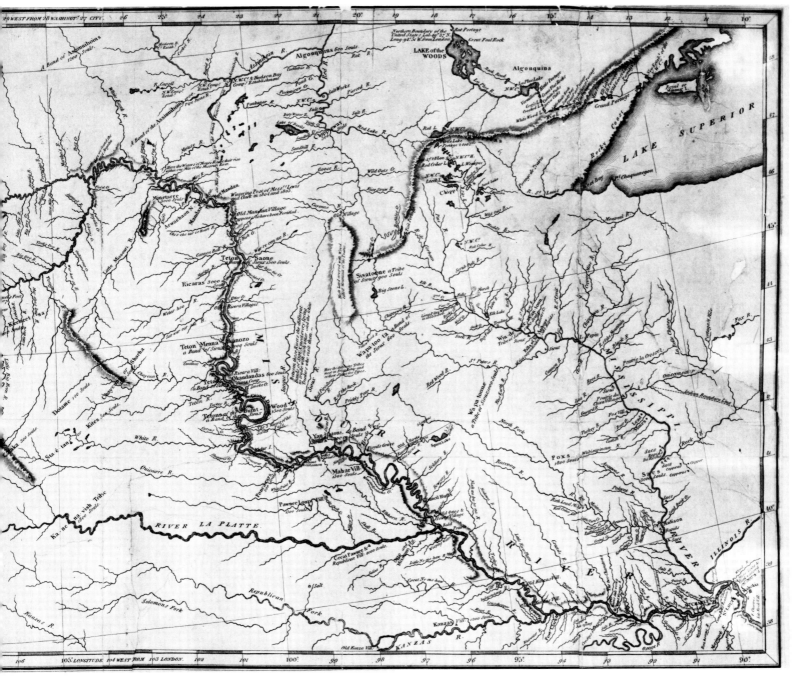

Cheyenne, the Blackfeet, Kiowa and Comanche. Sedentary farming people like the Pawnee, Arikara, Mandan and Hidatsa occupied the river bottoms. Here the women raised crops of corn, beans, squash and sunflowers, while the men hunted buffalo and went to war. In the desert Southwest dwelt the Hopi and Acoma, the Jemez and Zuni, Pueblo Indians in communal villages where the men tilled the fields and the women wove blankets and made pottery. Here, also, lived the Navaho and Apache, scattered over large territories in small family communities. In the Plateau and Great Basin regions lived such tribes as the Paiutes and Western Shoshoni; to the north and east, the Utes, the Nez Perce and the Bannocks. Living in small bands, the men hunted small game while the women gathered berries and dug roots. California was more bountious. Here many little tribes led rich social and ceremonial lives. Moreover, their women were famed for their exquisite basketry. Along the Pacific shores lived the Northwest Coast Indians, wealthy fishermen who lived in great plank houses and recorded their geneologies upon majestic totem poles.

It was the Plains Indians, however, who were to make the strongest impact upon the early artists. A typical example was one of the tribes that fascinated George Catlin. Along the shores of the Upper Missouri River near what is now Bismark, North Dakota, lived the earthlodge farming people, the Mandans. Occupying two stockaded villages on the high banks overlooking the river, there were, in 1804, some 1200 souls. Formerly they were a powerful tribe with perhaps 12,000 people inhabiting nine villages, but smallpox had decimated their numbers, and now they lived in fear of their enemies, the bellicose Sioux.

The Mandans were governed by a council composed of men who owned the tribe's sacred bundles. These were the priests and elders of the tribe, and it was they who appointed a Chief of War and a Chief of Peace. The tribe was divided into moieties – the Rights and the Lefts – and within each moiety were various matrilineal clans such as the Speckled Eagles and the Prairie Chickens. Marriage between moiety members was prohibited.

Once a year the Mandans held a spectacular ceremony – the *Okeepa* – to insure an abundance of buffalo. The ceremony was, in fact, a dramatization of Mandan origins, wherein the people re-established their faith in the deities. In addition, young men could gain prestige by communicating directly with *Wakonda*, the Great Spirit. By permitting skewers to be thrust through their chest muscles, and with thongs thrown over a house beam and attached to the skewers, supplicants were pulled from the ground. Hanging suspended a few feet from the earth, they dangled until they lost consciousness or tore themselves loose. It was through this personal sacrifice that men sought blessings from the gods.

Immediately following the *Okeepa*, the Mandan embarked on their annual buffalo hunt. In some instances the buffalo were led over cliffs, where they fell to their deaths below. There the women butchered the meat and divided it among the moieties. More often, the buffalo were surrounded by horsemen who shot them with arrows – dangerous work, in which horses were trampled and men thrown. It was from hunts such as these that meat was secured for the winter and hides were procured for use as robes, clothing, tipi covers and the like.

Yet it was agriculture that gave these Indians an economy potentially rich enough to support a large population. And it was only a series of natural disasters that prevented them from flourishing. As if the smallpox scourge of 1782 were not cruel enough, the Mandans were again struck in 1837. This time the population was reduced to a mere 150 people. Unlike other Plains Indians, the Mandans were never a barrier to white expansion.

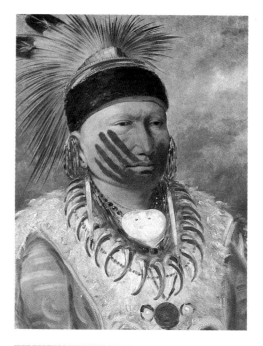

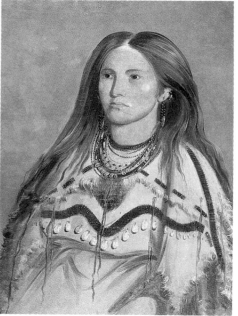

Top: *White Cloud*, a chief of the Iowa Indians as painted by George Catlin.
Above: George Catlin's portrait of *Mint*, a woman of the Mandan.
Right top: An Arapaho Ghost Dance, 1893. Paintings by such artists as Catlin and Bodmer often show ethnographically valuable detail not captured in early photographs.
Right: A self-portrait of Charles Bird King, Catlin's contemporary, who painted Indians brought east by the government.
Right center: Titian Ramsay Peale, one of the painters who accompanied Major Stephen Long on his 1820 'Yellowstone' expedition.
Far right: Like Charles Bird King, Charles BJF de Saint-Memin never travelled west, but portrayed Indian dignitaries who had been invited to visit Washington, DC.

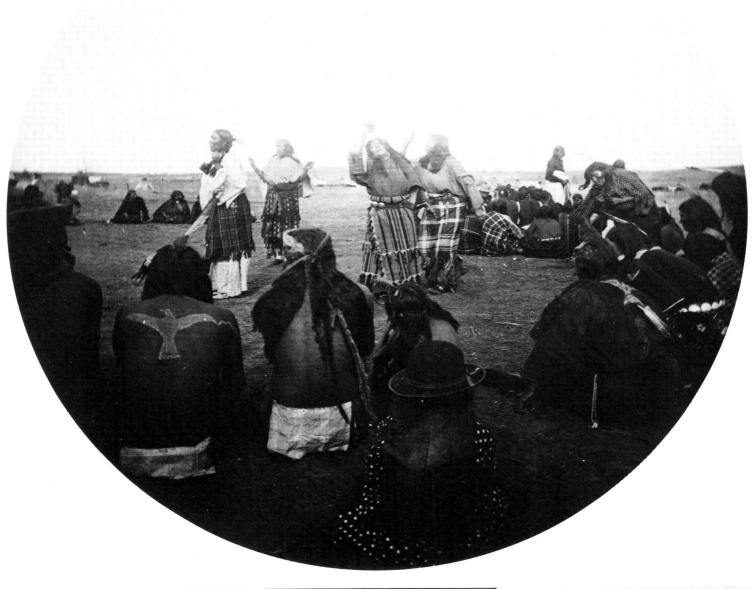

That we know as much as we do about minor tribes as the Mandans is due largely to the early artists who meticulously recorded the details of their daily lives. Catlin's paintings of the Mandan alone include panoramas of their villages, interiors of their lodges, portraits of their chiefs and medicine men, scenes of their war councils, buffalo dances, village games and much else, down even to such minutiae as the designs they painted on their buffaloskin robes. And the Mandans were only one of dozens of tribes exhaustively depicted by Catlin and his fellow artists.

To be sure, the bulk of this artistic record of Indian life was not set down until some 30 years after Lewis and Clark had returned from their expedition. First the new lands had to be more thoroughly explored, trails had to be opened into the interior and the beginnings of white settlement, mostly in the form of scattered trading posts and trappers' camps, had to be established.

Even as Lewis and Clark were struggling up the eastern range of the Rockies, Zebulon Pike was half way up the Mississippi from St Louis to its source, and hardly had Lewis and Clark returned than Pike set forth to explore the territory due west of St Louis. He visited Osage and Pawnee villages on his way to the mountains and to what was later to be named Pike's Peak. Here he became lost and, heading south, was captured by Spanish forces and taken to Santa Fe. Thence he was escorted through Mexico and Texas to Natchitoches.

Not until 1820 was any other significant exploration undertaken. Under the leadership of Major S H Long a scientific expedition to the headwaters of the Platte, Arkansas and Red Rivers was planned, and among its members were included a botanist, a mineralogist, a geologist and two artists, Titian Peale and Samuel Seymour, both of Philadelphia. The indifferently talented Seymour had the honor of being the first man to paint the Rocky Mountains.

Ho for Kansas!

Brethren, Friends, & Fellow Citizens:

I feel thankful to inform you that the

REAL ESTATE

AND

Homestead Association,

Will Leave Here the

15th of April, 1878,

In pursuit of Homes in the Southwestern Lands of America, at Transportation Rates, cheaper than ever was known before.

For full information inquire of

Benj. Singleton, better known as old Pap,

NO. 5 NORTH FRONT STREET.

Beware of Speculators and Adventurers, as it is a dangerous thing to fall in their hands.

Nashville, Tenn., March 18, 1878.

Above: An 1878 poster urging citizens of Tennessee to resettle in Kansas.
Below: The mass slaughter of buffaloes by Europeans was a deadly threat to the livelihood of the Plains Indians.
Top right: A wagon train of settlers moving west along the Oregon Trail. In the background is a landmark known as The Devil's Gate in Wyoming.
Bottom right: A family of settlers posing with their covered wagon (probably, because of its small size, homemade).

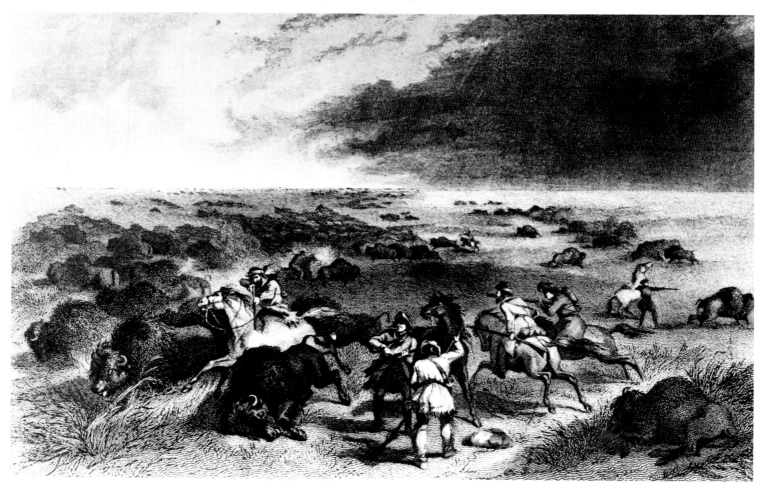

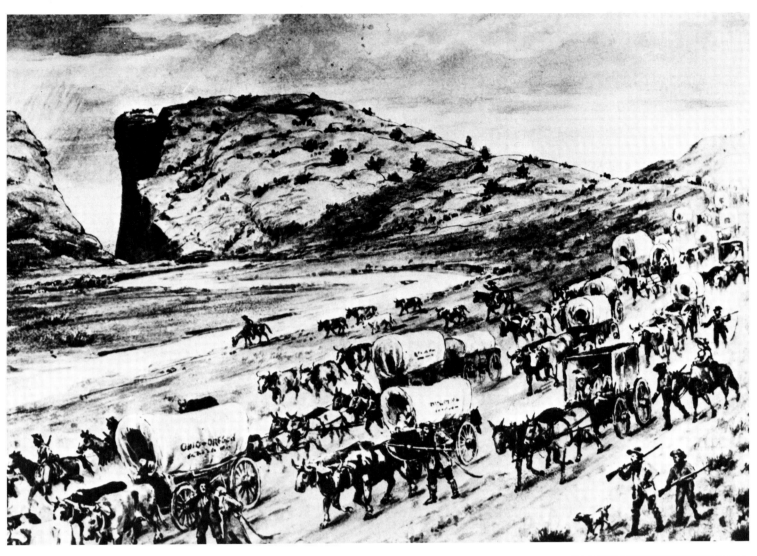

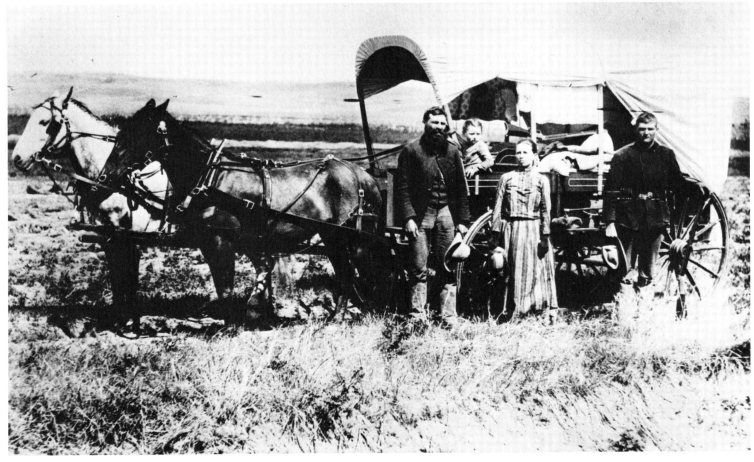

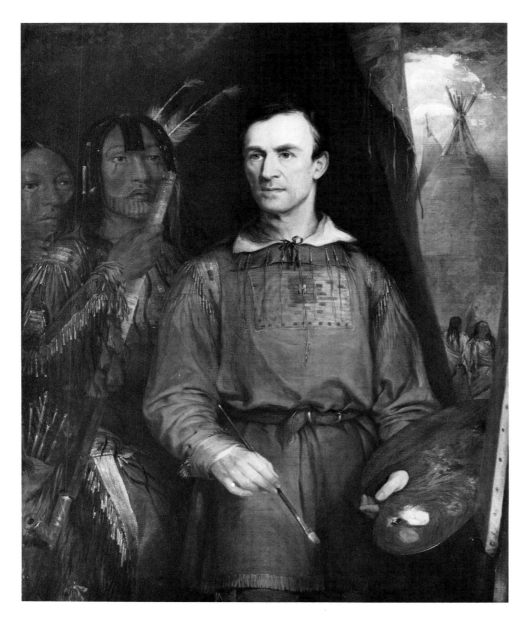

Of all the explorers, probably the most flamboyant was John Freemont. His journey in 1843, led by the indomitable scout Kit Carson, took him through Nevada, across the Sierras into California and as far as Oregon. He was a fine salesman, and his glowing report electrified Congress, which promptly ordered a hundred thousand copies of it to be printed. People clamored to read about their hero, the 'Pathfinder,' and the wonderful land he had discovered. And it was undoubtedly his personality and charisma, together with his brilliant account, that gave stimulus to the great western migration that followed soon thereafter.

Thomas Jefferson Farnham had already in 1838 led a small party to Oregon, and four years later Elijah White and 130 emigrants with 18 wagonloads of household goods and equipment headed for the Northwest. By 1845 the migration to the Oregon country started in earnest. Two years later from three to five thousand pioneers left in caravans from the jumping-off towns of Westport, St Joseph and Independence along the Missouri River. Most of these people were poor farmers from Iowa and Missouri. The Panic of 1837 had depressed the prices of crops, and men hoped by starting fresh in the Promised Land their fortunes would be bettered.

The route ran from the Missouri northwest through Kansas to Fort Kearny on the Platte, thence along that river to Chimney Rock and on past Council Bluffs. At a pace of about 15 miles a day, a well organized caravan of Conestoga or box wagons could expect to reach Fort Laramie in 45 days. Here was the last

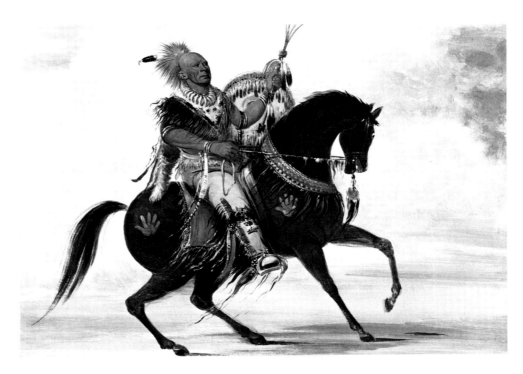

Catlin's *Keokuk on Horseback* (1835), showing the wealth of fine detail for which this artist is so cherished by anthropologists.

stop to refit, shoe the horses and oxen, repair the wagons, replace iron tires and wash the clothing. Upon leaving Fort Laramie, the trail continued along the Platte. At Independence Rock some of the travellers etched their initials and the date as a token of their journey. Heading due west through South Pass, the wagon trains followed the tributaries of the Green and the Green River itself, going on to Fort Bridger and along the Bear River to Fort Hall. From there, over the Blue Mountains to the Columbia River was an especially difficult route, for now the wagons had to be discarded and replaced by rafts for the trip down the Columbia to Fort Vancouver. In all, the journey from Independence to the Pacific coast, spanning over 2000 miles, took around five months.

Those pioneers desiring to make California their destination left the Oregon Trail at the Snake River and headed for the Humbolt River. This was an area lush with grass and flowing water. Westward, however, through the Humbolt Sink, with its salty bogs, and the desert beyond, the trip was harrowing. The Sierra-Nevada Mountains were formidable, with the boulder-strewn, turbulent Truckee River leading to the infamous Donner Pass. From there the California Trail led to the San Joaquin and Sacramento Valleys.

While the Oregon Trail was the principal route of the pioneers, the Santa Fe Trail from Independence was primarily one of commerce and trade. Each spring freighters gathered at Council Grove, Kansas, to assemble a great caravan before proceeding, as there was strength in numbers against marauding Kiowas and Comanches. Here captains, cooks and night guards were appointed, for organization was essential to a successful trip. The route traversed was to the Arkansas River, along that river to Bent's Fort and southwest to Santa Fe. A shortcut through the Cimarron Desert was hazardous, yet many traders braved the dangers. The traders brought with them such articles as silks, woolen and cotton goods, mirrors and hardware and returned with beaver pelts, gold bullion, horses and mules. Trading began as early as 1822, with an average annual value of $130,000.

The first great examples of western American art began to appear in the late 1830s, at about the time the initial period of exploration was reaching its climax and the great migration to the Far West was just starting. It was in the year 1832 that George Catlin began his trip up the Missouri River with the object of painting the Indians of the plains before their unique way of life

passed into oblivion. This young Philadelphia artist had already made portraits of some Eastern Indians, particularly Delawares, Shawnees and Iroquois, as well as some Plains Indians, including the Pawnees, Otoes, Missouris and Omahas. He was now prepared to add to his gallery the Plains Indians of the Missouri River basin. Proceeding by the river boat *Yellowstone* with paints, palette, canvas and easel as far as Fort Union (the American Fur Company's farthest post), Catlin stopped along the way to paint Sioux and Cheyenne Indians at Fort Pierre. At Fort Union he made portraits of Blackfeet and Crow Indians. Of them he wrote:

> They live in a country well stocked with Buffaloes and wild horses, which furnish them an excellent and easy living; their atmosphere is pure, which produces good health and long life; and they are the most independent and happiest races of Indians I have met with: they are all entirely in the state of primitive wildness, and consequently are picturesque and handsome, almost beyond description.

With two fur traders Catlin left Fort Union in a heavy canoe made of green timbers to float down the Missouri to the Mandan villages. There he spent some weeks painting portraits, ceremonies and scenes of hunting and village life. His depiction of the *Okeepa* ceremony stands to this day as a classic ethnographic record.

Over the next few years Catlin continued to paint Indians – the Osage, the Kiowas, the Comanches and Wichitas – almost obsessively driven to complete his 'Gallery', to record and preserve for posterity these all too perishable wonders of the West.

Below: At once realistic and slightly romanticized, *After the Skirmish* is typical of Frederic Remington's view of Western Army life.

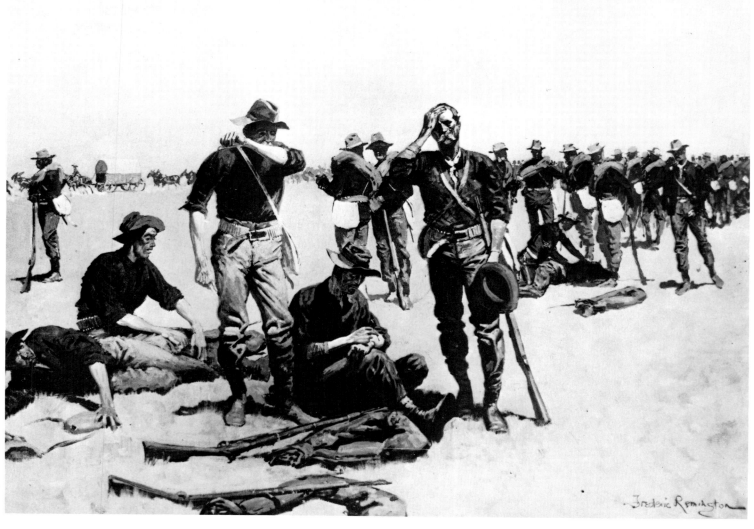

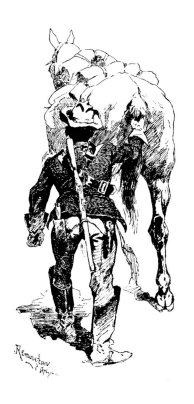

In the spring of 1833, a year after Catlin began his odyssey, Maximillian, Prince zu Wied, set out from St Louis on a scientific exploration of the West. To make a pictorial record, he brought with him Karl Bodmer, a young Swiss artist. While Bodmer possessed none of the dedication to a romantic cause that motivated Catlin, he was a conscientious and highly trained draftsman, ready to work on any subject that Maximillian assigned. The party proceeded up the Missouri, past the Mandan villages, and on to Fort Union at the confluence of the Missouri and Yellowstone Rivers. All the while Bodmer made sketches of the Indians and the landscapes. Continuing west, the Prince reached Fort McKenzie, some 500 miles west of Fort Union. While there, a battle broke out between a band of Piegan Blackfeet, who were camped outside the fort to trade, and a combined force of Assiniboins and Crees. The Prince joined the action by firing from the fort's parapets and credited himself with killing an Assiniboin warrior. Bodmer's painting of the skirmish, which dramatically captures the savagery of Indian warfare, is the only eyewitness portrayal by an artist of such a conflict.

In September the Prince retraced his route down the Missouri to Fort Clark. There he and Bodmer spent the winter. By now Bodmer had portraits of nearly all the Northern Plains Indians – Sioux, Assiniboin, Plains Cree, Gros Ventre, Crow, Blackfeet, Mandan and Hidatsa. Moreover, he rendered the landscapes of the Missouri River basin not only with accuracy, but with a genuine sense of grandeur. In sum, his work, though less comprehensive than Catlin's and lacking Catlin's passionate commitment, is at once more artistically sophisticated and more scientifically exact. As such, it forms another ethnographic record of immense value.

Of all the Indian tribes whose folkways Catlin, Bodmer and others depicted, one in particular began to loom large in the imagination of Easterners. The Sioux were in fact no more colorful or culturally distinctive than, say, the Cheyenne, Crow, Blackfeet or a dozen other tribes, but they were certainly more numerous, and, increasingly, they came to typify all Indian resistance to white westward expansion. After about 1850 the popular image of the Indian 'hostile' more and more began to coincide with that of the mounted Sioux warrior, a fact amply reflected in American popular art, not only in the second half of the nineteenth century, but still today.

Above: Remington called this little pen-and-ink sketch *Trooper in Tow*.
Below: This awkward lithograph shows the peace talks held at Fort Laramie in 1868. Standing is Chief Spotted Tail. Generals William S Harney and William T Sherman are to the right of the tent pole. Seated at the far right is General Alfred Terry. As a result of these talks the US Army agreed to abandon the Bozeman Trail and its three forts.

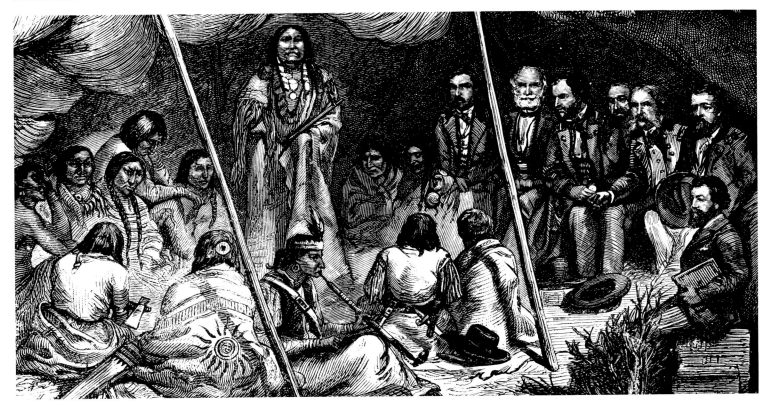

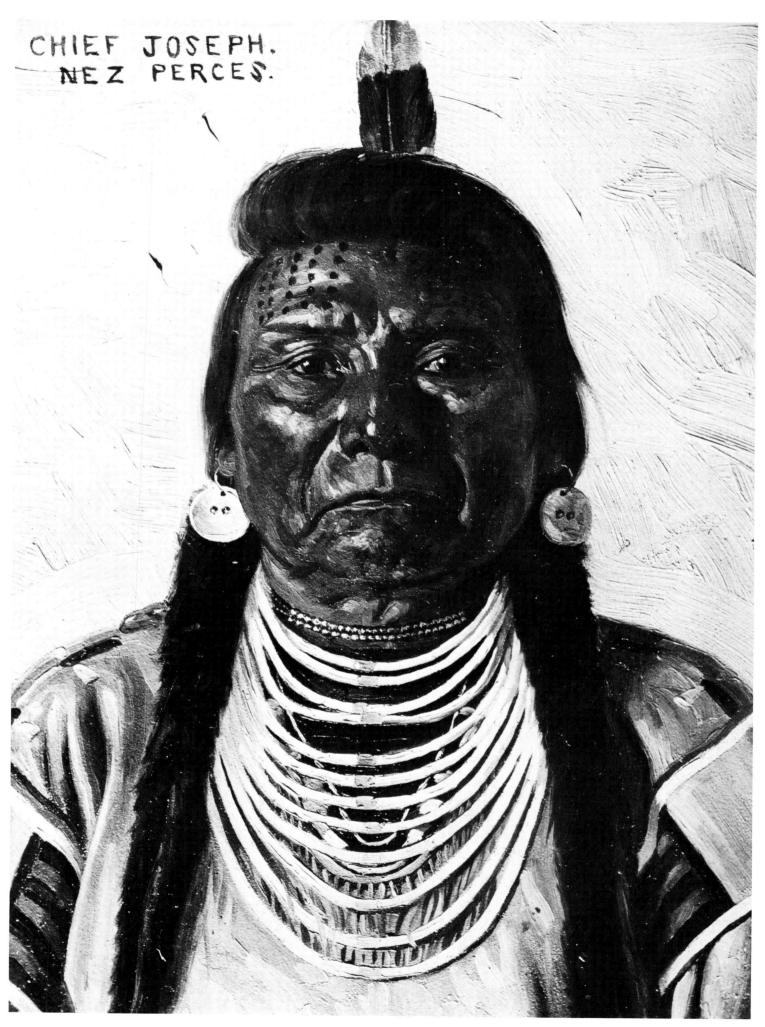

CHIEF JOSEPH.
NEZ PERCES.

The Sioux, whose territory encompassed the heart of the Great Plains, were tipi-dwelling hunters who moved their villages in accordance with the wanderings of the buffalo herds. Since the advent of the horse in the 1740s they had been efficient hunters, able to surround large herds and procure abundant supplies of meat and hides. In addition, the horse accentuated the warlike proclivities of the Sioux, since they now became cavalrymen able to cover a wide territory at a rapid pace. Inevitably the horse became a crucial element in Siouan society, for a man's wealth and prestige were determined by the number of horses he owned.

The Sioux, or Western Dakota, were composed of seven divisions, including the Oglala, the Brulé, the Without Bows and the Hunkpapa. Each division was made up of several bands under the leadership of a headman or chief. The divisions were governed by a council of headmen, elder priests, hunters and warriors of renown. From among them they appointed ten *Nacas* or executives, who in turn selected two to four promising younger men as 'Shirt Wearers' to serve as administrators. Such men were invested with special hair-fringed shirts as badges of their office. The locks of hair ornamenting the sleeves were not scalps, but rather bunches of hair donated by female relatives. In addition, the council appointed 'Pipe Bearers' who led the procession when the villages moved.

The Sioux believed in *Wankan Tanka* – the Great Mysterious One – who was one god, yet many: the Rock, the Sky, the Earth, the Sun, and so on. Lesser gods included the Buffalo, the Bear, the Four Winds and the Whirlwind. Man, too, was closely associated with the Great Mystery, for he possessed a Spirit, a Ghost, a Spirit-like and a Potency. The Spirit was one's personality, while the Ghost was vitality, as observed in one's breath and shadow. The Spirit-like was one's immortality, as observed in the growth of fingernails and hair after death. Finally, the Potency was the power an individual had to accomplish things.

The Sioux believed that the Spirit-like of man was associated with hair, and in turn hair was equated with life everlasting. When a warrior was killed and scalped in battle, it fell to his warrior society brothers to avenge his death, for the soul of an individual who had lost his scalp might not go to the Land of the Ancestors until a new scalp was provided. When the brother returned with the scalp of a fallen enemy, he presented it to the mother or close female relative and announced, 'Rejoice, here is your son. Now he is as one.'

The taking of scalps inevitably led to a gradual expansion of the vengeance circuit, and doubtless this fostered the spread of inter-tribal warfare. But at least all Indians understood the religious assumptions on which the practice of scalping was based. Most white men did not and regarded scalping simply as wanton sadism, an act to be avenged not necessarily in kind, but with any form of violent retaliation that came to hand. As conflict between white and red men intensified in the West during the years after the Civil War, whites came increasingly to look upon scalp-taking as a sort of arch-symbol of the Indians' presumed barbarity, and thus one of the justifications for not worrying overmuch about the survival of Indian culture. Scalping scenes became ever more prevalent in magazine illustrations and other forms of popular Western iconography, and though the subject was usually considered inappropriate for art with higher pretentions, it nevertheless seems to lurk as a sort of implicit menace in many famous paintings dealing with Indian fighting – in Remington's *The Emigrants*, for example, or Russell's *When Shadows Hint Death*.

It is difficult to give an exact date for the beginning of what we now loosely call the Indian Wars in the West. One of the first major incidents involving the regular US Army (as opposed to the incessant skirmishing between

The great Nez Perce chief Joseph, as portrayed by Elbridge Ayer Burbank.

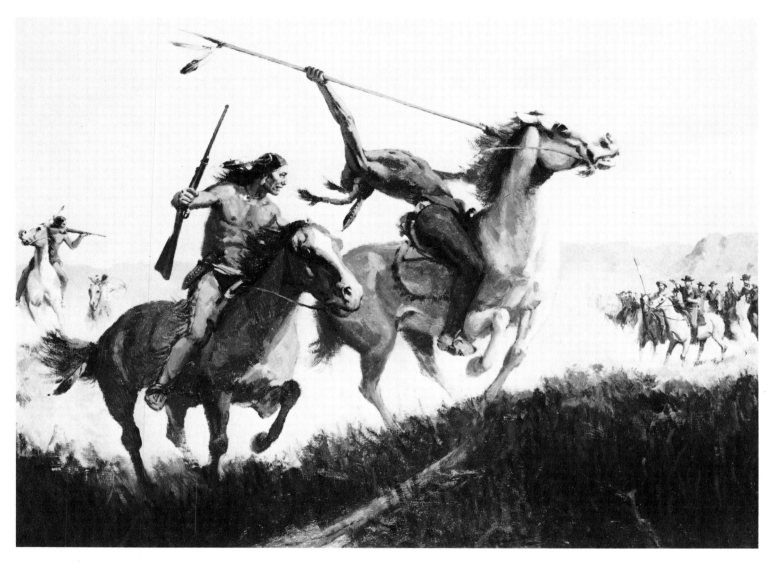

Indians and trappers or settlers) took place near Fort Laramie in 1854. As the result of an argument over the killing of an emigrant's runaway cow, Lieutenant John Gratton marched some 30 infantrymen, with cannon, into a Brulé Sioux camp and demanded satisfaction. Shots were fired, one of the Brulé chiefs, Brave Bear, was killed, and before the day was out Gratton and his entire command had been annihilated.

By the late 1850s the sides were drawn. From being a feared curiosity, the white man was now the enemy. For the following 20 years the Sioux attacked caravans, first of the emigrants and then of the miners. The United States Government established forts along the Bozeman Trail to protect the supply lines to the mining towns of Virginia City in what is now Montana. The Sioux harassed the supply trains and attacked the forts. Near Fort Phil Kearny the Sioux under Red Cloud, together with some Cheyennes and Arapahos, ambushed 81 blue coats in 1866 and killed all of them. Two years later, the so-called Red Cloud War was terminated by the Treaty of Fort Laramie in 1868. The Government capitulated to Red Cloud's demand that the forts be dismantled and the Bozeman Trail be closed.

For many of the Sioux the Laramie Treaty brought peace, but the encroachment of the railroads and the exploration of their sacred Black Hills for gold were fraught with ominous potentialities. And not all the Sioux were willing to be confined to reservations. Sitting Bull, Crazy Horse and their followers were not ready to give up their freedom to hunt buffalo or the liberty to practice their traditional folkways. In fact, within only eight years of the signing of the Laramie Treaty the stage was fully set for the most famous military encounter of the Indian Wars.

Western art has tended to concentrate on surprisingly few themes. One of the classics is battle between US cavalry and mounted Sioux braves.

18

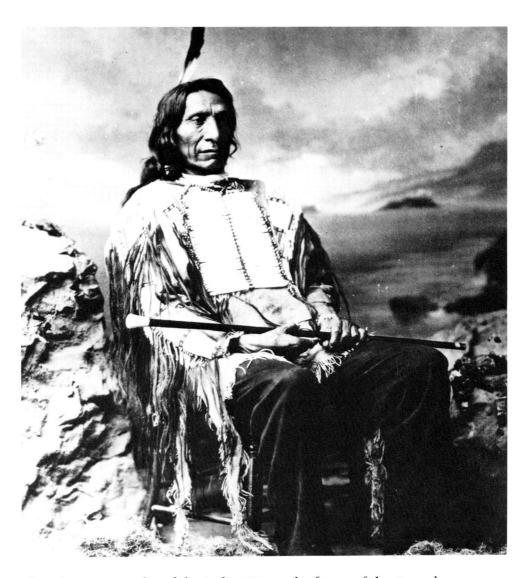

Photographic portraits of Indians in the nineteenth century were rare and often of poor quality. One of the best is this haunting study of Red Cloud, chief of the Oglala Sioux.

If, in the iconography of the Indian Wars, the figure of the Sioux brave came to typify the Indian 'hostile,' counterpart images of the white Indian fighter also quickly established themselves in the popular imagination. At first these were based mainly on civilian frontiersmen of the type of Davy Crockett and Kit Carson – tough, wily hunters, trappers and scouts who seemed to know as much about Indian warfare as the Indians themselves. Later, within about a decade after the end of the Civil War, these popular archetypes were joined by another, that of the blue-coated regular of the Indian-fighting Army of the West, and especially that of the cavalryman. Initially a romantic cardboard figure, the image of the pony soldier gradually became more realistic, and by the end of the century had assumed most of the characteristics we associate with it today. The final form in which this image has entered our national consciousness probably owes more to the paintings of Frederic Remington than to any other source. Yet for all their accurate, gritty detail, Remington's depictions remain idealizations.

The Indian-fighting Army of the late 1860s and 1870s was composed of ordinary men from many walks of life. The older commissioned officers were often veterans of the Civil War. Similarly, many non-commissioned officers were men who had been breveted in the Civil War and had sub-sequently accepted lesser rank in order to continue their service. Others were 'galvanized Yankees', men who had fought for the Confederacy and who chose to fight Indians rather than languish in prison camps. Recruits made up the bulk of the enlisted men's ranks. Some were Irish, Italian or German emigrants who chose army life as a means of support in an unfamiliar land. Others were men running from the law, who changed their names and became lost to the police. There were clerks and farm boys and

bums from the gutter. There were 'snow birds' who accepted food, clothing and shelter for the winter, only to desert in the spring and head for gold mining country.

What all these soldiers – infantry and cavalry alike – shared in common was a life of tedium on remote army posts, punctuated by intervals of harsh, dangerous campaigning against a pitiless foe. For this, the neglect of Washington, the disdainful attitudes of most civilians and $13 a month was hardly an overwhelming recompense. Yet in 1876 there occurred an event that was to transform these half-forgotten men almost overnight into folk heroes. And that event, oddly, was their worst and most inexcusable defeat.

In the imaginations of most Americans no episode in the winning of the West is more graphically realized than Custer's Last Stand. The words evoke an instant image, something we can visualize in near-perfect detail. The buckskin-clad Custer, revolver in hand, defiantly waiting for the final on-slaught, the circle of dead and dying troopers, the surrounding horde of frenzied Sioux warriors, some of whom are by now so close that in a few more seconds they must certainly deal Custer the fatal blow.

This image is imprinted on our mind's eye because we have seen it depicted so often in drawings and paintings, and later, derivatively, on film. We know that the image is almost certainly false – no one knows what Custer's last moments really looked like – but that does not matter. Custer's Last Stand has become an icon not of Western history, but of Western myth. And how it came to be so tells us something about one of the peculiar aspects of Western art.

It was in June 1876, the year of the Nation's Centennial, that General George Armstrong Custer, leading the 7th Cavalry, left the Yellowstone River to ride south along the Rosebud toward its headwaters. The plan was for Generals Terry and Gibbon to march south up the Bighorn River and with Custer's troops encircle a Sioux encampment known to be in the area. In his orders, Custer was given a certain leeway as to when and if to attack, but he was also cautioned not to be impetuous. Custer's troops numbered 31 officers, about 585 troopers and around 20 civilian employees, including packers and guides. He also had with him 40 Crow and Arikara Indian Scouts.

At dawn on 25 June, from a ridge overlooking the Little Bighorn valley, Custer's Indian scouts observed smoke from Sioux villages some 15 miles to the West. Although Custer doubted the significance of this reported sighting, he nonetheless felt sure that the Indians were in the vicinity and, still fearing their escape, ordered an advance.

Now he divided his troops, one battalion of three companies under Major Reno, another of three companies under Captain Benteen. Under his personal command he retained five companies consisting of some 215 men. Benteen was sent off to scout to the south, while Custer and Reno rode down the valley of a creek which emptied into the Little Bighorn. When the troops flushed some Indians from an abandoned campsite, Custer ordered Reno to pursue the hostiles and to attack what was sure to be an Indian village in the bottom lands across the river.

Soon thereafter Reno and his 112 men were set upon by a huge force of mounted Huncpapa Sioux under the leadership of Chief Gall. Narrowly avoiding destruction, Reno fell back across the Little Bighorn and eventually established a precarious defensive position on a bluff above the river. He had by this time lost about half his command.

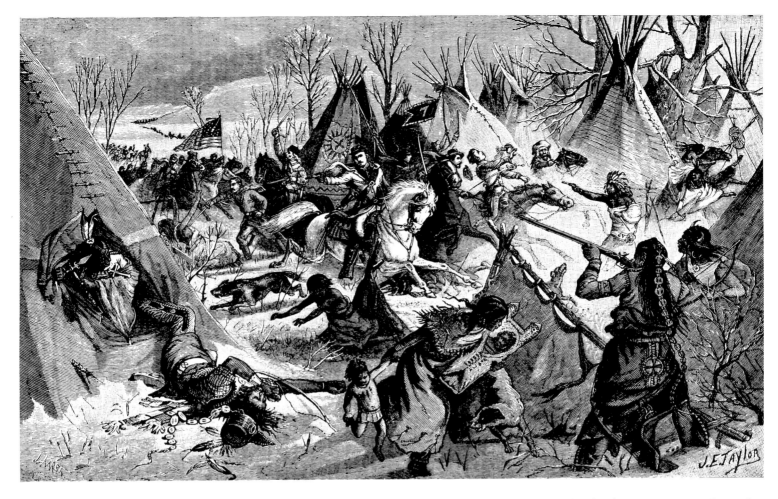

Above: Now considered disgraceful, but much admired and depicted at the time, was Custer's surprise attack on a Cheyenne village at the Battle of the Washita in 1868.

Below: No subject in Western art has been more thoroughly or, for the most part, more foolishly exploited than Custer's Last Stand.

Meanwhile, Custer, proceeding independently, had swung around to the northeast and had come in sight of at least part of the main Indian encampment, an immense affair numbering perhaps 12,000 souls in all, at least a third of whom were warriors. Whether Custer even then realized the full strength of the enemy, or, if he did, whether he could have extricated his command from the danger in which it now found itself, is moot. In any case, he charged, was soon overwhelmed by the combined forces of Gall and Crazy Horse and fell back to make a last ditch stand on a grassy slope northeast of the encampment. Within an hour – by about 1600 hours – Custer and his five companies had been obliterated.

Such are the military facts. Ever since, historians have argued about the puzzling unknowns that mark the incident – why Custer divided his forces in the first place, why it took him so long to recognize the size of the opposition, whether Reno or Benteen could have given him more assistance and so on. But that it was a defeat that reflects no great credit on the military competence of the defeated now seems obvious. And almost as obvious is that it was a relatively minor defeat – one that was neither decisive to the outcome of the Indian Wars nor of a scale that would even have attracted much notice a few years earlier amidst the carnage of the Civil War.

Yet this was by no means the way the matter was perceived in 1876, or for a long time thereafter. The nation was shocked and furious that a band of savages should have contrived so to thwart civilization's progress and to kill a man who, if he was not quite a national hero, was certainly about to become one. And all this in the year of the Centennial celebration.

Almost immediately, the battle became the subject of the artists' pencils, pens and brushes. In less than a month W M Cary's picture of Custer's last fight appeared in *The New York Graphic & Illustrated Evening Newspaper*. More famous was F Otto Becker's copy of Cassily Adams's version, repro-

duced as a lithograph for Anheuser-Busch, Inc. In all, it has been calculated that there have been over 800 paintings of the battle, and it is still being painted today. As for printed matter, there are more books pamphlets and articles about the Custer fight than about any other battle in American history.

Since no surviving white man witnessed the Custer engagement, a great deal of conjecture filled the canvases. And with conjecture came patent mistakes. Many artists depicted Custer wearing long hair and a buckskin shirt. In fact he had had a haircut just prior to the campaign and was wearing a blue flannel shirt. In many paintings sabers are much in evidence, though no sabers were carried to the Little Bighorn. Becker's mistakes were legion, not the least being that of equipping his Sioux warriors with African Zulu shields. Ironically, perhaps no single representation has done more to fix the image of Custer's Last Stand in our minds than Becker's absurd painting.

But of course many artists far better than Becker also tried their hands at the battle. Remington, Russell and Sharp all painted versions of it, as did William Dunton, N C Wyeth and Walt Kuhn. With the passage of time the artists' treatments may have become increasingly accurate in detail, but in spirit almost all their depictions – even the few that were irreverent – continued to refer to a battle that had become less history than legend.

The way artists represented the Battle of the Little Bighorn was, in fact, merely emblematic of a shift that was already taking place in the way people perceived the West as a whole. Since the beginning of the century people had seen the West as wonderful, but after about 1850 they also began to think of it as fabulous, a place in which events, people and things all seemed larger than life. This tendency to want to see the West in terms of epic and melodrama was – thanks largely to the vast popularity of sensational dime novels and highly colored stage productions – well advanced even before the nation was electrified by the news of Custer's defeat. And by the early 1880s, it was to find even more thrilling 'real life' expression in such extravaganzas as Buffalo Bill's hugely successful Wild West tent show.

That artists should in varying degrees be affected by this increasingly theatrical popular vision of the west was inevitable. Remington and Russell, for example, though they yield to none in the meticulous accuracy with which they render detail, seem almost incapable of approaching their subjects with the detached objectivity of such pre-Civil War painters as Catlin and Bodmer. Their work is rich in narrative, most of the narrative is explicitly dramatic and above all, the narrative almost never deviates from the accepted canons of the popular myth of the Wild West.

To be sure, narrative painting of any kind is liable to display a certain weakness for conventional dramatic effects, but in later nineteenth century Western art, even landscape painting seems to owe as much to theater as to observation. The painters of the so-called 'Rocky Mountain School,' for example – Albert Bierstadt, Thomas Hill, Thomas Moran and others – were quite shameless in the ways they both rearranged and distorted nature and manipulated light in impossible ways so as to give their huge canvases the maximum Wagnerian impact. Theatrical in a subtler way was Ralph Albert Blakelock, who habitually dissolved the details of his landscapes in mystical atmospherics.

The difference between pre-Civil War objectivity and post-Civil War theatricality is marked, but of course it is not absolute. In both periods there were artists who did not conform to the dominant moods and styles of their times – often at the price of neglect by their contemporaries. A case in point is that of Alfred Miller.

Above: This photograph of landscape painter Alfred Bierstadt was taken by the portraitist Napoleon Sarony.

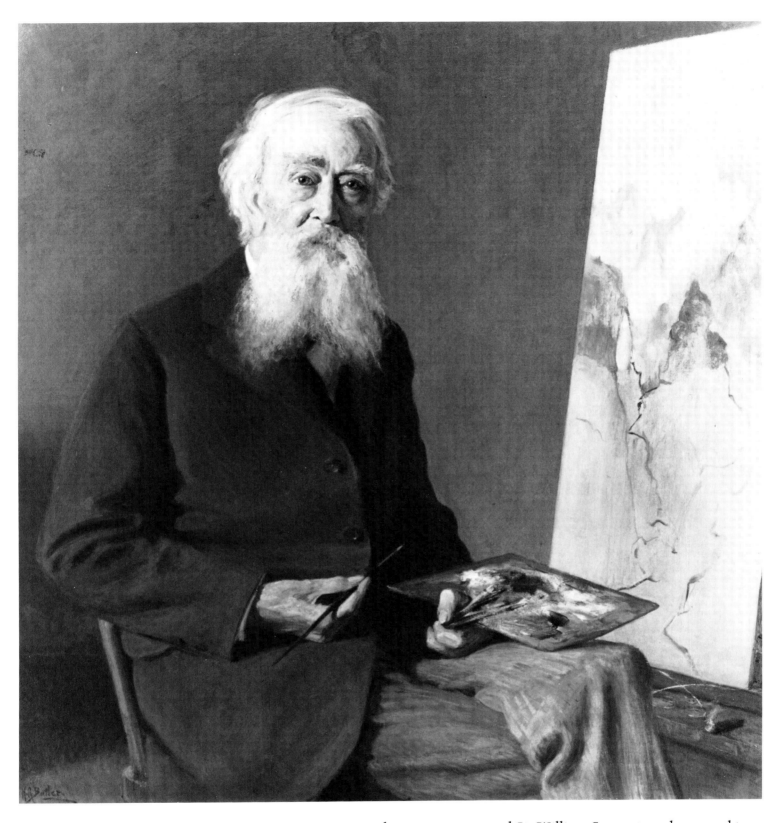

Above: Bierstadt's rival in landscape painting was Thomas Moran, portrayed here by Howard Russell Butler.

In 1834 a Scottish sportsman named Sir William Stewart made a grand tour of the Rockies. So enthralled was he with the dazzling mountains, the turbulent streams and the abundance of wild life that he employed Jim Bridger, a mountain man of heroic repute, to guide him as far north as the Big Horn Mountains of Wyoming and as far south as Taos, New Mexico. Returning to New Orleans in the fall of 1835, he chanced upon the painting of Alfred Jacob Miller. Stewart was impressed, and he asked Miller to join him on his next foray. Miller jumped at the opportunity. In the spring of 1837 they set out for the Missouri River and across the Plains to the Green River country of Wyoming. Along the way, Miller made portraits of the Indians, rendered Fort Laramie in watercolors and captured the excitement of a great fur trappers' rendezvous. Miller was prolific, and his shimmering

impressionistic paintings pleased Stewart. Miller subsequently returned to New Orleans and worked on paintings both for his patron and for a show in New York City in 1839. Miller later went to Scotland where he worked under the sponsorship of Stewart. He later settled in Baltimore under the patronage of the Peale Museum and William Walters. Unlike the works of Catlin and Bodmer, which received widespread publicity, Miller's paintings lay pretty much hidden until they were discovered nearly a hundred years later. When, however, they did become known, their exhaltation of the primitive rendered in an almost ethereal style served to remind viewers that romanticism in Western art was not solely a post-war phenomenon.

A phenomenon that *was* distinctly post-war, and that was to produce one of the greatest icons of Western romance, was the advent of the cowboy. Texas veterans returning home found their farms in shambles and their cattle strayed. Rounding up cattle and driving them north to supply the growing industrial cities of the East seemed to be good business. And so it was that the great cattle drives from Texas to the railhead towns of Abeline, Ellsworth and Dodge City began. Longhorn cattle were flushed out of the mesquite underbrush, rounded up and collected at a starting point. As many as 3000 head of cattle might be gathered. A drive generally required one 'trail boss,' nine cowboys, a cook and 60 or more horses. It took tough men to drive a herd 2000 miles from Texas to Kansas. Not only did the drovers have to endure hot, dry prairies, ford rivers, suffer terrifying lightning storms and hurtling stampedes, but near the end of the trail face Indian warriors and Kansas Jayhawkers demanding tolls. Yet for some men the hardships were

Far right: A self-portrait of Alfred Jacob Miller, the early impressionist.
Right: A self-portrait of George Caleb Bingham, one of the best of the pre-Civil War Western painters.
Below: Soon to join the Indian and the cavalryman in the trinity of Western icons was the image of the cowboy.

worth it. With luck, a 'ramrod' might sell his herd for a $30,000 profit.

Rather than trailing cattle, some men took up ranching, staking out for themselves as much as a thousand square miles of grazing land simply by acquiring strategic water rights. Huge ranches sprang up in Montana, the Dakotas, Wyoming, Colorado and New Mexico. Yet for the cowboy, life on these was no less arduous than on the drives. Cattle had to be rounded up, branded and driven to shipping points. Riding the line to keep drifting cattle on the ranch might mean eight hours in the saddle. So big were some ranches that cabins or stone huts were set up along the lines, and one or two cowboys could be stationed in them for long, lonely periods of time.

Probably more than anyone, it was Charles Russell who brought the cowboy to life for the American public. Charlie left his St Louis home at 16 to work on an uncle's sheep ranch in Montana and promptly got fired. Next he met up with a trapper named Hoover, spent some time living with the Blackfeet Indians and finally landed a job on a ranch wrangling horses. While he first made sketches of wildlife, he soon began to make pictures of ranching – the cattle, the horses and the cowboys. Almost from the beginning, his paintings told stories, many of which Charlie either witnessed or was part of. So accurate were his renditions of situations that old cattlemen viewing his paintings could recognize a particular horse that Charlie had portrayed. And his sense of action and use of color gave excitement to his figures and an aura of brilliant grandeur to his landscapes.

Russell neither introduced the cowboy to the public nor exalted him in any way he had not been exalted before, for the cowboy was an established folk

hero well before Charlie came on the scene. What Charlie did was to crystallize the hero's image. If there had ever been any doubt before about how real cowboys looked and acted, Charlie dispelled it forever. From then on, we would all have to visualize 'The Cowboy' as Charlie saw him, much as we would all have to visualize 'The Pirate' as Howard Pyle imagined him. Those cowboys who appeared in the first Western movies could not have been anything other than Charlie's cowboys, and it is hardly surprising that the first great Western movie hero, William S Hart, was Charlie's warm friend and ardent admirer.

Frederic Remington, Russell's famous contemporary, also painted cowboys – not as often, perhaps, but probably as accurately and with a good deal more technical facility. Yet somehow Remington's cowboys never quite achieved the same degree of earthy poetry as Russell's. Perhaps because Remington had a more sharply developed theatrical sense than Russell, his stage managing tended to distance him more from his subject matter. His forte was a kind of ultra-realistic melodrama, in which every detail was perfect, but the concept often seemed slightly contrived. On the other hand, if Remington was never quite as personally involved in his work as Russell, some of his dazzling effects were matchless.

Having studied art briefly at Yale, Remington had an irresistible urge to go west. Arriving in Montana in 1881, he began sketching and sold one of his works to *Harper's Weekly*. He made several subsequent trips to the West but finally settled in the East, where he turned out paintings in profusion. Remington's works covered a broad spectrum of the West. His subjects included not only cowboys, but Indians, emigrants, cavalrymen, even stagecoaches. Some of his paintings record facts, while others are entirely imaginary. But all are inherently dramatic and are executed with an impressive degree of technique.

Remington's long suit was action. Some of his paintings seem almost to explode from the canvas, making the alarmed viewer feel as though he were about to be trampled under the flying hoofs of the onrushing cavalry troop, Indian war party or whatever else Remington has chosen to hurl at him. In other paintings, though little action seems to be taking place, an eruption of violence is so palpably imminent that the scenes are taut with suspense. And even in paintings where his human or animal subjects appear relatively at peace, Remington often achieves another kind of action through his bold use of dramatic composition and lighting.

Remington's strengths and weaknesses were different from those of Russell, but the two men had one important thing in common: nostalgia. By the early years of the twentieth century both had become convinced that the West they had known and loved in their youth had disappeared forever, and now they were determined to memorialize that vanished West in their art. Thus they became the first painters deliberately to represent the West not as it was in their own time, but as it had been.

In so doing they may be said to have founded a school of painting that persists to this day. The long list of Western artists who continued to paint in the retrospective spirit of Remington and Russell includes such names as N C Wyeth, John Clymer, Harold von Schmidt, Newman Myrah, Don Spaulding and many more. Their paintings, though full of individual variation, have common hallmarks – a preference for the realistic style, dramatic narrative concepts and themes that consciously refer to one or another aspect of the received legend of the Old West.

But other painters continued to paint the West as they found it, though sometimes still with that hint of the fabulous that has become so much a

Top: Charles Marion Russell.
Above: Frederic Remington at work.
Right: Georgia O'Keeffe in 1931, with her canvas *Life and Death*. The skull and flowers form a famous motif.

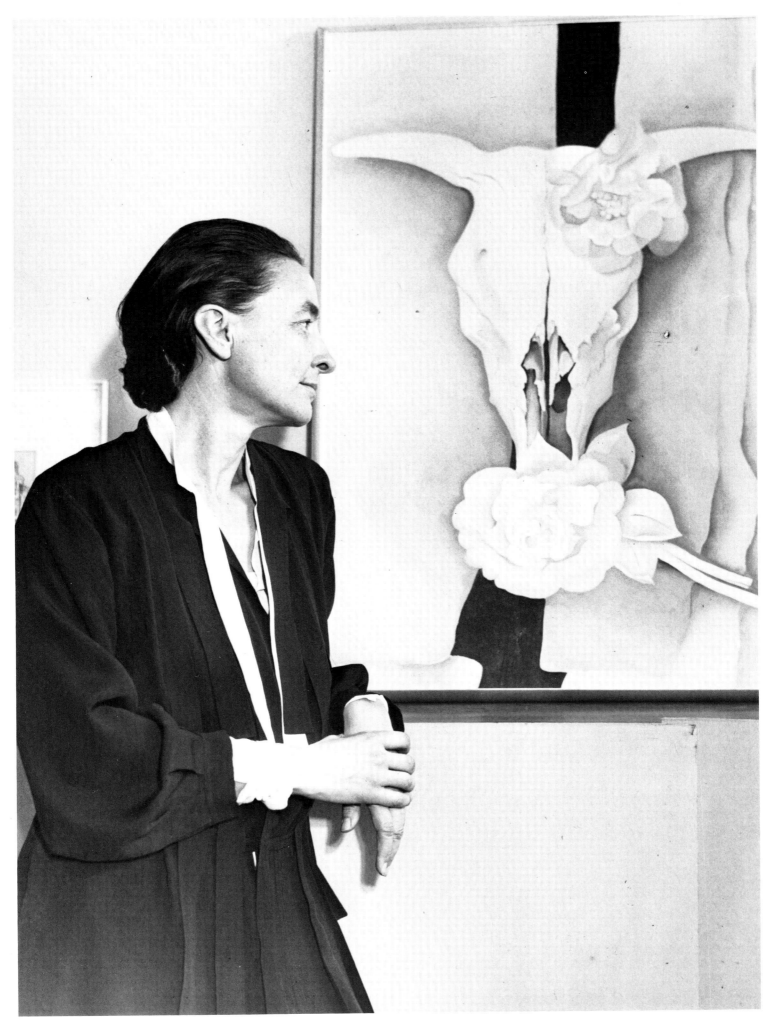

part of Western art in general. Some of these, such as Peter Hurd and Winold Reiss, chose the path of realism; some, such as Nicolai Fechin, of impressionism; some, such as Fritz Scholder, of abstract expressionism; and some, such as the great Georgia O'Keeffe, of a style so personal that it defies any easy classification. But that many contemporary artists have found more than enough to inspire them in the New West is patent.

Given all the past and present diversity in Western painting it is fair to wonder just how meaningful the term 'Western art' really is. Artists such as Catlin, Bierstadt, Russell and O'Keeffe obviously painted in very different ways and had very different intentions. Occasionally, to be sure, they painted similar subjects, but does that confer on them any commonality greater than the painting, of, say, nudes, religious scenes or still lifes confers on other artists? The answer to that question may depend on how you feel about the West itself.

Right: Newman Myrah
Below: Don Spaulding

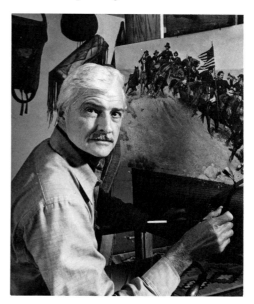

From one, strictly logical point of view, the West is not a single place, but many. Its vast area contains every sort of environment, from mountains to deserts to forests to prairies. Its history is so discontinuous and its people are so diverse that it is often easier to understand both in terms of particular regions than in terms of the West as a whole. Yet almost from the time of Lewis and Clark most Americans have tended to take a more subjective view and to think of the West as having a special over-arching identity. At first it was seen primarily as a huge natural wonderland, and the earliest artists faithfully reported its various marvels to the Eastern public. But the things they portrayed were so exotic and of such a scale as to seem fantastic. So much so that when some artists did begin to render their subjects in more theatrical and fanciful ways, their exaggerations went all but unnoticed.

Artists were not, of course, solely responsible for the gradual romanticization of the West. Writers, poets, actors and many others contributed to the process. But it was a process for which the public was certainly ready,

Hurd was a Bird

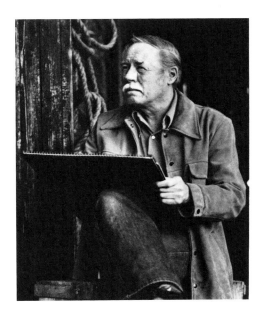

and in fact demanded. Thus a sort of mythical West was slowly super-imposed on the real West. Like all myths this was less and more than the reality it sought to interpret. It was composed of selected situations and images that were understood both to typify the West and to be more expressive of the West's peculiar spirit. As time passed, many Americans (artists included) found it increasingly difficult to keep these visions separate.

If anything lends cohesion to Western art it is probably this shared vision, this common imaginative structure by which artists and viewers can approach subjects (at least initially) in the same way. To the extent that this facilitates aesthetic communication it has doubtless been a good thing, but it has not of itself been any guarantee of good art. At worst, in the hands of lazy or inept artists, it has merely produced a form of western genre painting that is at once stereotyped, overblown and repetitive. But for artists of greater talent, this informed vision seems to have provided a kind of jumping off point from which their subsequent leaps to personal statement may have been made not only more accessible to the viewer but also more focused and effective. Thus Russell's cowboys and Indians transcend the genre in which they seem superficially rooted and end as moving, uniquely poetic creations. By the same token, O'Keeffe begins with a set of props long familiar in Southwestern landscape paintings – sun bleached animal skulls, stark adobe walls, eroded hills and the like – and turns them into some of the most haunting and individual images in all contemporary art.

The paintings reproduced in this book illustrate the simultaneous unity and diversity of Western art. I have selected most of them for what seems to me their intrinsic merit, but I confess that a few – Becker's very famous and very silly *Custer's Last Fight*, for example – are here only because they touch on some important aspect of Western history or represent some characteristic phase in the development of Western art. In any case, I hope you will agree with me that even the least of these paintings are never less than entertaining and the best are extraordinary by any standard.

Bottom left: Peter Hurd, as sketched by Andrew Wyeth in 1940.
Below: An older Hurd in his studio.

PICTURE CREDITS

35. *Moonlight* (1885)
Ralph Albert Blakelock (1847-1919)
The Brooklyn Museum, NY
Oil on canvas, 27¼ × 32¼ inches
Dick S Ramsay Fund

36. *She Comes Out First, Sioux* (1899)
Elbridge Ayer Burbank (1858-1949)
The Butler Institute of American Art, Youngstown, OH
Oil on canvas, 13 × 9 inches

37. *The Crow War Bonnet* (c 1901)
Joseph Sharp (1859-1953)
Buffalo Bill Historical Center, Cody, WY
Oil on canvas, 24⅛ × 20⅛ inches

38. *On the Southern Plains* (1907)
Frederic Remington (1861-1909)
The Metropolitan Museum of Art, NY
Oil on canvas, 30⅛ × 51⅛ inches
Gift of Several Gentlemen, 1911

39. *The Scout: Friends or Enemies?* (c 1890)
Frederic Remington (1861-1909)
Sterling and Francine Clark Art Institute, Williamstown, MA
Oil on canvas, 27 × 40 inches

40. *The Emigrants* (1904)
Frederic Remington (1861-1909)
The Hogg Brothers Collection, Museum of Fine Arts, Houston, TX
Oil on canvas, 30 × 45 inches

41. *My Bunkie* (1899)
Charles Schreyvogel (1861-1912)
Metropolitan Museum of Art, NY
Oil on canvas, 25³⁄₁₆ × 34 inches
Gift of friends of the artist, 1912

42. *Attack at Dawn* (1904)
Charles Schreyvogel (1861-1912)
The Thomas Gilcrease Institute of American History and Art, Tulsa, OK
Oil on canvas, 34 × 46 inches

43. *The Strenuous Life* (1901)
Charles Russell (1864-1926)
The Thomas Gilcrease Institute of American History and Art, Tulsa, OK
Oil on canvas, 36 × 23 inches

44. *When Shadows Hint Death* (1915)
Charles Russell (1864-1926)
The Duquesne Club, Pittsburgh, PA
Oil on canvas, 30 × 40 inches

45. *Salute to the Robe Trade* (1920)
Charles Russell (1864-1926)
The Thomas Gilcrease Institute of American History and Art, Tulsa, OK
Oil on canvas, 29 × 47 inches

46. *Indian Girl* (1917)
Robert Henri (1865-1929)
The Indianapolis Museum of Art, Indianapolis, Indiana
Oil on canvas, 32 × 26 inches
Gift of Mrs John N Carey

47. *Moki Snake Dance* (1904)
E Irving Couse (1866-1936)
The Anschutz Collection, Denver, CO
Oil on canvas, 36 × 48 inches
Photo by James O Milmoe

48. *The Lookout* (c 1902)
William R Leigh (1866-1955)
The Woolaroc Museum, Bartlesville, OK
Oil on canvas

49. *The Elk Hunter* (c 1912)
Bert Phillips (1868-1956)
The Anschutz Collection, Denver, CO
Oil on canvas, 28 × 40 inches
Photo by James O Milmoe

50. *Wyoming Elk* (no date)
Carl Rungius (1869-1959)
Buffalo Bill Historical Center, Cody, WY
Oil on canvas, 30⅛ × 40⅛ inches

51. *Sangre de Cristo Mountains* (1925)
Ernest Blumenschein (1874-1960)
The Anschutz Collection, Denver, CO
Oil on canvas, 50 × 60 inches
Photo by Malcolm Varon, New York, NY

52. *Peace and Plenty* (1925)
Oscar Berninghaus (1874-1952)
The Saint Louis Art Museum, St Louis, MO
Oil on canvas, 35 × 39½ inches

53. *The Pony Express* (1924)
Frank Tenney Johnson (1874-1939)
The Thomas Gilcrease Institute of American History and Art, Tulsa, OK
Oil on canvas, 42 × 56 inches

54. *Where the Desert Meets the Mountain* (before 1922)
Walter Ufer (1876-1937)
The Anschutz Collection, Denver, CO
Oil on canvas, 36 × 40 inches
Photo by James O Milmoe

55. *Medicine Robe* (1915)
Maynard Dixon (1875-1946)
Buffalo Bill Historical Center, Cody, WY
Oil on masonite, 40 × 30 inches

56. *The Custer Fight* (no date)
W Herbert Dunton (1878-1936)
Buffalo Bill Historical Center, Cody, WY
Oil on canvas, 32 × 50 inches

57. *Buffalo Dancer* (no date)
Gerald Cassidy (1879-1934)
The Anschutz Collection, Denver, CO
Oil on canvas, 57 × 46 inches
Photo by James O Milmoe

58. *Moving the Herd* (1923)
W H D Koerner (1879-1938)
Buffalo Bill Historical Center, Cody, WY
Oil on canvas, 26¼ × 56¼ inches

59. *Indian Woman With Children* (1926)
Nicolai Fechin (1881-1955)
The Anschutz Collection, Denver, CO
Oil on canvas, 36 × 30 inches
Photo by Malcolm Varon, New York, NY

60. *Pueblo Pottery* (1917)
Henry C Balink (1882-1963)
Museum of New Mexico, Santa Fe, NM
Oil on canvas, 27 × 33 inches

61. *Cutting Out* (1904)
N C Wyeth (1882-1935)
Buffalo Bill Historical Center, Cody, WY
Oil on canvas, 38¼ × 26 inches

62. *The Encounter* (c 1920)
Ernest Martin Hennings (1886-1956)
The Anschutz Collection, Denver, CO
Oil on canvas, 30¼ × 30¼ inches
Photo by James O Milmoe

63. *Angry Bull* (no date)
Winold Reiss (1888-1953)
Courtesy of Burlington, Inc

64. *Black Cross, New Mexico* (1929)
Georgia O'Keeffe (1887-1986)
The Art Institute of Chicago, Chicago, IL
Oil on canvas, 39 × 30¹⁄₁₆ inches

65. *Red Hills, Grey Sky* (1935)
Georgia O'Keeffe (1887-1986)
The Anschutz Collection, Denver, CO
Oil on canvas, 14 × 20 inches
Photo by James O Milmoe

66. *Threshing on the High Plains* (1969)
Thomas Hart Benton (1889-1975)

The Anschutz Collection, Denver, CO
Oil on canvas, 18 × 34 inches
Photo by James O Milmoe

67. *Indian Scouting Party* (1940)
Harold von Schmidt (1893-1982)
The Anschutz Collection, Denver, CO
Oil on canvas, 30 × 50 inches
Photo by Arthur Coleman, Palm Springs, CA

68. *Letter From Home* (no date)
Olaf Wieghorst (1899-)
National Cowboy Hall of Fame, Oklahoma City, OK
Oil on canvas, 24 × 30 inches

69. *Coe Ranch* (no date)
Peter Hurd (1904-1984)
Santa Ana Editions, NM

70. *Wild Horse Race* (c 1935)
Frank Mechau (1904-1946)
The Anschutz Collection, Denver, CO
Oil on canvas, 40 × 100 inches
Photo by James O Milmoe

71. *Gold Train* (1970)
John Clymer (1907-)
Buffalo Bill Historical Center, Cody, WY
Oil on canvas, 60 × 120 inches

72. *The Hand Warmer* (1973)
Tom Lovell (1909-)
National Cowboy Hall of Fame, Oklahoma City, OK
Oil on canvas, 27 × 37 inches

73. *Dakota Pipe Clan Magic* (c 1950)
Oscar Howe (1915-)
Courtesy of Mr and Mrs Peter H Hassrick
Watercolor, 10½ × 17½ inches

74. *At The Sing* (no date)
R Brownell McGrew (1916-)
The Anschutz Collection
Acrylic/masonite, 36 × 60 inches
Photo by James O Milmoe

75. *Trail To a Lost Freedom – Chief Joseph* (no date)
Newman Myrah (1921-)
Courtesy of the Artist
Oil on canvas, 30 × 40 inches

76. *Stampede* (1963)
Harry Jackson (1921-)
Wyoming Foundry Studios, Inc
Oil on canvas, 10 × 21 feet
Photo by Scott Hyde

77. *Sharing An Apple* (1969)
Tom Ryan (1922-)
National Cowboy Hall of Fame, Oklahoma City, OK
Oil on canvas, 25¼ × 30 inches

78. *Crow Indian Wearing 1860 Medicine Bonnet* (1983)
James Bama (1926-)
Courtesy of the Artist

79. *The Skirmish Line* (no date)
Don Spaulding (1926-)
Courtesy of the Artist
Oil on canvas, 20 × 34 inches

80. *An American Portrait* (1979)
Fritz Scholder (1937-)
The Anschutz Collection, Denver, CO
Oil on canvas, 40 × 35 inches
Photo by James O Milmoe

81. *Dream Shirt* (1981)
Ned Jacob (1938-)
The Anschutz Collection, Denver, CO
Pastel/paper, 31½ × 17½ inches
Photo by James O Milmoe

82. *Popo Aggie River Camp* (1976)
Michael Coleman (1946-)
Buffalo Bill Historical Center, Cody, WY
Gouache, 15 × 27 inches

THE PAINTINGS

An Osage Warrior (c 1804)

The Henry Francis du Pont Winterthur Museum, Winterthur, Delaware

Charles B J F de Saint-Memin (1770-1852)

Charles Balthazer Julien Févret de Saint-Memin, a young French nobleman, fled his mother country during the Revolution to make his living as an artist in the United States. With the aid of a physiognotrace, a wooden contraption that enabled him to trace the exact profiles of his subjects, Saint-Memin made portraits of prominent individuals in Washington, Philadelphia and Baltimore.

It was Meriwether Lewis, upon instruction from President Thomas Jefferson, who made arrangements for 12 Osage Indian Chiefs to visit Washington. Here not only would they meet the President, but tour such Eastern cities as New York, Philadelphia, Baltimore and Washington, all to the end of establishing firm diplomatic relations with the Indian Nations within the boundaries of the new Louisiana Purchase.

Saint-Memin's portraits of five of the Chiefs are the earliest likenesses of Plains Indians known to exist. His rendering of this *Warrior* captures the native physiognomy admirably. Bedecked in face paint and red deer-hair roach, a bird's-head headdress, bone hair-pipe earrings and silver armlet, the character portrayed in this watercolor is nothing if not striking.

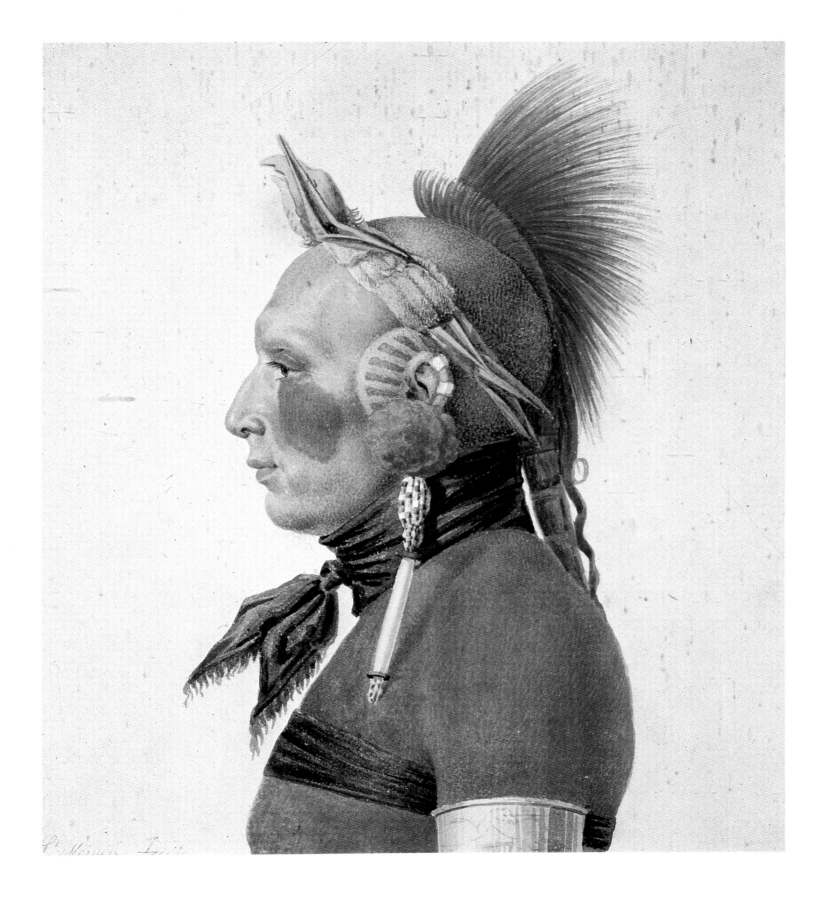

35

Petalesharro, Generous Chief, Pawnee (1821)

The White House Collection

Charles Bird King (1785-1862)

Born in Newport, Rhode Island, King studied first with Samuel King and later moved to New York to work under Edward Savage. In 1805 he sailed to London to study with Benjamin West. Returning to the United States, he settled in Washington, where he engaged in painting portraits of distinguished citizens.

It was at this time the policy of the Superintendant of Indian Trade, Thomas L McKenny, to bring Western Indians to the Eastern cities. Having them visit Washington to meet the president was a gesture of friendship. To show them New York, Philadelphia and Baltimore was to impress them with the military power and cultural achievements of the United States.

King was prevailed upon to paint the likenesses of the visiting Indians. His so-called 'Indian Gallery' eventually rose to a total of 89 portraits, but a fire at the Smithsonian Institution in 1865 destroyed all save three. King's portrait of *Petalesharro*, the Generous Chief, shows the Pawnee headman wearing a bonnet of golden eagle feathers with ermine-tail pendants, glass beads and a silver peace medal. Petalesharro received much popular acclaim because he was said to have rescued a Comanche maiden about to be sacrificed in the Pawnee Morning Star Ceremony.

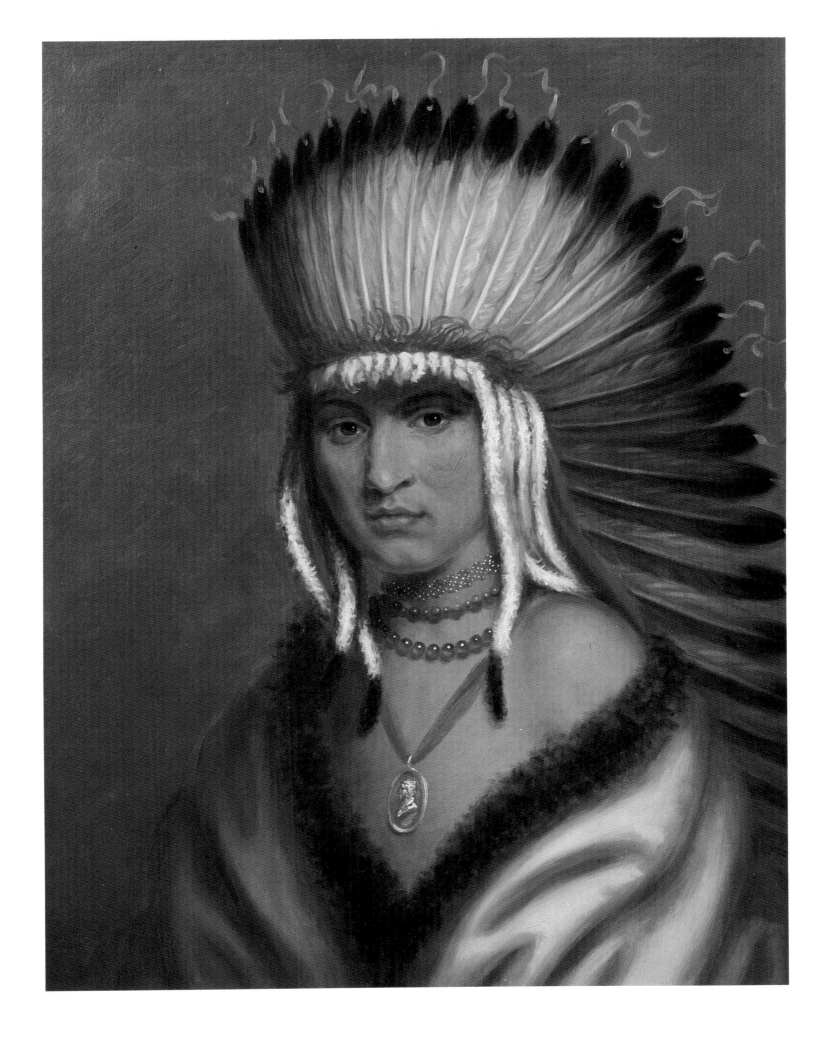

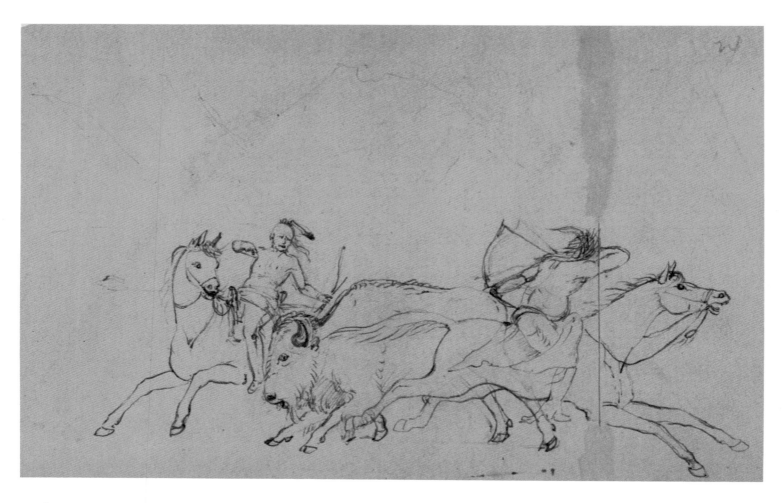

Indians Hunting Buffaloes (1820)

The American Philosophical Society, Philadelphia, Pennsylvania

Titian Ramsay Peale (1799-1885)

The youngest son of Charles Wilson Peale, the famous Philadelphia artist, naturalist and museum director, Titian Peale at the age of 19 was assigned a position on the scientific staff of the Yellowstone Expedition led by Major Stephen Long. His job was to collect, preserve and sketch specimens, as well as to make drawings of the geological formations observed during the course of the exploration.

While young Peale had difficulty with the academic aspects of school work, he had early shown a talent for sketching birds and animals. His brother's admonition to practice from nature stood Titian in good stead. His *Indians Hunting Buffaloes* is one of an action-packed series of sketches of mounted hunters in full pursuit of their quarry, the buffalo. Not only are these sketches the first to show a Plains Indian hunt, they also include the first drawings of Plains tipis.

Able as Titian was, his horse appears as a stylized Arabian with a characteristically dished face, rather than a more roman-nosed Indian pony. Throughout the century, many artists continued to show Indians with Arabian horses. Whether this was a form of artistic convention or the result of simple ignorance is not always clear.

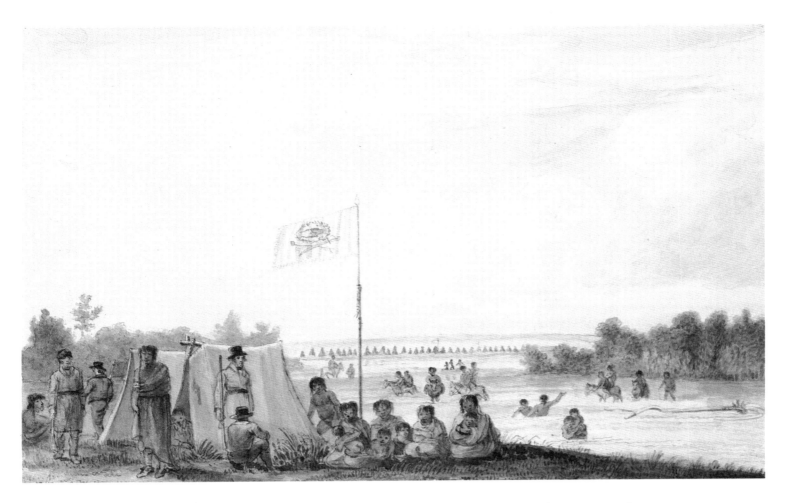

Detachment of the Long Expedition at the Encampment of Kiowa and Allied Indians on the Arkansas (1820)

The Beineke Rare Book and Manuscript Collection, Yale University

Samuel Seymour (1796-1823)

A Philadelphia artist of some note, Samuel Seymour joined Major Stephen Long's party along with Titian Peale a painter for the Yellowstone Expedition. His orders were to paint landscapes and portraits of Indians in council and engaging in ceremonial activities. His watercolor *Detachment of the Long Expedition* does just that. Not only has Seymour recorded Long's meeting with these Southern Plains Indians, but he has painted a thoughtfully composed picture. The figures in the foreground and middle distance are balanced by groves of trees, with a row of conical tipis in the distance adding a contrast to the monotony of the plains and endless sky. As a focal point, Seymour has employed the expedition's banner, drawn and painted by Titian Peale.

Seymour was a painterly artist and his other works, such as the *Pawnee Indian Council* and *Distant View of the Rocky Mountains*, attested to his ability at composition. His *Distant View of the Rocky Mountains* was the first picture of the snowcapped Rockies, showing Long's Peak in what is now Colorado.

Black Rock, A Two Kettle(?) Chief (1832)
Buffalo Chase, A Surround by the Hidatsa (1832-1833)
Bird's Eye View of the Mandan Village (1832)

National Museum of American Art, Smithsonian Institution

George Catlin (1796-1872)

As a young man, George Catlin read law in Connecticut, but his over-powering ambition to paint Indians and record their way of life before it was overwhelmed by white encroachment soon won out. Moving to Philadelphia, where he practiced portrait painting, this self-taught artist became friends with, among other Philadelphia artists, Thomas Sully, whose influence shows in Catlin's later works.

To fulfill his goal, Catlin left the East and from St Louis proceeded up the Missouri River as far as Fort Union at the mouth of the Yellowstone, painting Indians all the way. There he made portraits of Blackfeet and Crows. Returning down river, Catlin painted panoramic views of the countryside, as well as wildlife. Upon reaching the Mandan villages, Catlin paused to paint portraits of leading personages, as well as scenes from the Indians' daily and ceremonial life. His *Bird's Eye View of the Mandan Village* is an excellent example of Catlin's attention to ethnographic detail. In his impressionistic painting *Buffalo Chase*, Catlin conveys the action and danger of the hunt. His portrait *Black Rock* shows the distinguished Chief of the Two Kettle division wearing a split-horn ermine cap with a trail of eagle feathers, a mark reserved for the bravest of leaders. Black Rock wears also a painted buffalo robe decorated with drawings of his exploits in battle.

That Catlin was the most prolific eye-witness illustrator of Western Indian life is undoubted. The Smithsonian alone has over 600 of his paintings and drawings, and many more are scatered in museums and collections throughout the country. In sum, his work constitutes a priceless ethnographic legacy. But whether he was as good an artist as he was a reporter is another question. In his almost obsessive desire to record everything he saw, he often worked hurriedly, paying scant attention to composition, draftsmanship or the subtleties of coloration. And though he could rise above many of these defects in his more finished pieces, there is, even in his best work, a sometimes slightly stilted and amateurish quality that some viewers find awkward, and others charmingly unaffected.

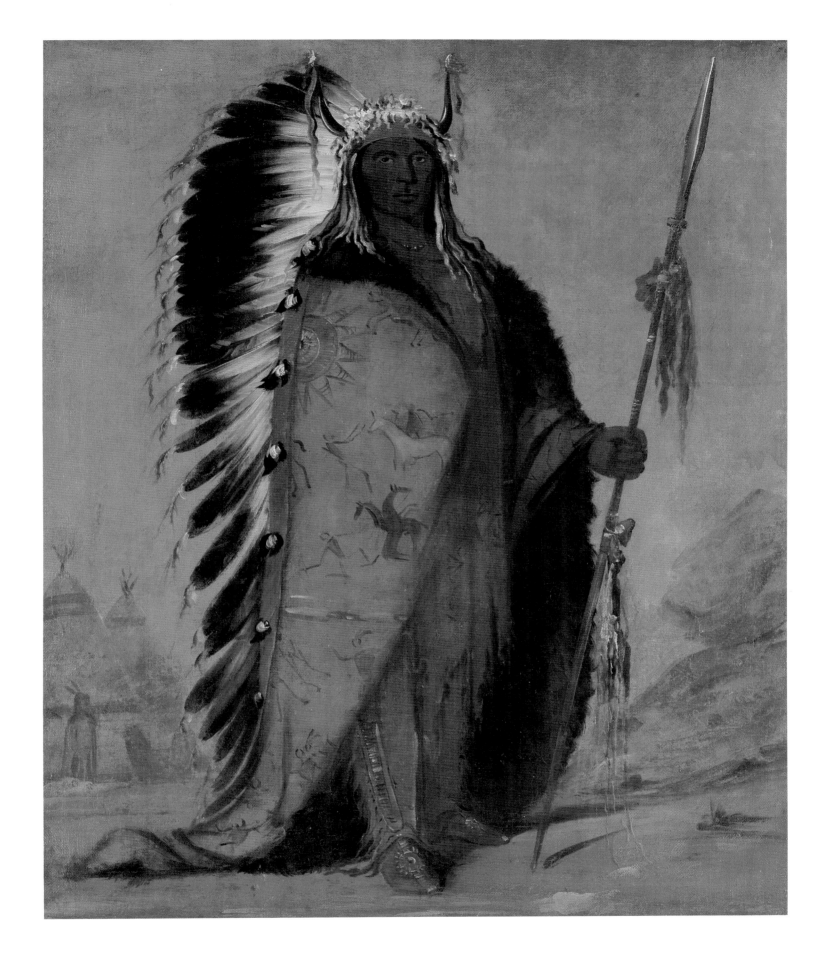

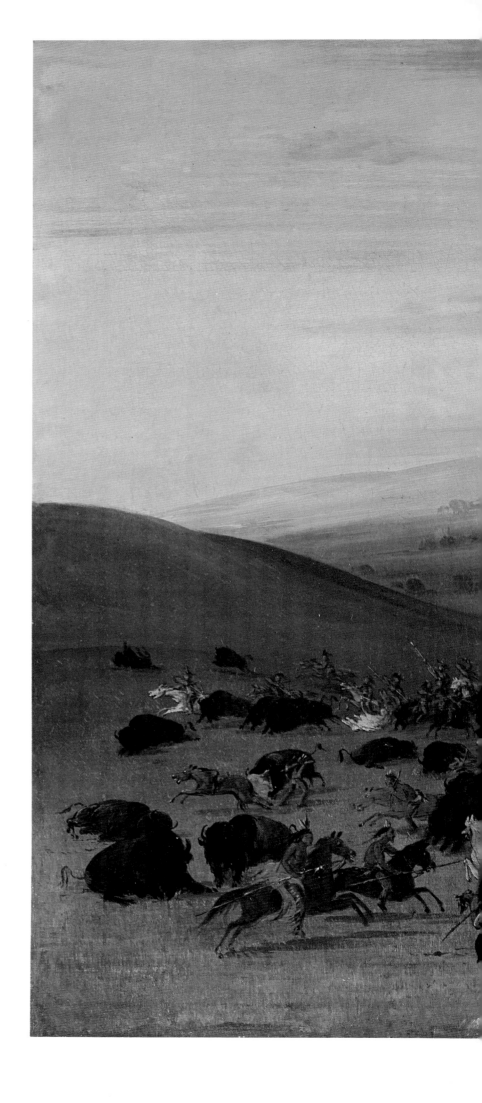

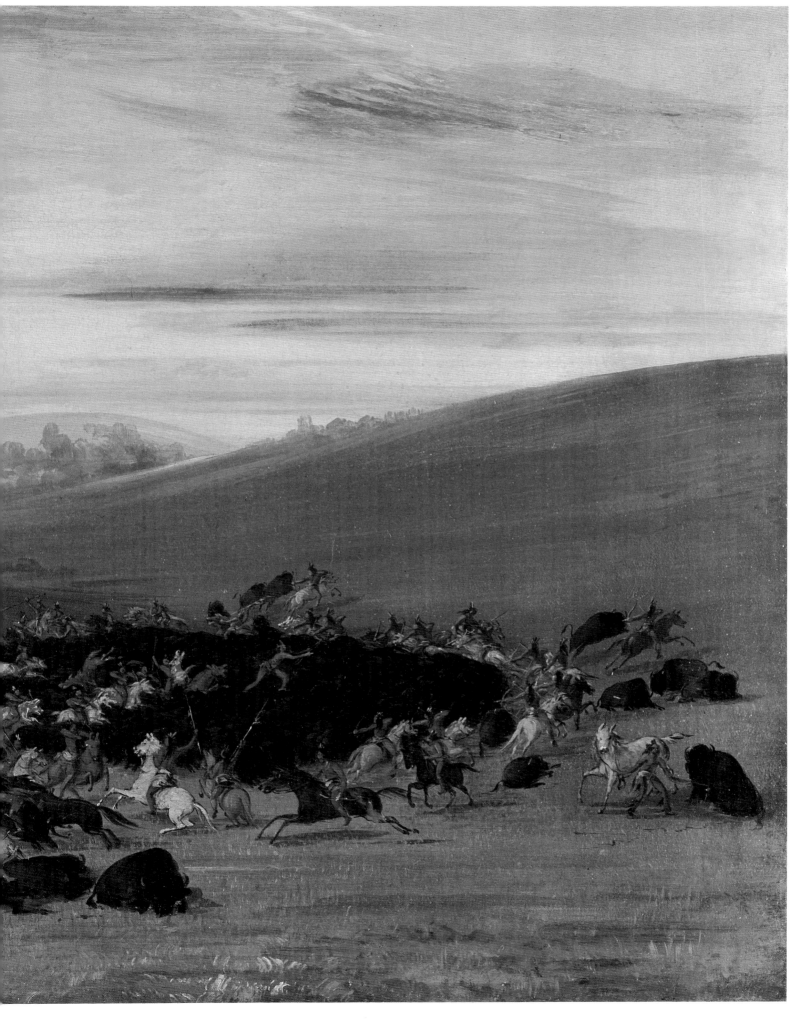

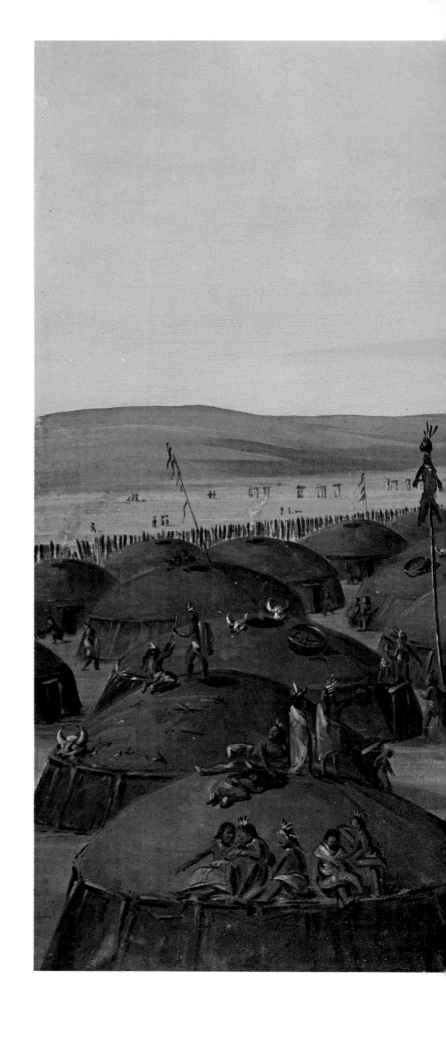

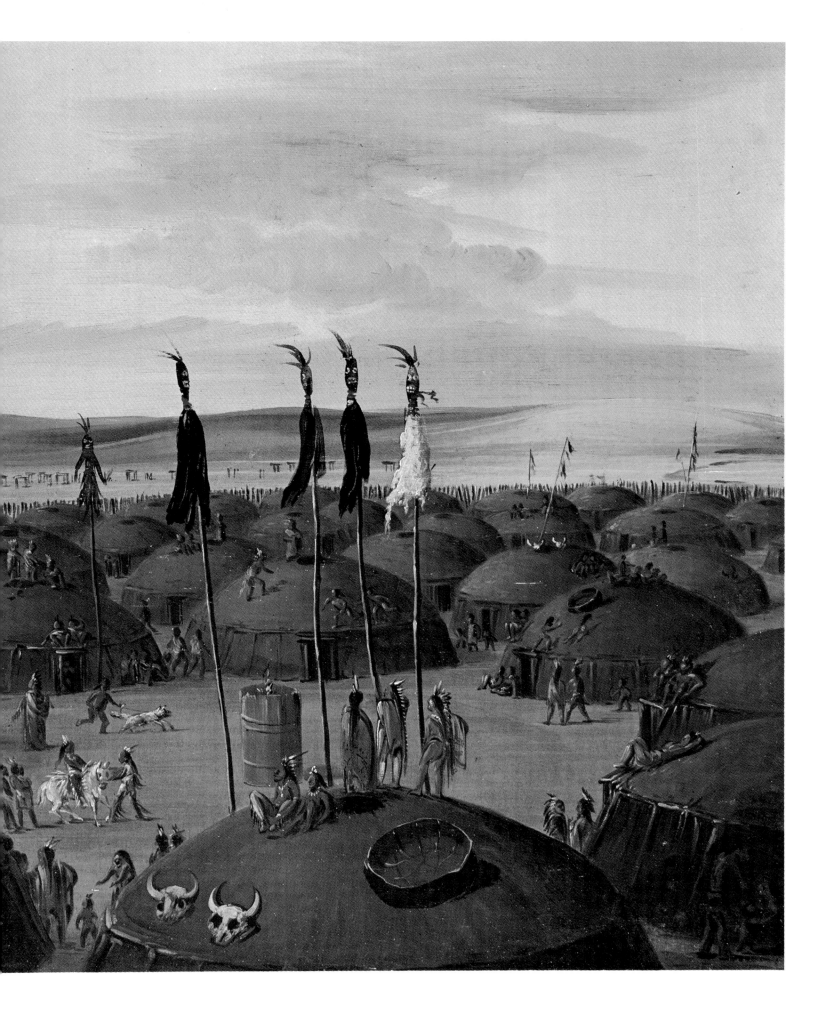

Indian Hunters Pursuing the Buffalo in the Early Spring
(*c 1825*)
The Public Archives of Canada
Peter Rindisbacher (1806-1834)

A self-trained artist, Rindisbacher was born in Switzerland and came to Canada with his parents in 1821. There he began painting the American scene in watercolors. The hardships of Manitoba winters induced the Swiss colonists to settle near Fort Snelling, Minnesota, and it was here that Rindisbacher continued his work. Astonishingly, much of this 'boy artist's' best work was done before he was 20.

Indian Hunters shows buffalo-hunting Indians, apparently Cree, on snowshoes attacking the mired beasts with bows and arrows, as well as spears, aided by packs of dogs. The artist has well conveyed both the fierce action of the hunt and the bleakness of the Northern Plains in winter.

Many of Rindisbacher's paintings are violent in nature, not only in his buffalo hunting scenes, but in his *Murder of David Tully and Family by Sisseton Sioux* and *Drunken Frolic Amongst the Chippeways and Assiniboines.* Not only was Rindisbacher careful with detail and composition, but he achieved a certain luminescence in his watercolors that made for an individual style both pleasing and authoritative. His untimely death at the age of 28 robbed the country of a faithful recorder of life on the Northern Plains.

(page 48)
Sioux Indians (1850)
The Joslyn Art Museum, Omaha, Nebraska
Seth Eastman (1808-1875)

Seth Eastman, born in Brunswick, Maine, graduated from West Point in 1829. Part of his courses included drawing, which he later taught at the 'Point' for seven years. Stationed at Fort Snelling in Minnesota in 1841, he painted many scenes of Indian life – primarily of the Santee Sioux. Eastman was comprehensive in his selection of subject matter, including scenes of Indians traveling, playing lacrosse and maple sugaring; of a shaman curing the sick; of buffalo hunting, burial and much else. His drawing is clean and precise, and his figures, which generally are more-or-less passive, are well proportioned.

His painting *Sioux Indians* shows his sense of composition and his interest in detail. It also tells a great deal about Indian life: the dugout canoes and how they were maneuvered, the horse travois, the baby carrier, the use of the tump line, smoking customs and so on. Visible, too, are such trade items as blankets, pails and gingham blouses.

Eastman's technically proficient paintings received much acclaim, so much so that he was commissioned to illustrate the prestigious *Indian Tribes of the United States* by Henry Schoolcraft. For this, Eastman submitted nearly 300 pictures. Later, after serving in the Civil War, Eastman retired as a brevet major general to devote himself almost exclusively to painting Indians, many of his works having been commissioned by Congress.

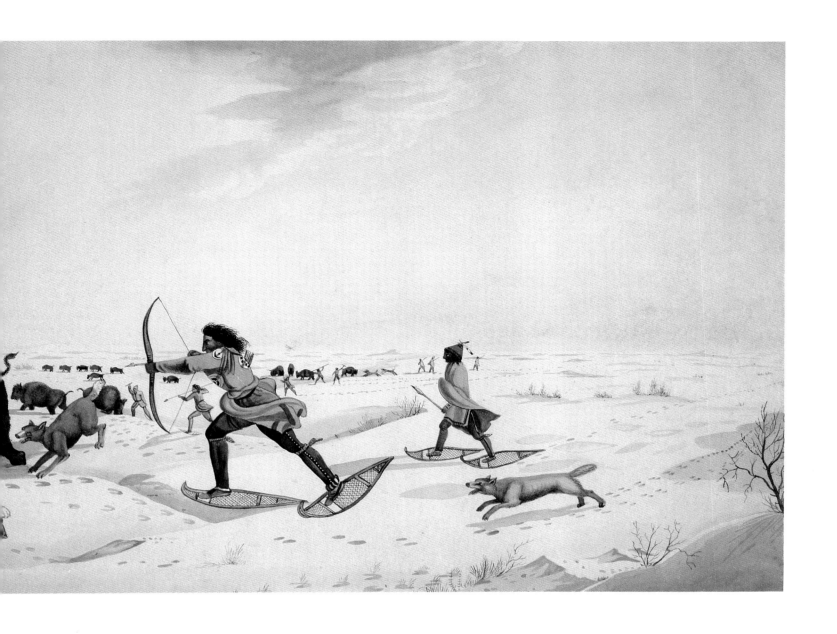

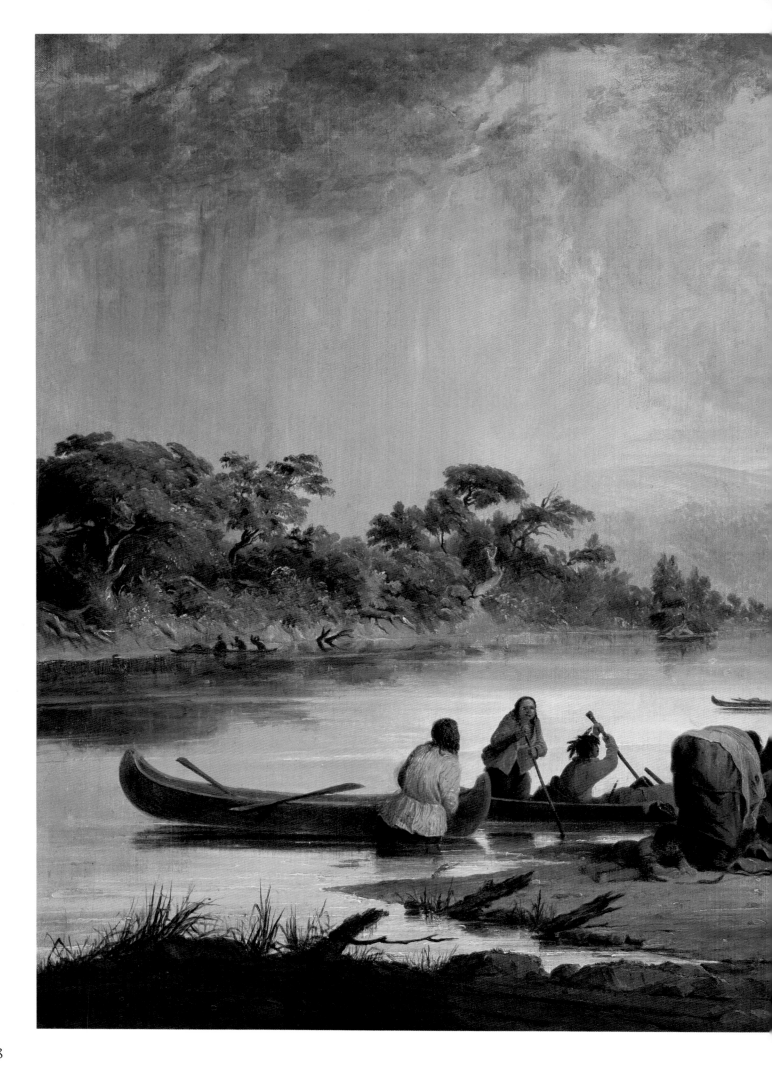

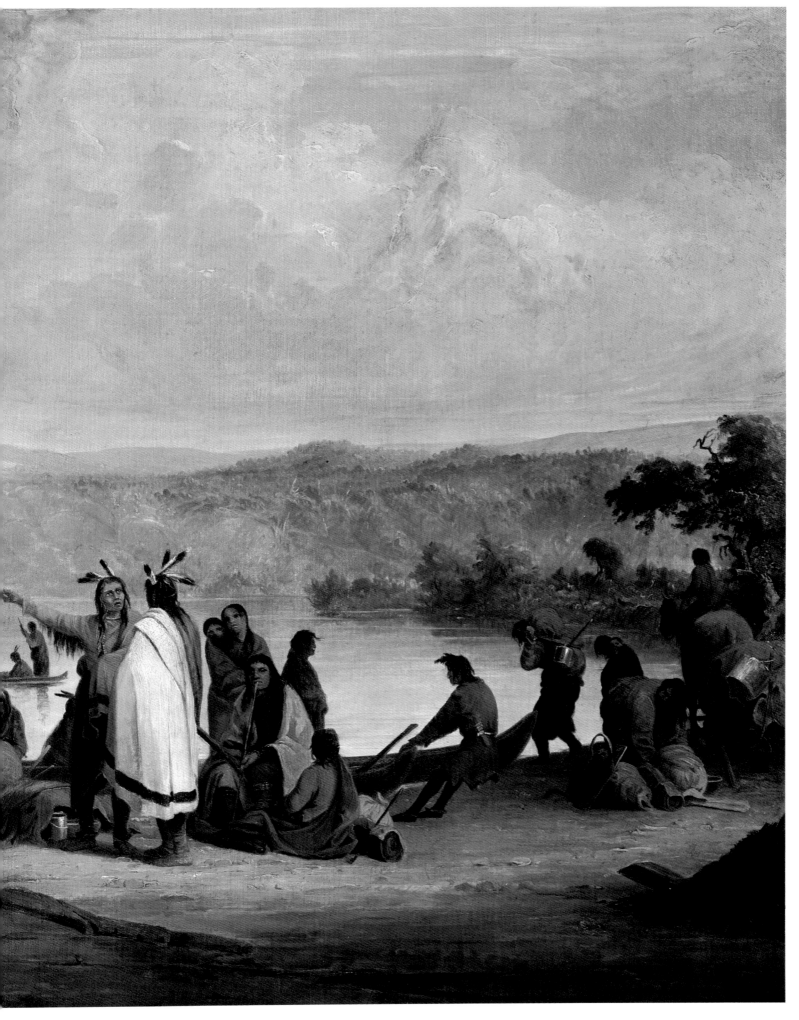

Pehriska-Ruhpa (c 1840)

The Buffalo Bill Historical Center, Cody, Wyoming

Bison Dance of the Mandan Indians (c 1834)

The Emron Art Foundation, Josyln Art Museum, Omaha, Nebraska

Karl Bodmer (1809-1893)

As a young Swiss artist, Karl Bodmer was employed by Maximillian, Prince zu Wied, to accompany him on a scientific expedition to the far reaches of North America. In the spring of 1833 the two men ventured by steamboat up the Missouri River to Fort McKenzie at the mouth of the Marias River. It was here the travelers witnessed the Indian battle between the Blackfeet and combined Cree and Assiniboine. All the while Bodmer sketched landscapes and scenes of wildlife and Indians. When autumn approached, he and the Prince returned downstream to winter at the Mandan and Hidatsa villages.

Pehriska-Ruhpa (The Two Ravens), an Hidatsa headman, posed for Bodmer in the costume of a Mandan Dog Dancer for what was to become perhaps the most dramatic Indian portrait ever painted. In his *Bison Dance of the Mandan Indians*, Bodmer has captured the intensity and exhuberance of a native ceremony. Compositionally, it is an excitingly balanced picture, and Bodmer's attention to detail is so sure that it ranks as a masterpiece of ethnographic realism. Another painting, *Assinboine-Cree Attack on a Piegan Camp*, is a vivid portrayal of the savagery of Indian warfare and a study in Indian weaponry, showing lances, knives, war clubs, bows and arrows and muzzleloading trade guns.

Upon returning to Europe, Maximillian devoted himself to the publication of *Travels in the Interior of North America*, published, first in German and later in French and English, in 1832-1834. Bodmer executed the illustrations to accompany the text, in all some 82 colored engravings.

Bodmer is often ranked with Catlin as one of the two outstanding pre-Civil War recorders of Western Indian life. Their work, is however, difficult to compare. Catlin's enormous output dwarfs that of Bodmer and covers many more subjects, but it was often sketchily and naively executed. Bodmer, who went on to become one of the founders of the Barbizon school, was technically a much more proficient painter, and his fine draughtsmanship permitted him to render many details with a precision of great value to anthropologists. Thus the work of the two men, while dissimilar, was splendidly complimentary.

Tab. 2

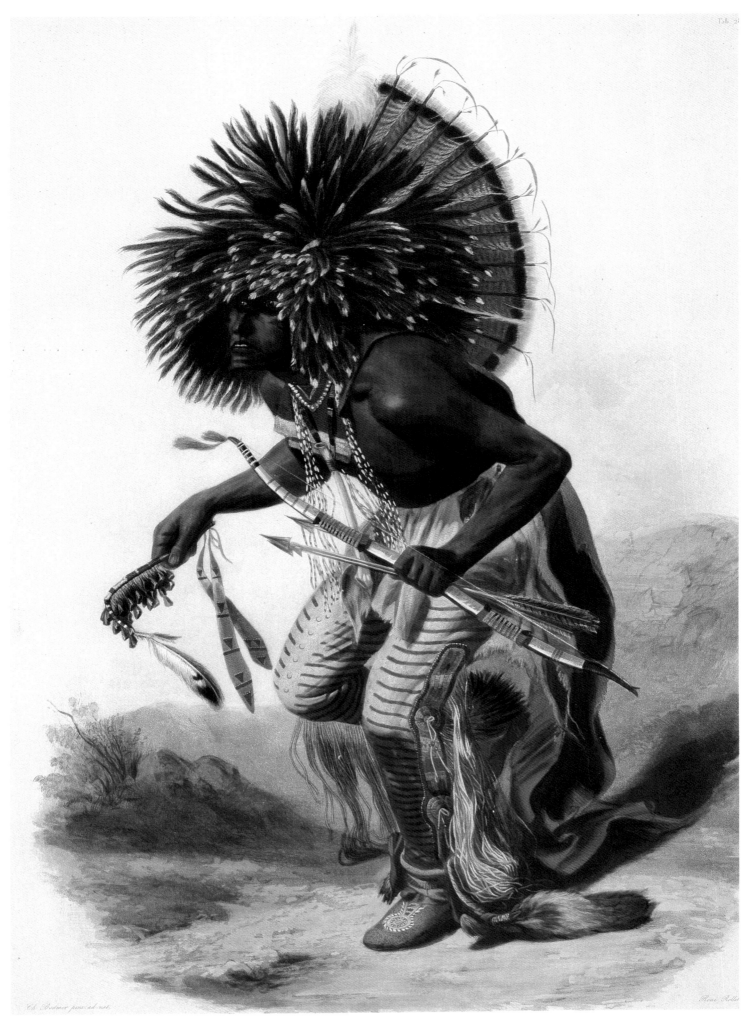

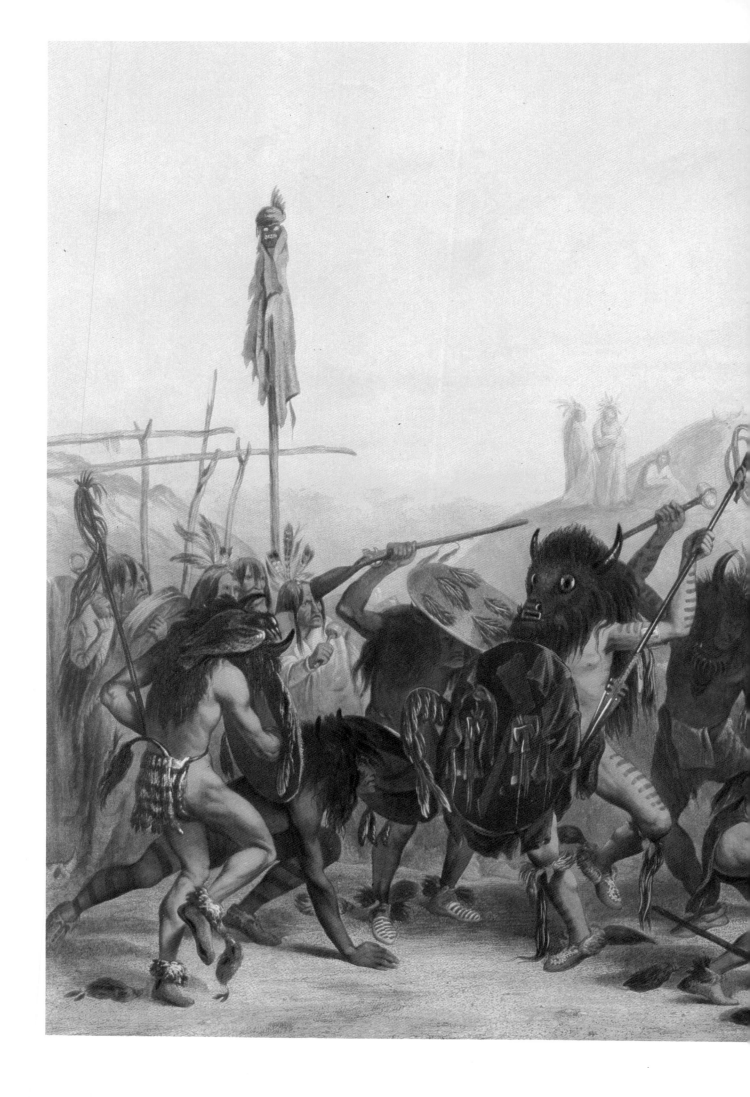

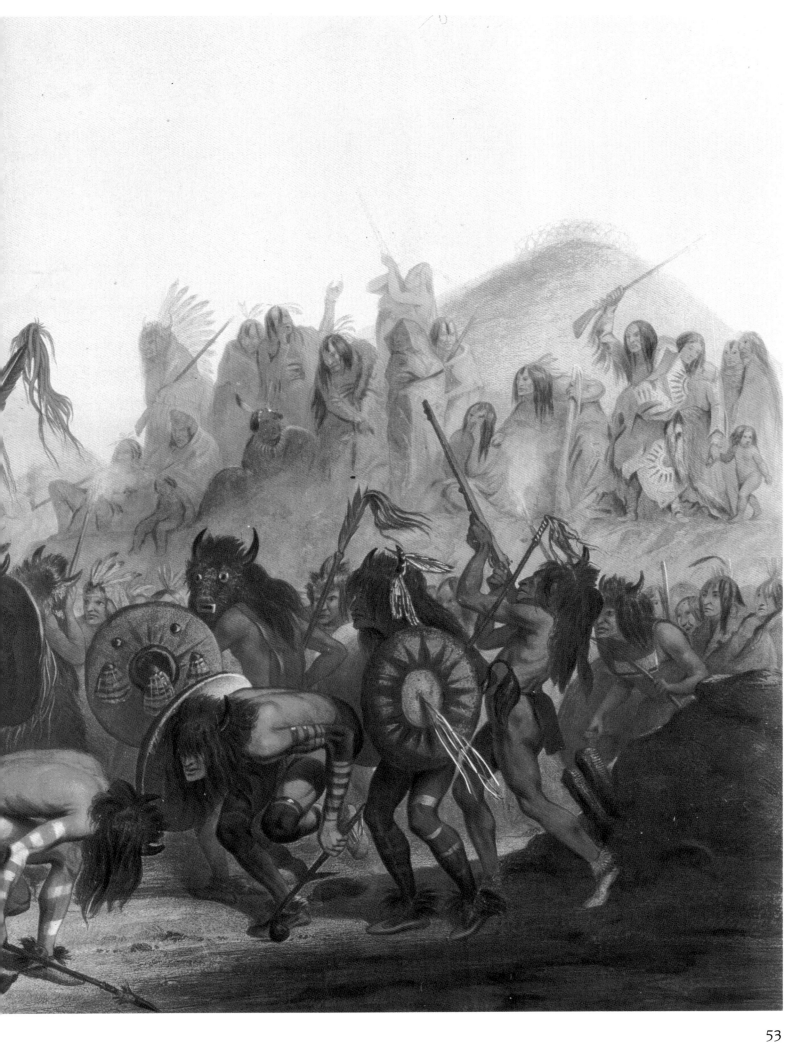

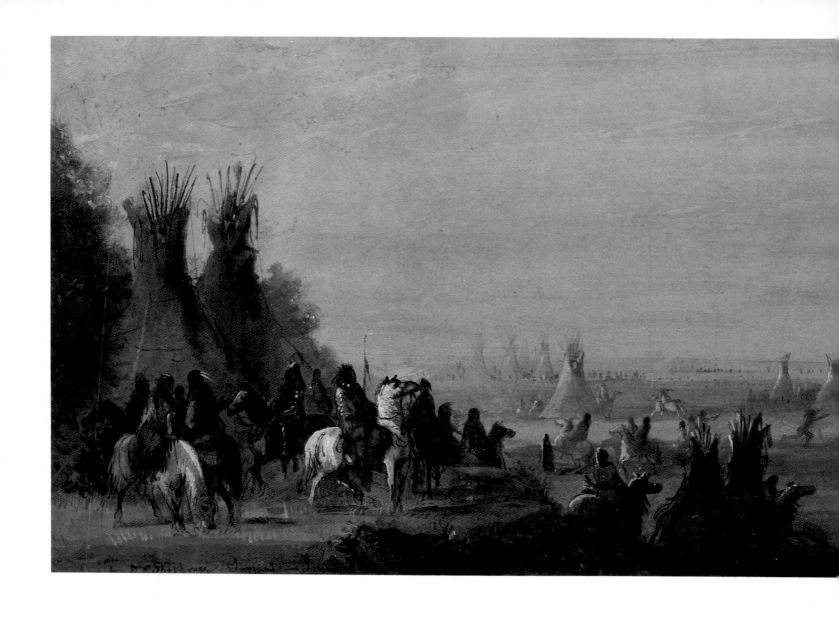

Shoshone Encampment at Trapper's Rendezvous on Green River (1837)

The Thomas Gilcrease Institute of American History and Art, Tulsa, Oklahoma

Alfred Jacob Miller (1810-1874)

Born in Baltimore, Miller first studied under Thomas Sully. Later, in Paris, he attended the Ecole des Beaux Arts. In 1837 Miller established himself in New Orleans, and it was here that Captian William Drummond Stewart, a Scottish sportsman, employed Miller as his artist for a hunting trip in the Rocky Mountains. Miller was prolific, painting everything from scenery to trappers' caravans to Indians. In his painting, *Shoshone Encampment . . . on Green River* Miller's aerial portrayal of the scale and excitement of the trapper's great rendezvous is compelling.

Captain Stewart returned to his castle in Scotland, where Miller, as artist in residence, made finished oil paintings from his watercolor sketches. Later he returned to Baltimore where he specialized in portraits and continued to develop his Western scenes.

Miller's work is interesting in that, although it could at times be sharply realistic, in some of his paintings we begin to see early signs of the romantic style that would eventually become dominant in Western art. The rendering becomes more loose and impressionistic, the landscape and atmosphere more ethereal, the lighting more heavily freighted with mood. In this, however, he was ahead of his time and did not greatly influence his contemporaries.

Fur Traders Descending the Missouri (1845)

The Metropolitan Museum of Art, New York City

The Concealed Enemy (1845)

The Stark Museum of Art, Orange, Texas

George Caleb Bingham (1811-1879)

Born in Virginia, Bingham was eight years old when his family moved to Missouri. He forsook his studies for the ministry and law and turned to art. Self-taught, he took up portraiture. At the age of 26 he enrolled at the Pennsylvania Academy, but three months in Philadelphia was enough. He continued portrait painting in Washington for four years, but returned to Missouri, where he devoted himself to scenes of Western life.

Much of Bingham's work was devoted to depicting everyday life on the frontier. He was fond of scenes of local political campaigns and elections, of rural shooting matches, of people playing cards or checkers and the like. Most of these acutely observed paintings are full of life and are rendered with engaging humor. And occasionally, as in *Fur Traders Descending the Missouri*, they achieve something more – a genuine poetry. Here his relaxed figures seem to float timelessly through an unreal world suffused with a brilliant golden haze. Yet as usual in Bingham's work, the draftsmanship is sharp and, in the detail of the black cat tethered to the prow of the canoe there is the familiar homey touch.

Bingham was less successful in his melodramatic Indian genre paintings. Not only were his effects too calculated, he seemed to have had trouble painting convincing Indian faces. His *The Concealed Enemy*, with its protagonist looking vaguely like a Boston banker, is a case in point.

In addition to being one of the most popular painters of his day, Bingham was notable for being the first important Western painter who was not a visitor from the East but actually lived on the frontier. His preference for homespun, rather than exotic, subject-matter may be a result of this fact.

In addition to his painting, Bingham participated in politics, joined the Union forces in the Civil War and taught art as a professor at the University of Missouri.

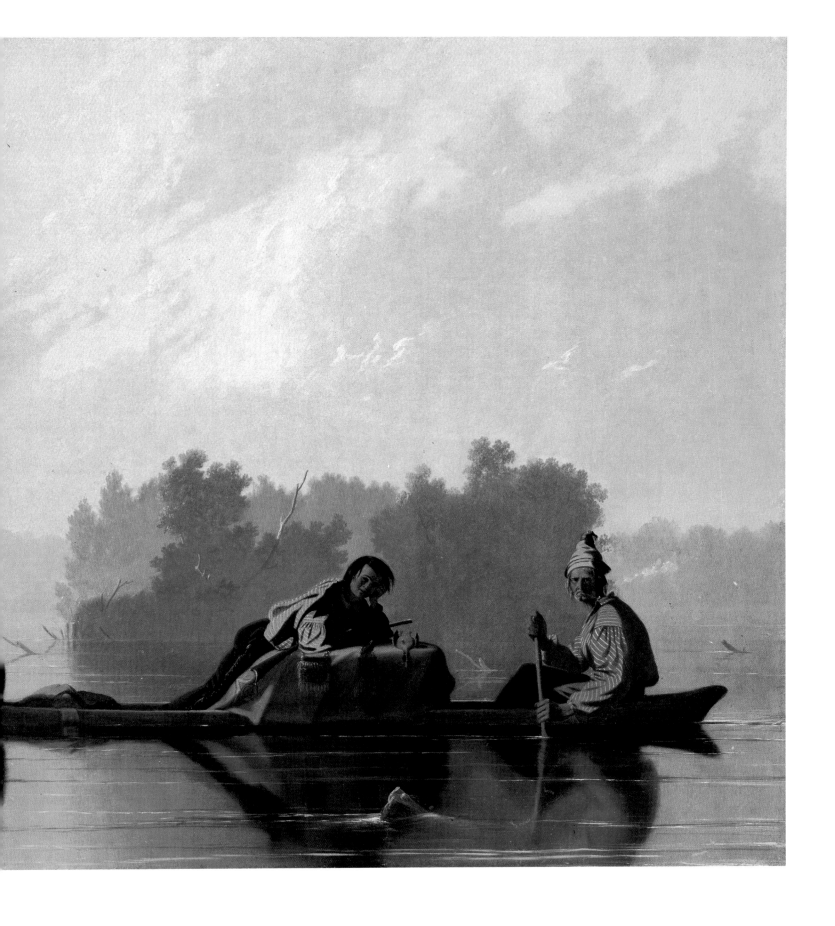

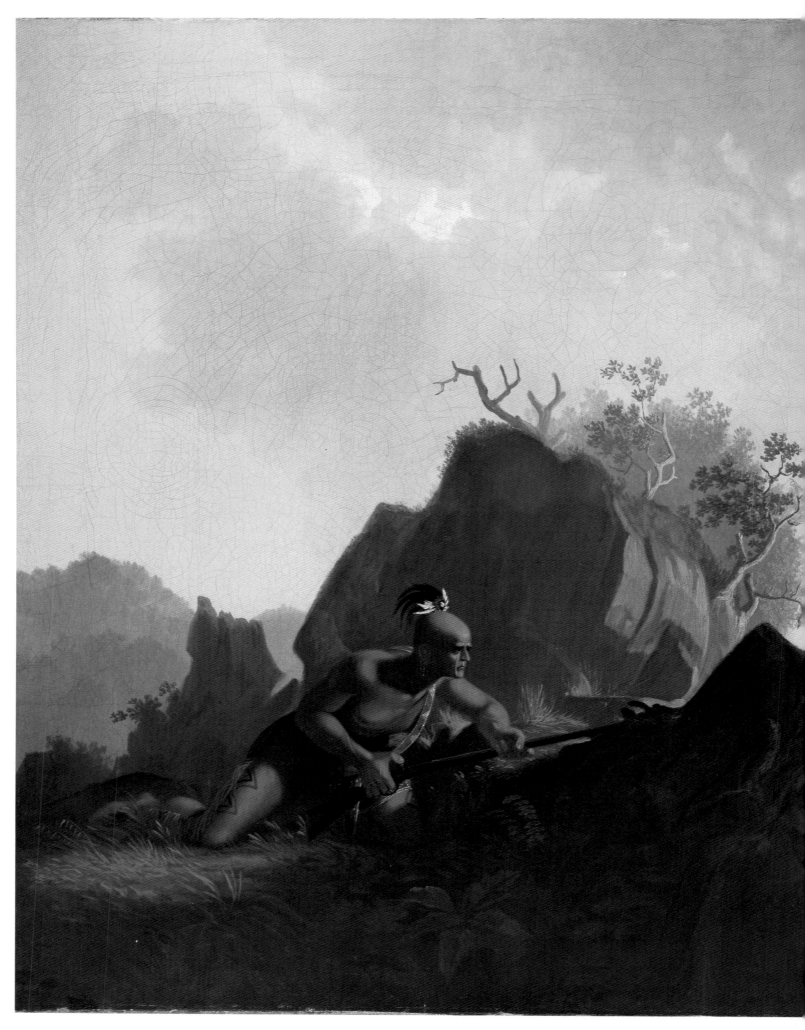

Pronghorned Antelope (1843)

The American Museum of Natural History, New York City

John Woodhouse Audubon (1812-1862)

Son of the famed artist-ornithologist John James Audubon, John Wood-house was born in Kentucky. He studied under his father and accompanied him on his many journeys collecting bird and animal specimens. When his father began his *Viviparous Quadrupeds of North America*, it was a joint effort, with John Woodhouse and his brother, Victor, helping with both text and color plates. In 1849 young John joined the gold rush and while he found little if any of the precious metal, he did bring back numerous animal specimens.

His *Pronghorned Antelope* shows the work of a keen draftsman who has caught the alert tension of these nervous animals. The Indians hunted this swift and graceful prey on horseback. While the antelope easily outran the horses at first, they did not possess great endurance and were eventually overrun, whereupon the Indians killed them in great numbers.

John Woodhouse's animal studies are so like his father's that, unless signed, they can be difficult to tell apart. Although, for example, young John painted about half the animals in *Quadrupeds* (and Victor painted many of the backgrounds), the result is nevertheless a work almost seamless uniformity.

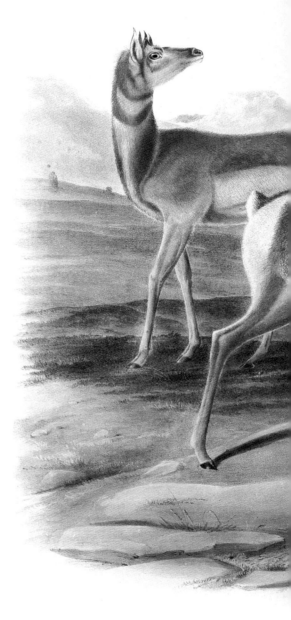

(page 62)
Prairie Burial (1848)

The Anschutz Collection

William T Ranney (1813-1857)

Born in Middletown, Connecticut, Ranney went south as a boy to work for an uncle in North Carolina, and later he was apprenticed to a tinsmith. He briefly studied art in Brooklyn and joined the Army during the war with Mexico, where he was stationed in Texas. After the war he returned to Brooklyn, where he painted portraits and Western genre.

Ranney was one of the earliest Western painters to specialize in narrative. Thus most of his canvases appeared as stop-action glimpses of incidents in larger implied stories. The stories themselves could involve violence, suspense or, as in *Prairie Burial*, sentimentalized emotion.

As *Prairie Burial* suggests, Ranney's execution often tended to be a bit pedestrian, for his draftsmanship, composition and color sense could all have stood improvement. Yet his works were well received by his con-temporaries, and in 1850 he was elected to membership in the prestigious National Academy of Design, an endorsement of his particular approach that may well have had some effect on the future of Western painting. He was only 44 when he died.

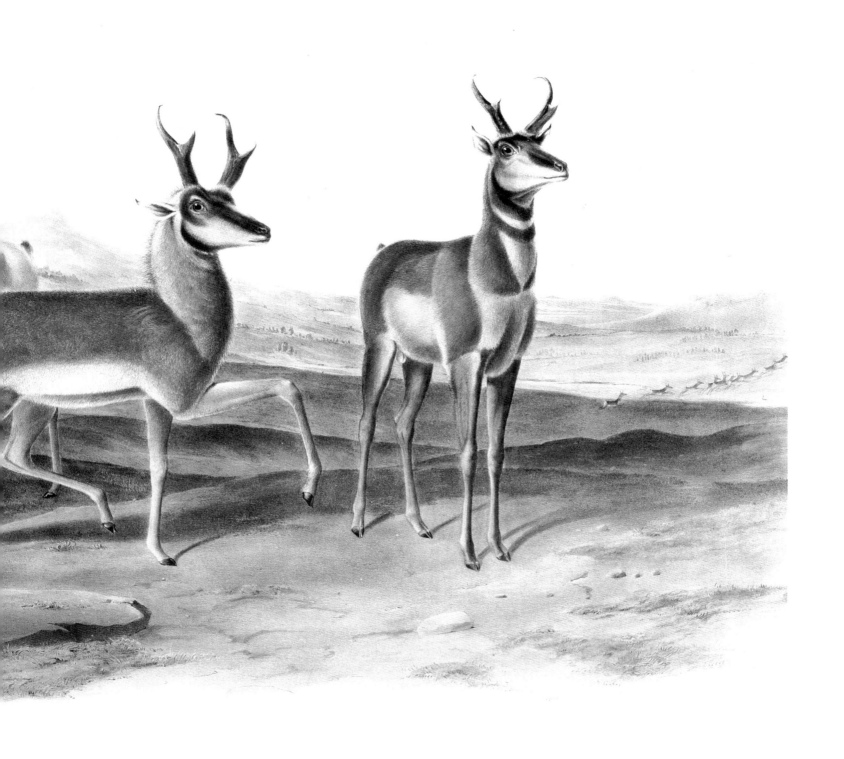

Group of Piegan Indians (1867)

The Denver Public Library Western Collection, Denver, Colorado

John Mix Stanley (1814-1872)

Stanley moved to Detroit from his native New York in 1834. There the self-taught artist painted both landscapes and portraits. He also made sporadic trips to the West, visiting Fort Snelling in Minnesota and Fort Gibson in Oklahoma, as well as New Mexico, California and, later, the Northwest. His most significant journey, however, was with the Isaac Stevens Expedition of 1853, surveying for a transcontinental railroad route. On this trip he made sketches of the Piegan division of the Blackfeet Indian tribe, and these he developed into an exhibition of paintings presented by the Smithsonian in Washington. All but five of these paintings were destroyed by fire in 1865. Stanley spent his last days in Detroit, where he devoted himself to painting Indians.

Stanley's *Group of Piegan Indians*, though a later work, is nevertheless still based on observations he made on the Stevens Expedition. The painting is authentic in detail – the Blackfeet costumes, for example, are perfectly accurate – but in spirit it is considerably removed from the detached, factual reportage of earlier artists such as Catlin. Its painterly triangular composition and its subtextual implication that the Indians are waiting for something to happen make it very much a work of the more romantically inclined second half of the nineteenth century.

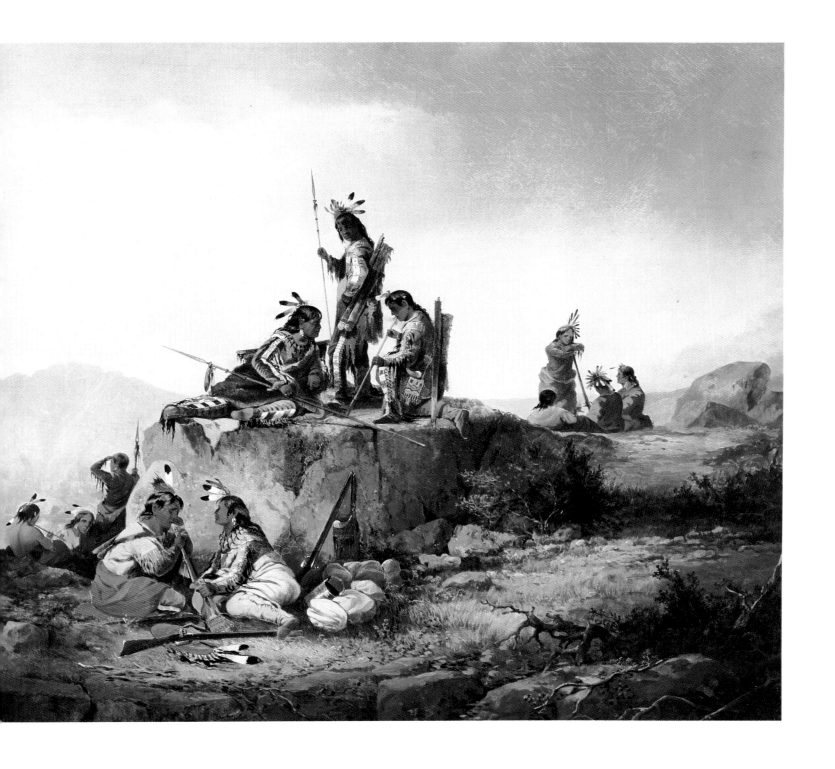

The Death Struggle (c 1845)

The Shelburne Museum, Shelburne, Vermont

Charles Deas (1818-1867)

Deas grew up in Philadelphia surrounded by art. Probably influenced by Thomas Sully, the Philadelphia portraitist, he attended the National Academy of Design. A visit to George Catlin's Indian Gallery whetted his interest in the West. While visiting his brother at Fort Crawford, Wisconsin, he made sojourns to various forts in the region, including Fort Snelling. In 1841 he moved to St Louis, where he made trips to visit several Indian tribes, and he later joined Major Wharton's expedition to Platte River headwaters in 1844.

Like Ranney, Deas was a deliberately narrative painter, and some of his works were violent indeed, as his *Death Struggle* will attest. Here Deas's use of strong chiaroscuro combines with a plunging diagonal line of composition to make this lurid picture even more horrifying. It is all very melodramatic and not a little absurd.

Deas's works were well received, and he often showed his paintings at the American Art Union, though few remain today. At the age of only 29 he lost his mind and was confined to an asylum until his death.

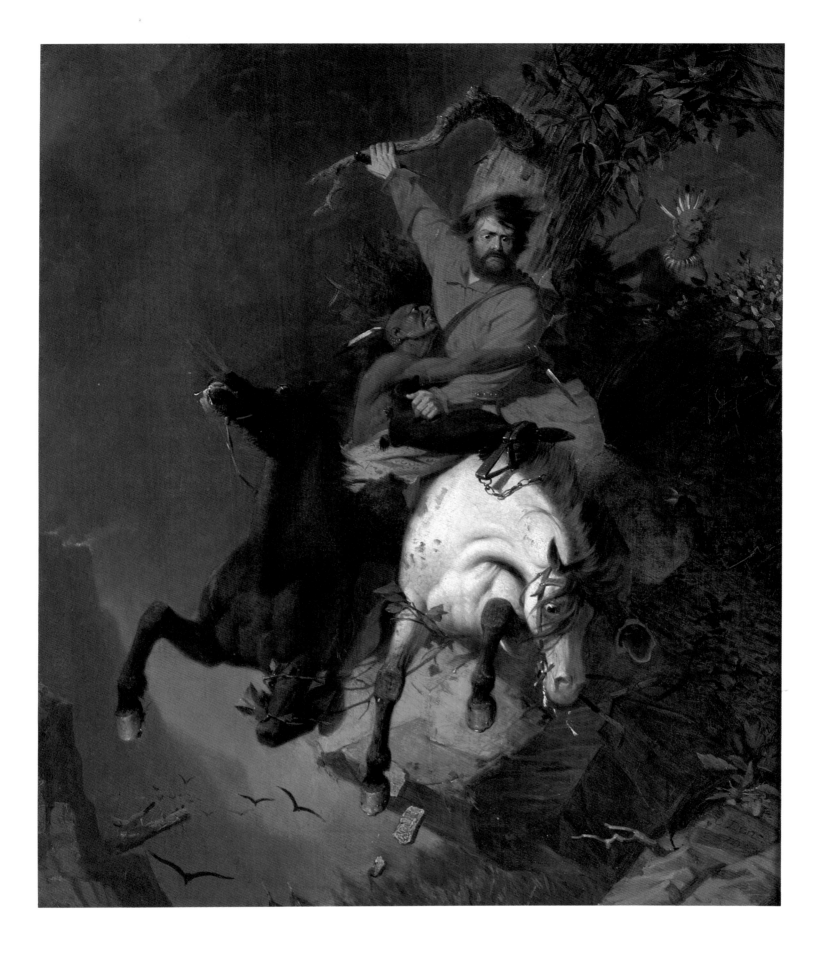

Buffalo Dance (1852)

The Thomas Gilcrease Institute of American History and Art, Tulsa, Oklahoma

Rudolph Kurz (1818-1871)

Since boyhood in his native Switzerland, Kurz's sole ambition seems to have been to paint American forests, animals and, most important, Indians. It was Karl Bodmer who cautioned him to master his skill at drawing and painting before undertaking his project. Kurz complied by spending three years studying in Paris. By 1846 he considered himself ready and proceeded to New Orleans. He had planned to draw Comanche Indians in Mexico, but the Mexican War had broken out, and he could not cross the border. As an alternative he decided to go north, eventually settling in St Joseph, Missouri. There he made sketches of Iowas, Otoes, Pawnees, Osages and other neighboring tribes. By 1851 he had journeyed up the Missouri River and had obtained a clerking position at Fort Berthold. Now he sketched Hidatsa and Mandan survivors. When cholera broke out among them, he was advised to leave, for the Indians believed his drawings might somehow be to blame. He therefore moved west to Fort Union near the mouth of the Yellowstone. Here the Crow, Assiniboin and Plains Cree traded, and Kurz sketched them as well.

The *Buffalo Dance* of the Omaha shows his superb skill as a draftsman and his strict attention to detail. It is one of his rare sketches that constitute a fully realized picture, for with few exceptions Kurz was not able to convert his myriad drawings into finished works of art.

California Vaqueros (1876-1877)

The Anschutz Collection

James Walker (1818-1889)

Walker came to the United States from England at an early age and studied art in New York City. He later went to Mexico at the outbreak of the Mexican War, where he was captured and imprisoned. He escaped and became an interpreter for the American Army, while at the same time making sketches of battle scenes. Walker joined the Union Forces during the Civil War and again sketched various battles. Well known for his paintings *The Battle of Lookout Mountain* and *The Third Day of Gettysburg*, he built a reputation as a Civil War painter. After the war, he journeyed to California, where he portrayed the life of the vaqueros.

His painting *California Vaqueros* is typical of Walker's precision. He has shown vaqueros waving their lariats to move cattle in a dust-filled plain and has well conveyed the movement and tension in both the cattle and horses. Because the vaqueros were the forerunners of the American cowboys, Walker's loving attention to their costumes and gear and to the trappings of their horses adds a special dimension of historical interest to his work.

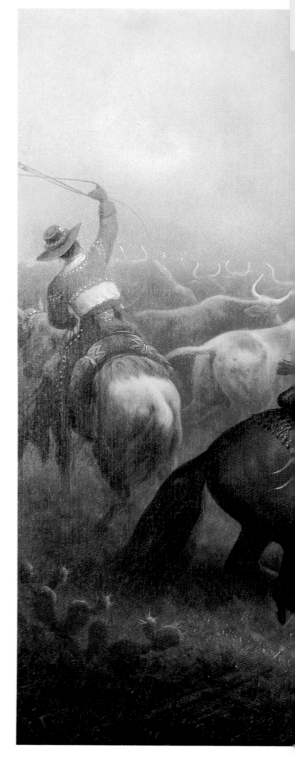

(page 72)

Sunday Morning in the Mines (1872)

The Crocker Art Museum, Sacramento, California

Charles Nahl (1819-1878)

Born in Kassel, Germany, Nahl studied art at the Academy there and later in Paris. In 1848 Nahl reached New York, where he painted and held an exhibition at the American Art Union. In 1850 he was caught up in the California gold rush, and he, together with his brother, became miners. Nahl supplemented his mining by making sketches of the activities surrounding the mines and eventually devoted full time to his art work. Not only did he exchange his drawings for gold dust, but sold them to newspapers and magazines, and later to books, for engravings.

One of Nahl's most popular finished works was his *Sunday Morning in the Mines*. This busy canvas is an odd blend of boisterous Western subject-matter and the heightened realism and relentlessly anecdotal approach favored by the Düsseldorf school of genre painters. Everybody in this painting is doing something, and Nahl takes great pains to ensure that we know exactly what it is that each is doing. All the actions are supposed to be in some way 'typical,' yet when they are lumped together in a single scene the total effect is more cartoon-like than believable. Not for nothing was Nahl known as 'the Cruickshank of California.'

Whatever else his merits, Nahl was one of the few painters to leave us scenes of Western mining life. In this he reminds us how narrow was the range of subject-matter through which most other nineteenth century painters chose to portray the West.

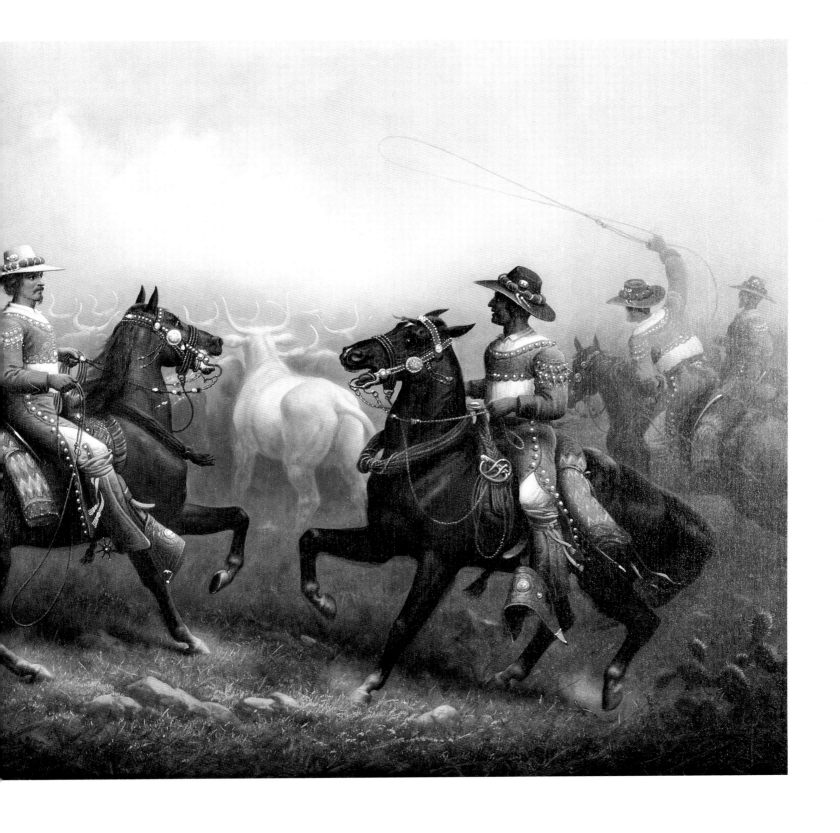

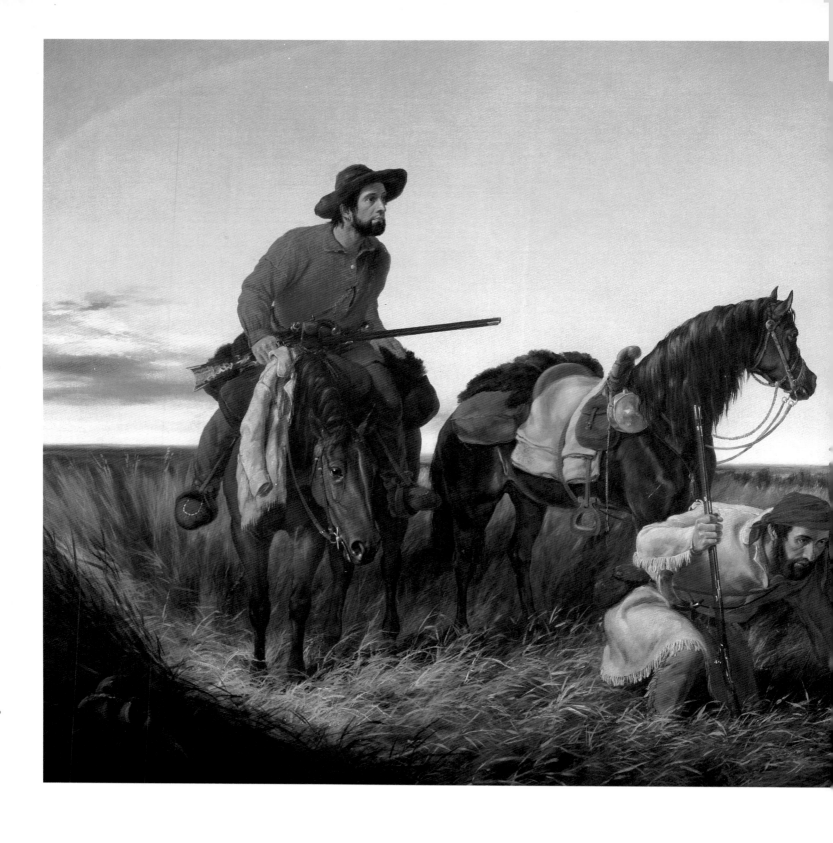

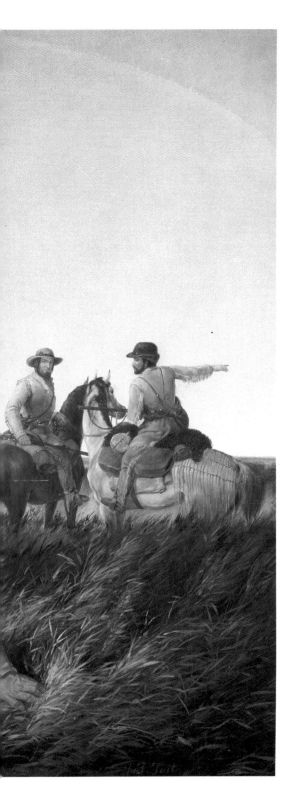

Trappers at Fault (1852)

The Denver Art Museum, Denver, Colorado

Arthur F Tait (1819-1905)

Tait was born near Liverpool, England. He found employment with an art dealer at the age of 12, taught himself to paint and eventually gravitated to New York when he was 31. Two years later he was elected a member of the National Academy of Design. Tait specialized in animal and sporting scenes. Although he never set foot on the Great Plains or the Rocky Mountains, his Western genre paintings were among his most popular works. His illustrations became widely known through their publication as prints by the lithographers Currier and Ives.

Tait was by no means a great painter, but his works were made convincing by his careful attention to detail, and they were made engaging both by his portrayal of dramatic action and his good sense of composition. In *Trappers at Fault* he uses the hunter's crimson shirt against an azure sky to establish the strength of his figure. For someone who had never experienced Western life, he surely caught the tension of trappers who had lost the way.

Encampment on the Platte River (1865)

The Anschutz Collection

Worthington Whittredge (1820-1910)

Born near Springfield, Ohio, Whittredge first worked as a sign painter, but soon turned to painting landscapes. At the age of 29 he went to Germany to study at Düsseldorf, and it was 10 years before he returned to the United States. Whittredge made several trips west, where he found much new subject matter for his landscapes. His works were well received, and in recognition of his popularity he was elected president of the National Academy of Design in 1876.

His painting *Encampment* shows the placid character of Whittredge's landscapes. Here is the Hudson River School moved west. Whittredge catches the serenity of the Plains against a hazy backdrop of the distant Rocky Mountains. The Indian figures in the foreground accentuate the sense of expanse. Whittredge has chosen for his setting the South Platte River near what is now Greeley, Colorado.

The territory bordering the South Platte River was the domain of the Arapaho Indians and the neighboring Cheyenne. These nomadic buffalo hunters set up their villages along the banks of the rivers in order to have easy access to water and to the wild game, including the buffalo, that came to drink. Moreover, the river bottoms were lush with wild vegetables, fruits and berries – oases amidst the vast, empty Great American Desert.

(page 78)

Held Up (1897)

The National Museum of American History, Smithsonian Institution

Newbold H Trotter (1827-1898)

Trotter, a Philadelphian, studied with van Starkenborg in Holland, a painter of cattle. Trotter, himself, became an animal painter, and his work was displayed both in Philadelphia and Boston. Apparently he traveled in the West, for after 1876 well-wrought Western themes suddenly began to appear in his work, but no details of his travels are known.

His painting *Held Up* shows a scene not uncommon on the Western Plains. The east-west tracks of the transcontinental railroads crossed the north-south migration trails of the bison herds. That the train's and buffalo's paths should cross was inevitable. Excursions were arranged whereby hunters could get their kills merely by shooting from the windows of the passenger cars.

Many artists had a difficult time in properly portraying the buffalo, for it can be a hard animal to draw. But not Trotter. His buffalo are not only real, but full of life, as he shows them running and even kicking. Equally authentic is his feeling for prairie space, something other artists occasionally lost in their efforts to capture dramatic action close up.

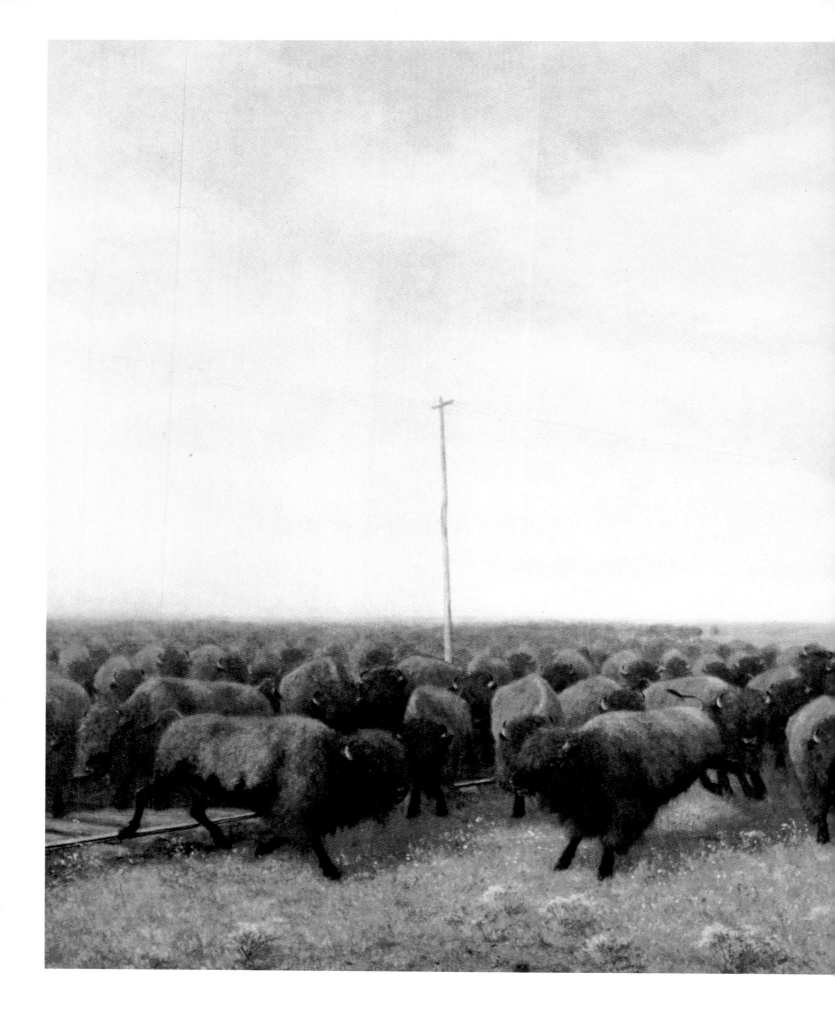

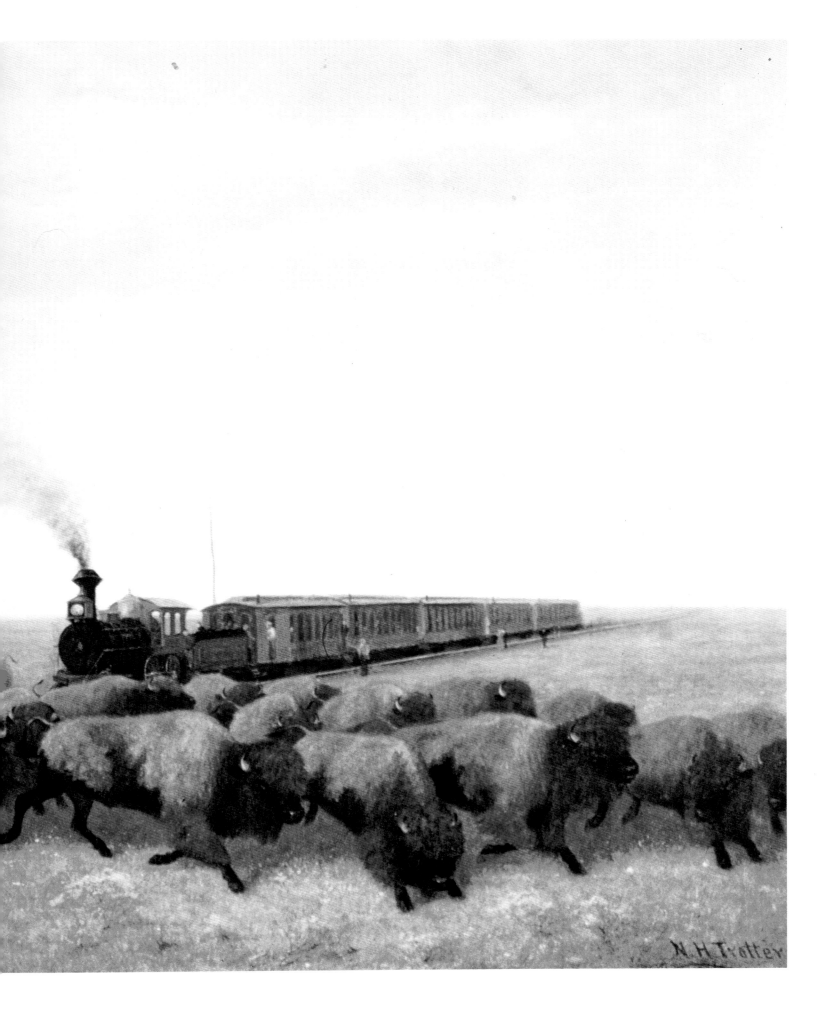

N.H.Trotter

The Attack on an Emigrant Train (c 1856)

The University of Michigan Museum of Art

Charles Wimar (1828-1862)

Born in Siegburg, Germany, Wimar came to St Louis with his parents in 1843. He first studied with Leon Pomarede, who was completing an immense panorama of the Mississippi River. In 1852 he returned to Germany to study and paint at Düsseldorf under Emanuel Leutze. There he began to paint Indians. In 1856 he returned to St Louis, from which he made many trips up the Missouri River, making sketches and notes for his finished works.

The Attack on an Emigrant Train is a representative example of Düsseldorf theatricality, with bold use of light and shadow to dramatize the action. It is interesting to note that Wimar was uninformed with respect to Indian shields. The figure in the left foreground is shown grasping his shield by a handle, whereas shields were actually equipped with a strap to be worn over the shoulder and around the neck. (When attacking, Indians wore their shields over the chest; when retreating, the shields were swung around to protect the back.) Equally incorrect are the inevitable white Arabian horses.

Wimar's landscapes were of a piece with his action paintings. They may not have been quite as well done as those of Bierstadt, but Wimar yielded nothing to his fellow German in stagy grandiosity.

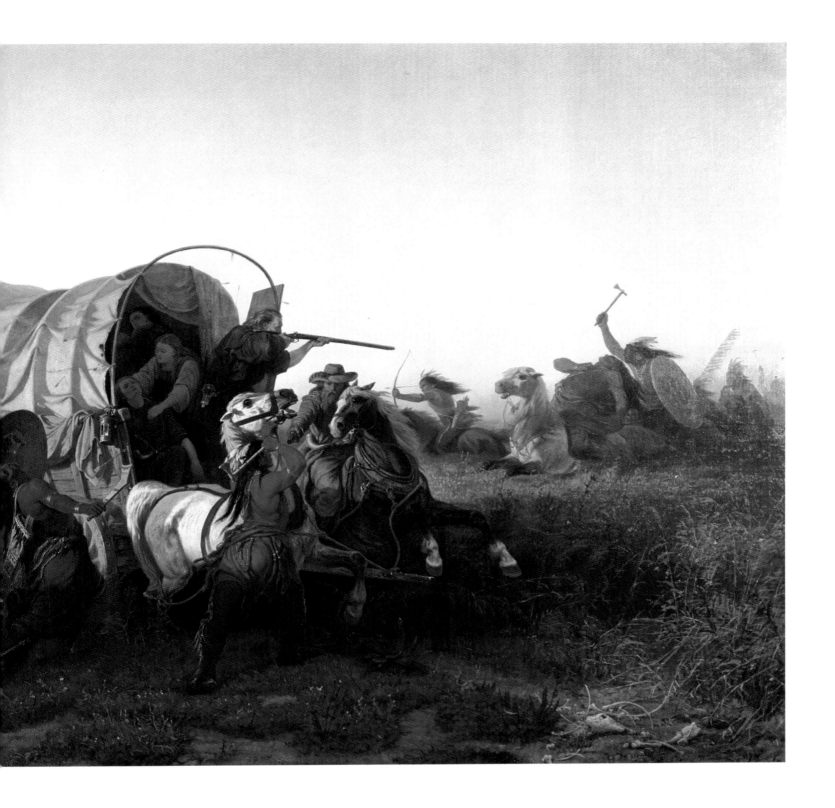

Great Canyon of the Sierras — Yosemite (1871)

The Crocker Art Museum, Sacramento, California

Thomas Hill (1829-1913)

Hill was born in Birmingham, England, and came to America at the age of 15. First employed as a carriage painter, Hill took lessons at the Pennsylvania Academy of Fine Arts. He later moved to California, where he first saw the Yosemite Valley in 1862. In 1866 he went to Paris to study for two years, after which he returned to New England, where he painted landscapes. Again he moved to California and thereafter devoted most of his energies to making a living by painting scenes of Yosemite.

Great Canyon of the Sierras, by the sheer size, six feet by 10 feet, seeks to convey the grandeur of the valley, but Hill's handling of a sharp foreground against a deliberately misty treatment of the monumental cliffs insures an added eloquence. Like Bierstadt and Moran, he was seldom content just to let nature speak for itself.

Hill enjoyed painting on large canvases. His *The Driving of the Last Spike*, commemorating the joining of the railroad tracks of the Union Pacific with the Central Pacific, was over eight feet by 11 feet in size. Purportedly commissioned by California Governor Leland Stanford (who never paid for it), the painting was finally bought by a Paul Tietzen, who gave it to the state over 30 years after Hill's death.

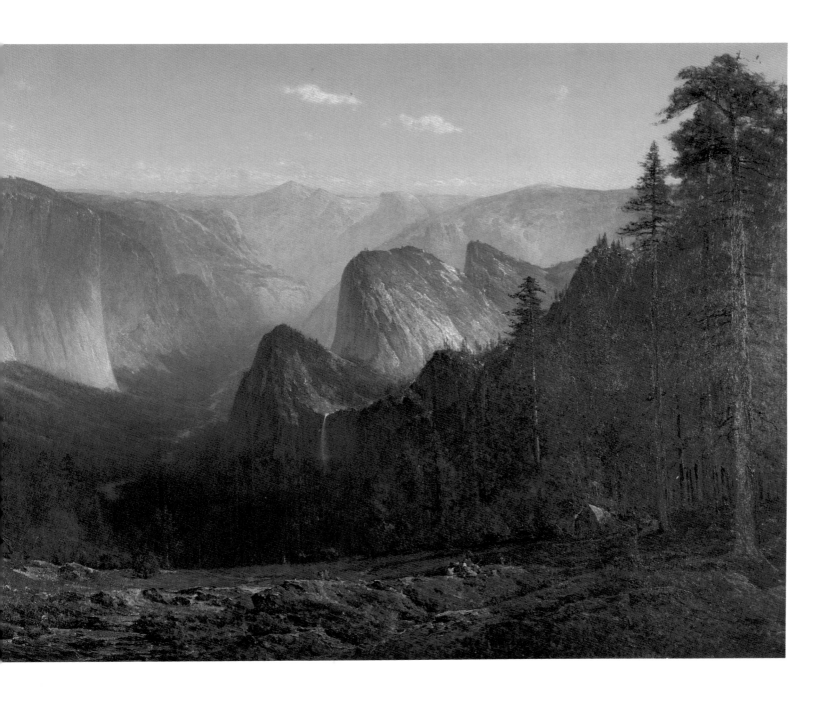

A Herd of Buffaloes on the Bed of the River Missouri
(1860)

The Thomas Gilcrease Institute of American History and Art, Tulsa, Oklahoma

William Hays (1830-1875)

Hays, a New Yorker, took painting lessons from John R Smith. At the age of 20 he exhibited at the National Academy of Design. Hays liked to point animals, and as a result of a trip up the Missouri River in 1860 he came to specialize in Western wildlife.

His painting *A Herd of Buffaloes* dramatically conveys the vastness of the bison herds that flowed like rivers over the prairies. Estimates of their numbers run into the millions, and Hays's painting well conveys the undulating movements of the countless beasts.

Hays's buffalo have been criticized for having humps that are too high. In fact, he seems also to have had minor difficulties with the proportions of some of his other animals – the heads of his pronghorn antelope, for example.

Except for his Missouri River sojourn, Hays spent his life in the East, especially in the Adironacks. There he continued to paint animals and flowers.

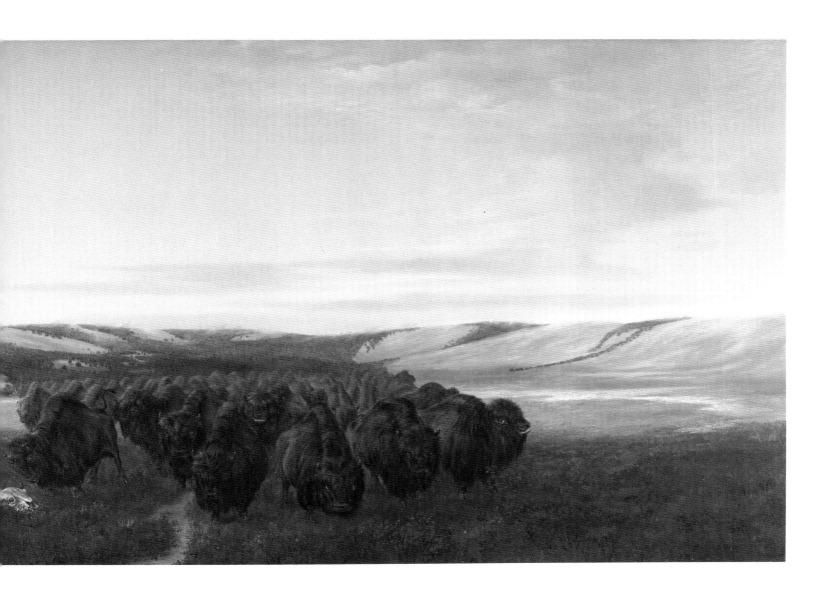

The Sierra Nevada in California (1868)

The National Museum of American Art, Smithsonian Institution

Storm in the Rocky Mountains – Mt Rosalie (1866)

The Brooklyn Museum, New York City

Albert Bierstadt (1830-1902)

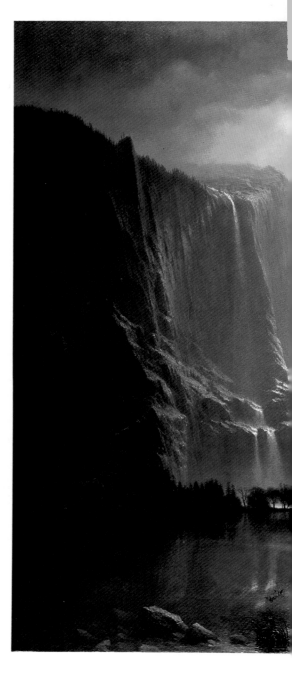

His parents brought Bierstadt from Germany to New Bedford, Massachusetts, when he was two. In 1853 he returned to Germany to study with various artists, including Emanuel Leutze and Worthington Whittredge. By the age of 27 Bierstadt was back in New Bedford. Two years later he joined General Frederick Lander's expedition surveying the wagon route to the Pacific Coast, now familiarly known as the Oregon Trail. Bierstadt made another trip west in 1863, this to be his last, save for his briefly setting up a studio in San Francisco in 1871-1873.

An unfriendly critic once said of Bierstadt that nature's grandeur 'did not daunt him.' His *Storm in the Rocky Mountains* is typical of his grandiloquent style, with flashing sun-drenched mountains and tempestuous skies. Here the size of the mountains is made to seem even more imposing by the tiny running figures in the foreground. This device, together with his re-positioning of rocks, trees and even mountains to insure compositional balance and drama, makes Bierstadt's landscape overwhelming. His arbitrary manipulation of lighting is as unnatural as it is effective.

Bierstadt's *The Sierra Nevada in California* repeats the pattern of *Storm in the Rocky Mountains*. His large scale canvases met with popular acclaim both in the East and in Europe, where he was decorated by Russia's Tsar. And the prices he received were as large as his paintings. For his famed *The Rocky Mountains*, measuring over six by 10 feet, he got $25,000, the highest price ever paid an American artist, and more than most had made from painting in their entire lives.

Modern critics have not been kind to Bierstadt. Yet judged solely on how well he accomplished what he set out to do, he is undeniably impressive. And although it seems unlikely that his style of romantic aggrandizement of nature will ever again be widely popular, stranger things have happened in art history.

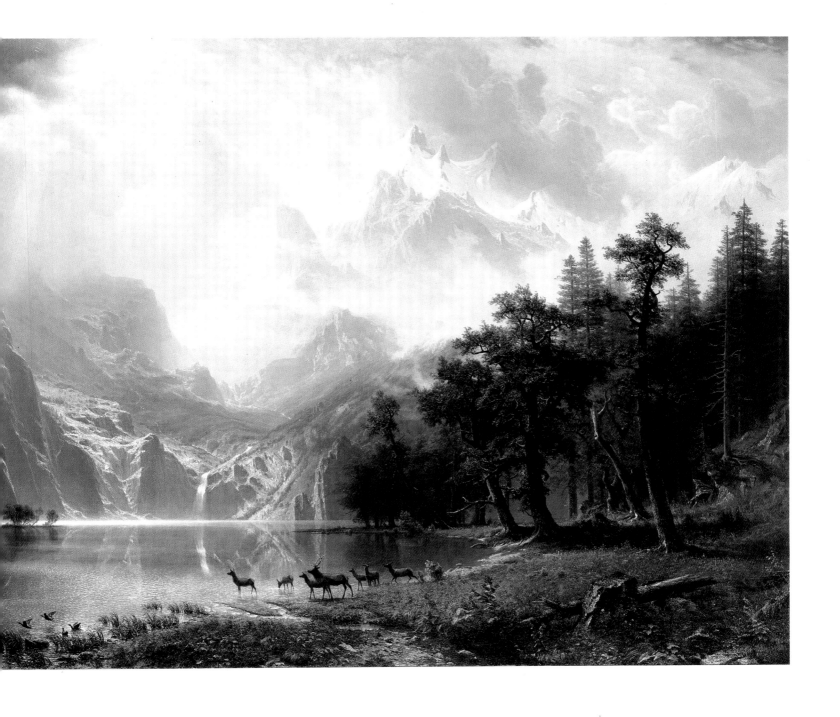

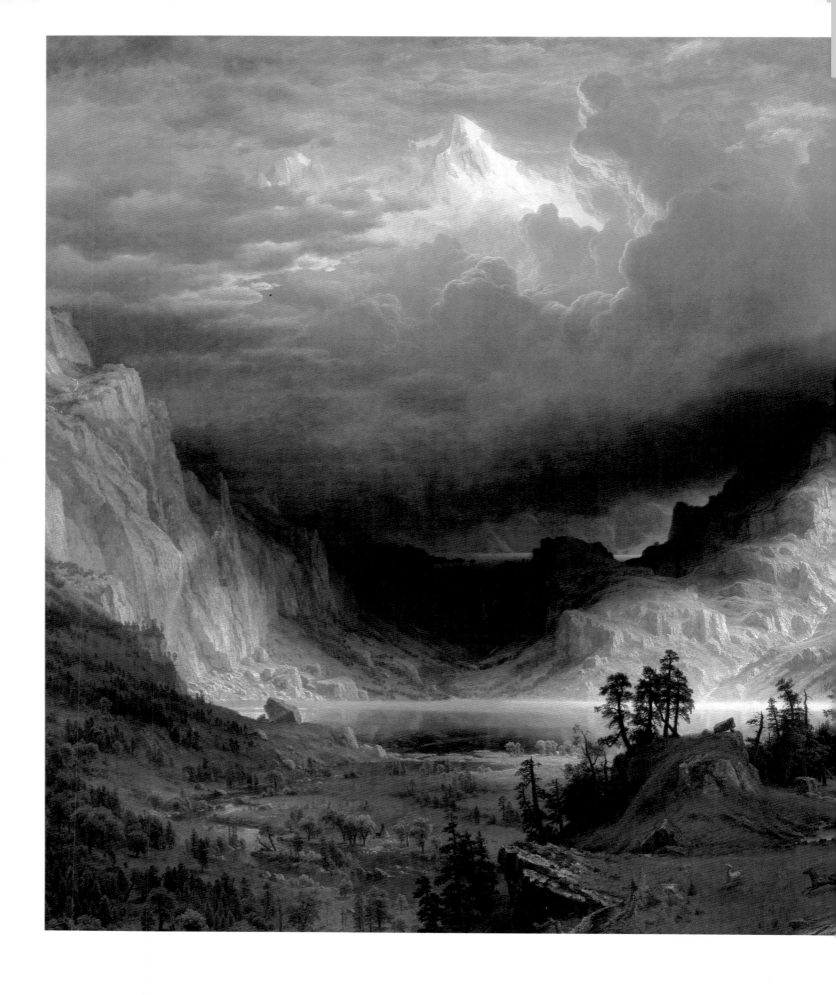

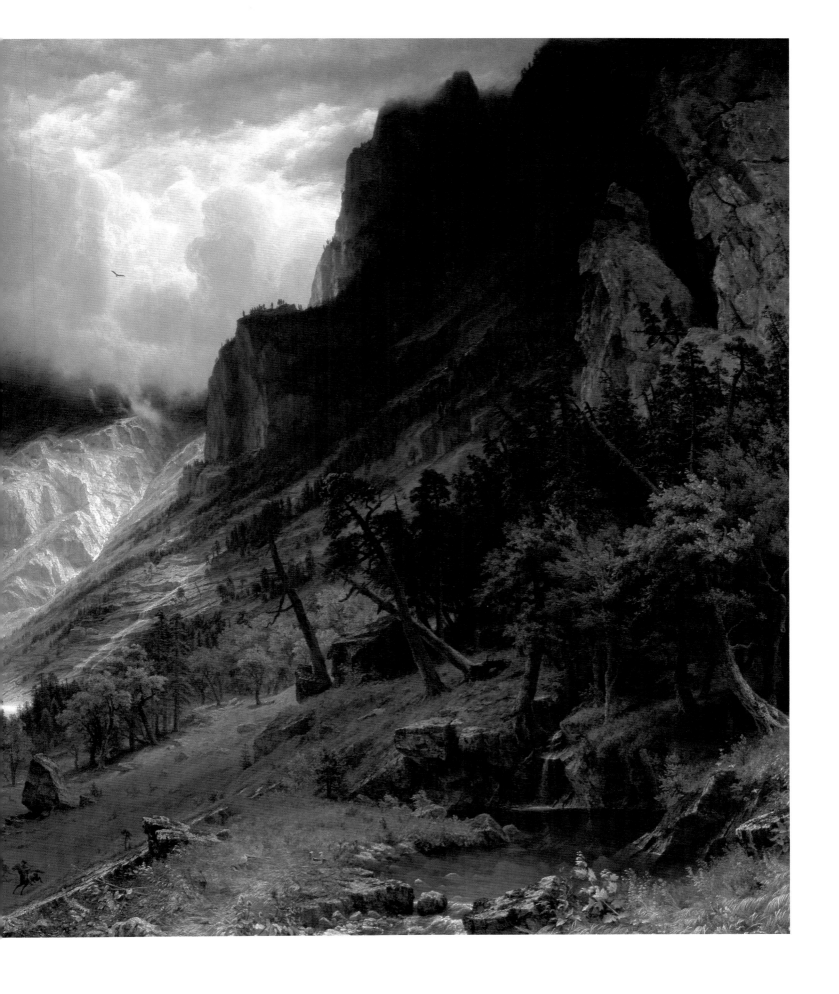

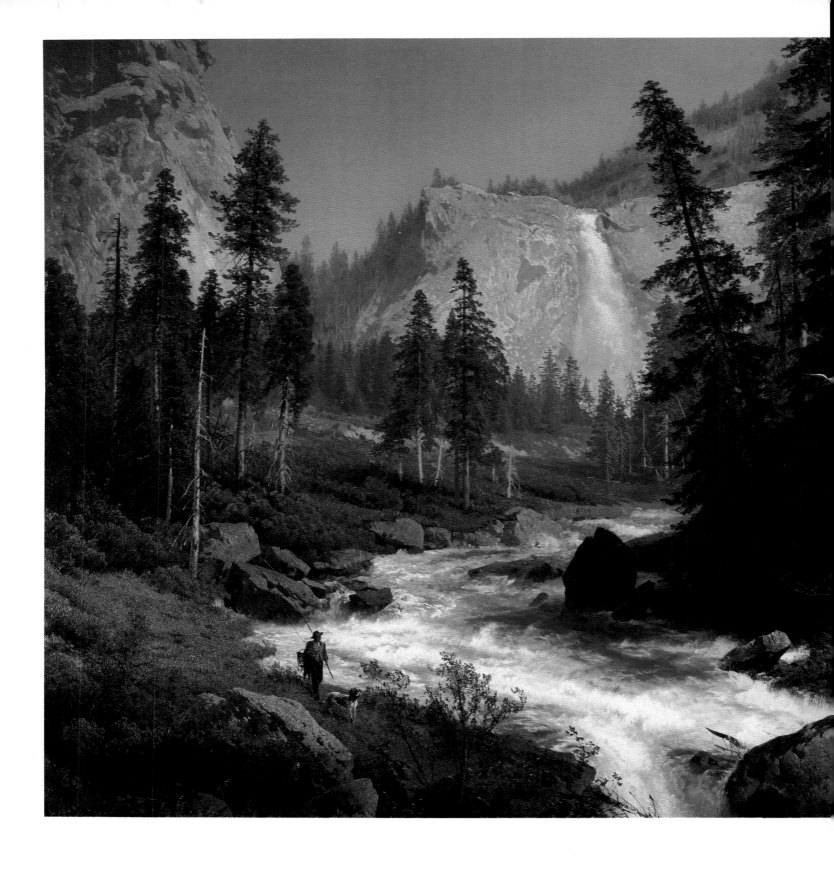

Sentinel Rock, Yosemite (1875)
The Anschutz Collection
Hermann Herzog (1831-1932)

Born in Germany, Herzog took up his study of art at Düsseldorf at the age of 17. He later studied landscape painting under the Norwegian artist Hans Gude and for a while stayed in Norway to perfect his skills. After returning to Düsseldorf, he sold a painting to the Queen of Hanover, and with that bit of luck he became a favorite of European nobility. The Emperor of Russia and Queen Victoria of England were among his clients. Herzog traveled extensively throughout Europe seeking subjects for his landscapes, but in 1869 he left Germany to settle in Philadelphia. From there he traveled throughout the United States and Mexico.

One might suppose that, given his background and training, Herzog would have approached landscape in much the same spirit of Düsseldorf theatricality as Bierstadt. Yet this was far from the case. His *Sentinal Rock* exhibits the forthrightness of Herzog's style. Unlike Bierstadt, Herzog's paintings are straightforward representations of nature, dramatized only to the extent that drama is inherent in his subjects. In other respects, his technique is fully polished as Bierstadt's.

Herzog lived to be 101 years old and was active in promoting his works until his death.

(page 92)
The Grand Canyon of the Yellowstone (1872)
The National Museum of American Art, Smithsonian Institution
Thomas Moran (1837-1926)

Born in England, Moran was early brought to Philadelphia. While apprenticed to a woodblock engraving firm, he learned the art of drawing. His brother, a marine artist, encouraged his interest in watercolors, and in 1858 he exhibited in the Pennsylvania Academy of Fine Arts. At the age of 21 Moran went to London. Impressed by the works of J M W Turner, he studied and copied them. Ten years later he joined the Hayden Expedition exploring the Yellowstone region. His watercolors of the natural wonders he encountered on this trip are among his best works.

As *The Grand Canyon of the Yellowstone* suggests, Moran was at one with Bierstadt in his approach to nature. 'The old idea that art is best defined as "painting nature as it looks . . ." does not satisfy me,' he wrote. 'An artist's business is to produce for the spectator of his picture the impression produced by nature on himself.' Apparently Yellowstone overwhelmed Moran, for that is certainly what he tries to do to the viewer in this grandiose seven-by-12-foot spectacular.

It was Moran's painting as much as anything that influenced the United States Congress to declare the Yellowstone region a National Park in 1872, the first such preserve in history. A 12,000-foot peak in the Grand Tetons is named after him.

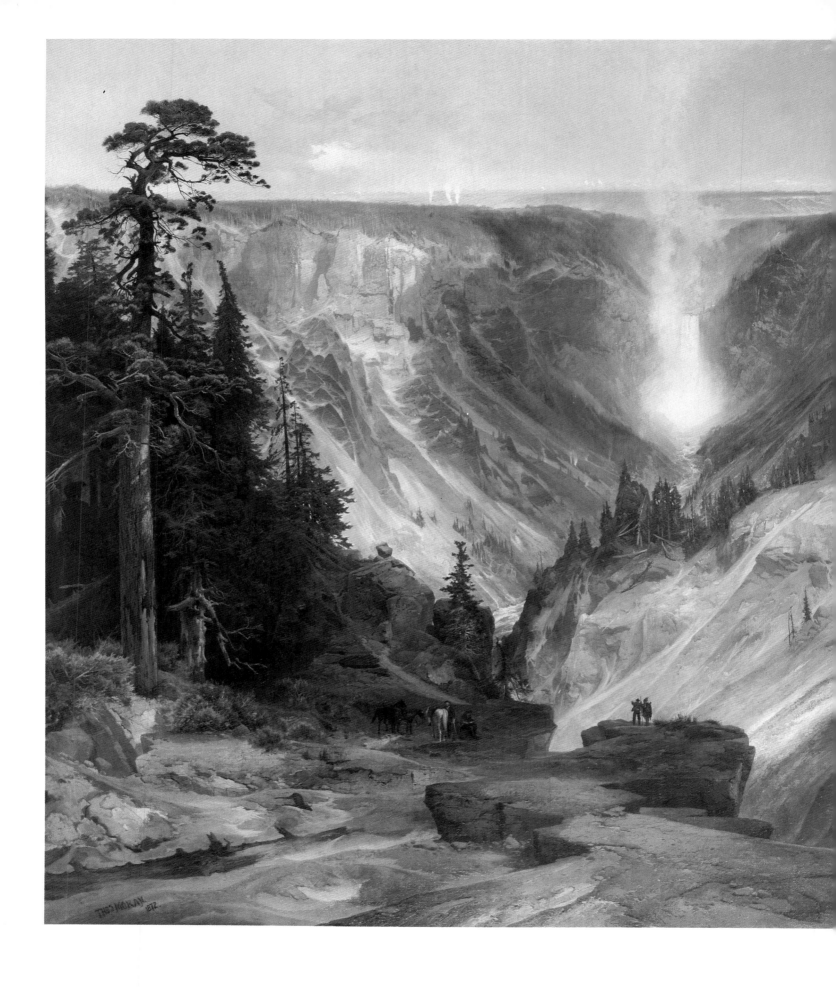

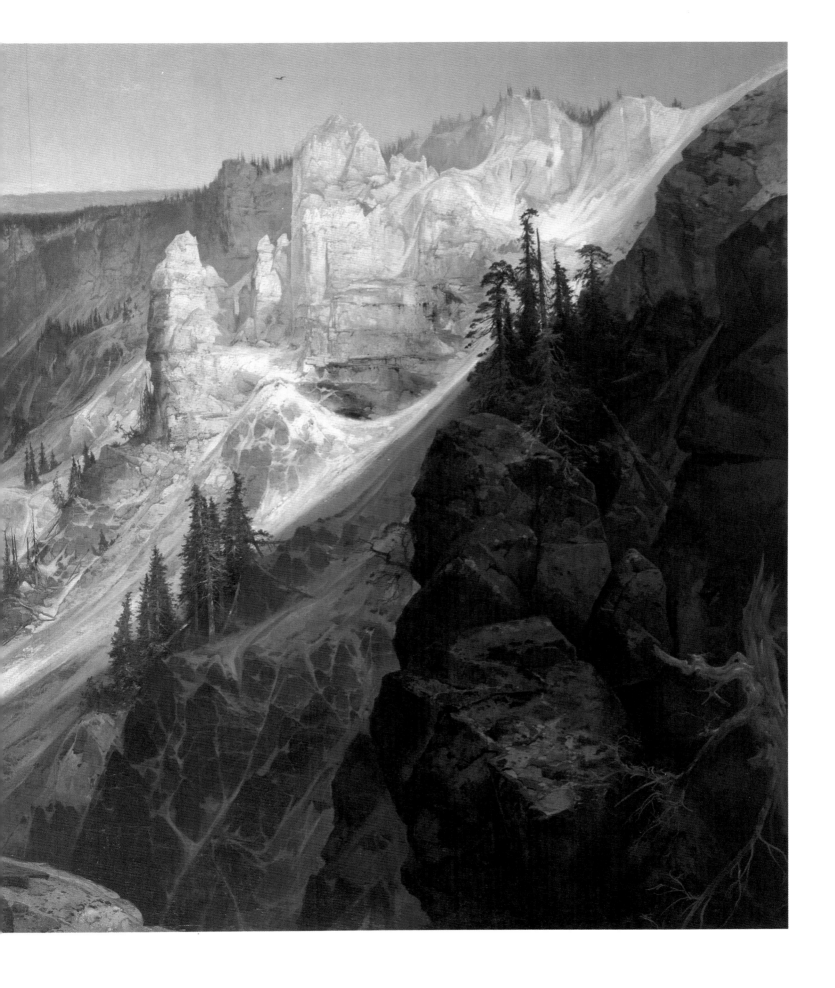

The Upper Missouri (c 1875)

The Rockwell Museum, Corning, New York

William Cary (1840-1922)

Cary was born in Tappan, New York, and grew up in New York City. At the age of 21 he travelled west. Going by boat up the Missouri River, he got as far as Fort Union, near the confluence of the Yellowstone. He had planned to continue to Fort Benton by river, but his boat, the *Chippewa*, blew a boiler and burned. After spending six weeks at Fort Union, he joined a wagon train headed for Fort Benton. Though the train was captured by Crow Indians, it was released when a Crow chief recognized one of the fur company's men. After spending two weeks at Fort Benton, Cary proceeded westward to Walla Walla, Portland, and eventually San Francisco. Perhaps understandably, it was not until he was 34 that he ventured west again.

The sketches Cary made on his trip formed the basis for his many illustrations for national magazines and newspapers. His painting *The Upper Missouri* is typical of his ability to portray everyday activities of Western life. However, not all of his paintings were reportorial. Many were of imagined subjects, often melodramatic and full of violent action, and very much in keeping with the now-established popular image of the Wild West.

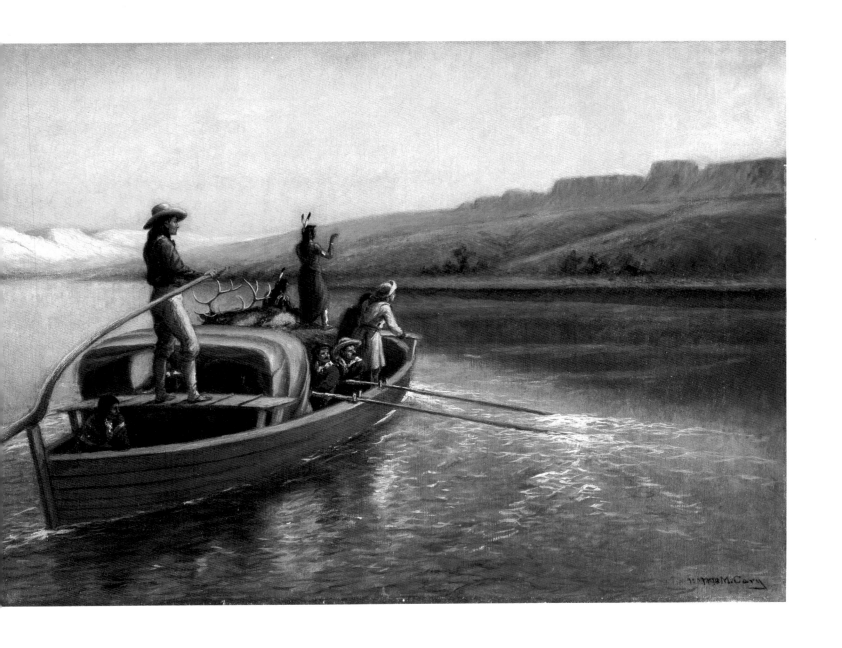

Custer's Last Fight (1886)

Courtesy of Anheuser-Busch Companies Inc

Cassily Adams (1843-1921)
Otto Becker (1854-1945)

Cassily Adams was born in Zanesville, Ohio, and studied art first at the Boston Academy of Arts and later at the Cincinnati Art School. For a while he lived in St Louis but later moved to Cincinnati, where he maintained a studio.

Otto Becker was born in Dresden, Germany, where he studied at the Royal Academy of Arts. Arriving at New York at the age of 19, he did lithographic work there and later in Philadelphia, Boston and St Louis. He finally established himself as a lithographer in Milwaukee in 1880.

Adams's huge painting *Custer's Last Fight*, measuring 12 by 32 feet, was completed in 1886 and valued at $50,000. In 1890 Anheuser-Busch, Inc., acquired the painting as part of the assets of a bankrupt saloon. Five years later Otto Becker was employed to paint a version of Adams's *Custer's Last Fight* from which 150,000 colored lithographs were reproduced. Copies of it were presented to practically every saloon in the United States. As a result, *Custer's Last Fight* became probably even better known to frequenters of beer halls than the *Mona Lisa*.

Whether the painting does more violence to art or to history is moot. Among its factual errors: Custer's flowing locks were cut prior to this campaign; no one, including officers, carried sabers; and no known Indians were equipped with Zulu shields. Yet the painting is one of the great American icons, for millions the definitive image of a great battle whose ultimate winner may have been Anheuser-Busch.

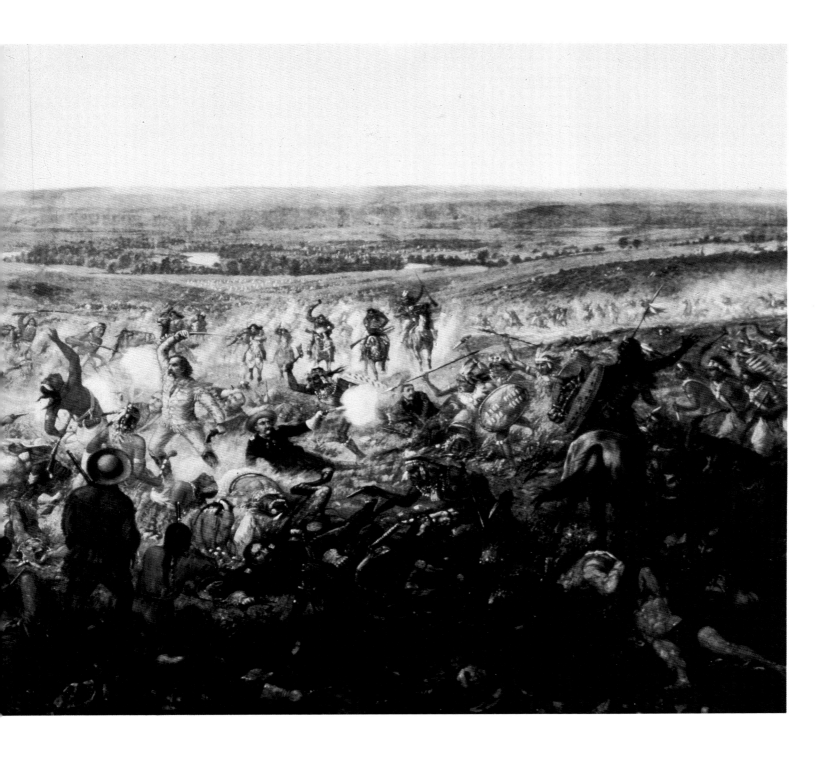

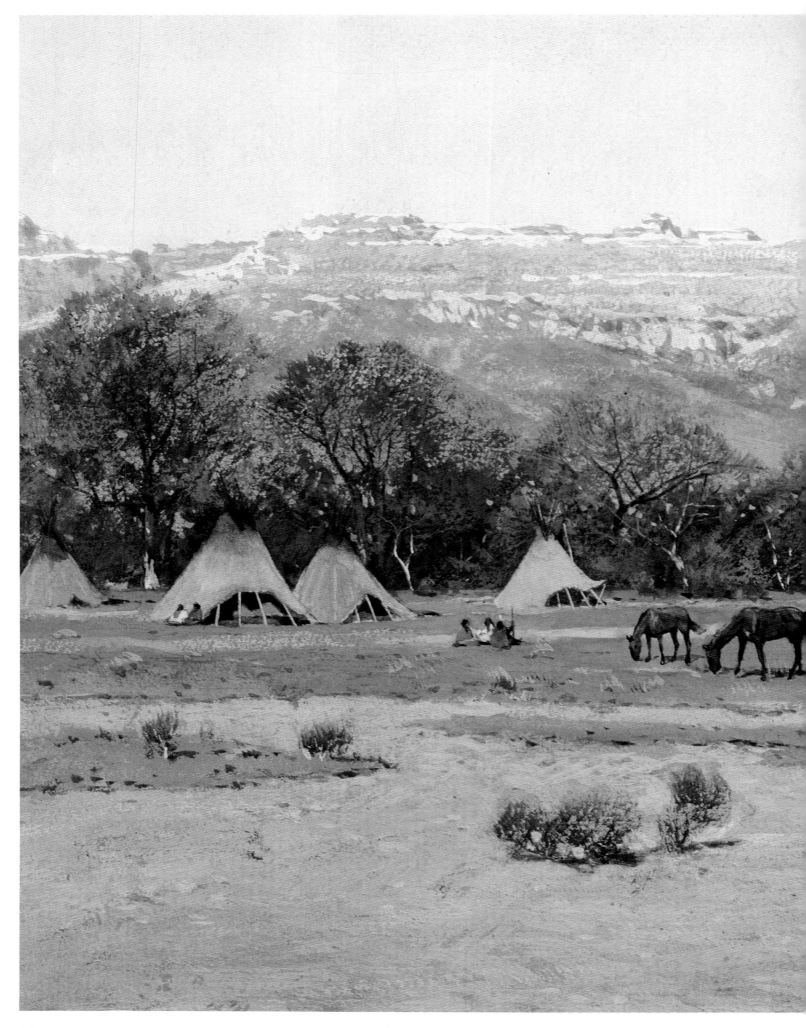

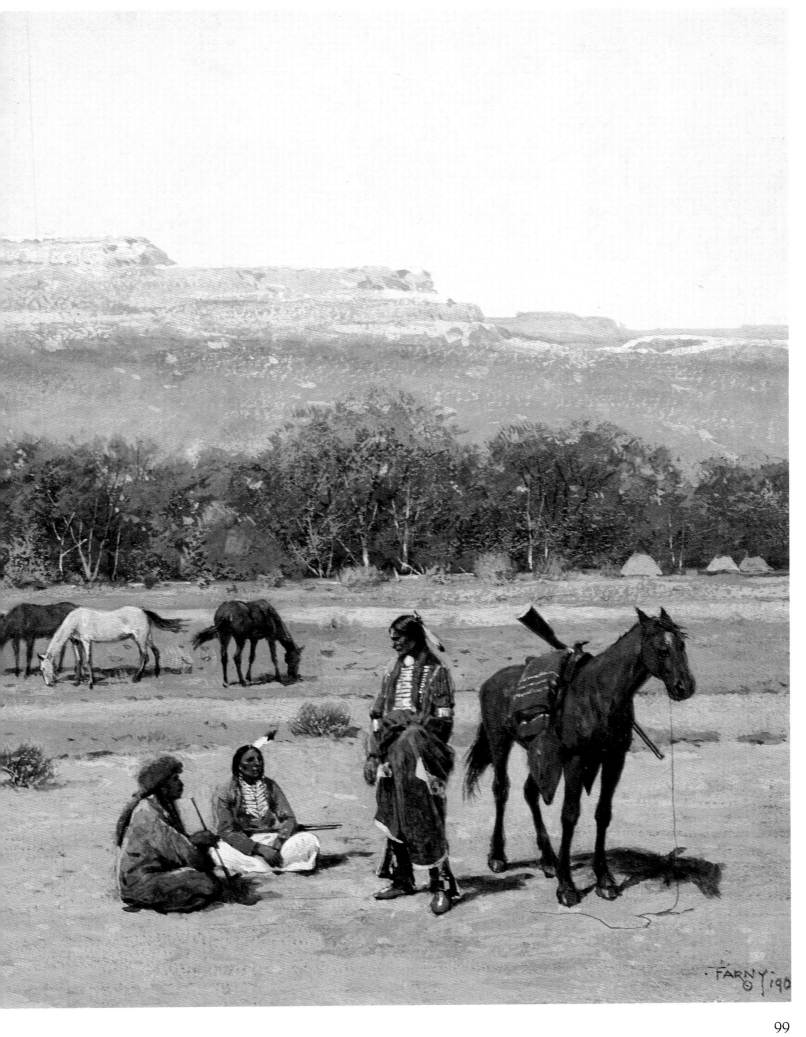

(page 98)
Indian Encampment (1901)
The Anschutz Collection
Henry Farny (1847-1916)

Farny's family came to this country from France in 1852 and settled in Cincinnati. In his 20s he spent several years studying art in Europe, and upon his return he became an illustrator for various weekly magazines. In 1881 he made his first trip west and was immediately enthralled by the landscape and the Indians. He now began painting Indian genre, filling his Cincinnati studio with a large collection of Indian artifacts to be used as supportive material for his paintings.

Farny's excellent *Indian Encampment* is typical of his work in several respects. For one thing it is a gouache, one of Farny's favorite media. For another, it has about it a remoteness and placidity that contrasts with the super-heated Wild West scenes favored by many of his contemporaries. Its use of well-defined receding horizontal planes may reflect the influence of Japanese landscape painting, in which Farny was intensely interested. And its harsh midday lighting is another Farny hallmark. In fact his colors continued to lighten throughout his career, in the end achieving effects not far removed from impressionism.

Moonlight (1885)
The Brooklyn Museum, New York City
Ralph Albert Blakelock (1847-1919)

Born in New York, Blakelock was sent to the Free Academy at the age of 17. He gave up in two years in favor of painting landscapes and was considered good enough to exhibit in the National Academy of Design. In 1869 he went west, where he traveled extensively making notes and sketches.

Blakelock's impressionistic style, combining impasto overlaid with an opaque layer of paint, or scumble, gave his painting a somewhat mystical, if not surreal character. By using light and shadow with little regard for color, his chiarascuro effects gave his paintings an ethereal quality. His painting *Moonlight* is typical of his style, showing a dimly lit Indian encampment hidden among gigantic trees against a gloomy, somewhat ominous, sunset. As in so many of Blakelock's pictures, this appears to be an imaginary scene.

Blakelock's romanticism, as expressed in his impressionistic renderings, was ahead of its time, or in any event the buying public's taste. His paintings did not sell and he was financially destitute. At the age of 52 he lost his mind and spent the remainder of his life in mental institutions.

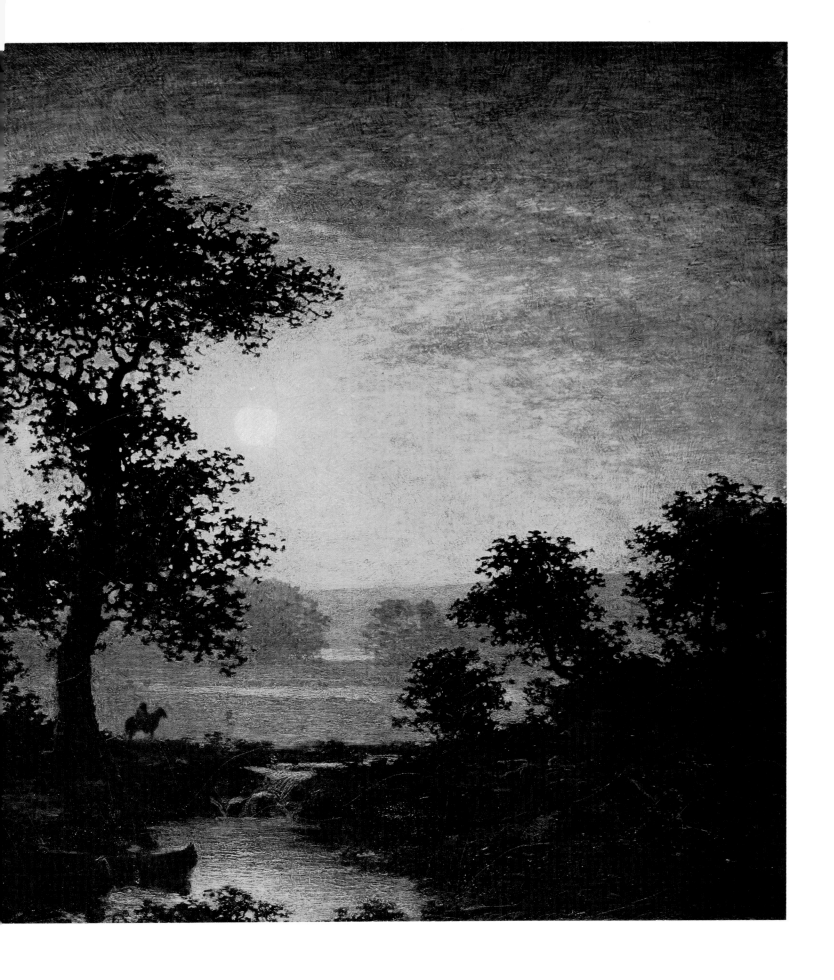

She Comes Out First, Sioux (c 1895)

The Butler Institute of American Art, Youngstown, Ohio

Elbridge Ayer Burbank (1858-1949)

Burbank began painting Indians at the suggestion of his uncle, E E Ayer. Ayer had given a collection of Indian artifacts to the Newberry Library in Chicago. Burbank went west, probably in 1895, making notes and sketches for his later finished portraits in oil. These he exhibited in Philadelphia.

His portrait of *She Comes Out First* was done at Pine Ridge Reservation in South Dakota. Burbank's attention to detail makes the painting ethnographically invaluable. Here the sitter wears a solidly beaded yoked elkskin dress, a German silver concho belt and a hair-pipe bone necklace, all of which might weigh as much as 50 pounds. In addition, she wears two pairs of dentalium earrings tipped with abalone shells. Her face is adorned with a series of red-painted stripes, and in her hair are four eagle down feathers, all of which show her to have had the *Hunkaype* ceremony performed in her honor. This rite was a 'coming out' feast for young people who were 'joined like brothers.' Many gifts and horses would have been given in her name, and she would be recognized as a person of high status in Sioux Indian society.

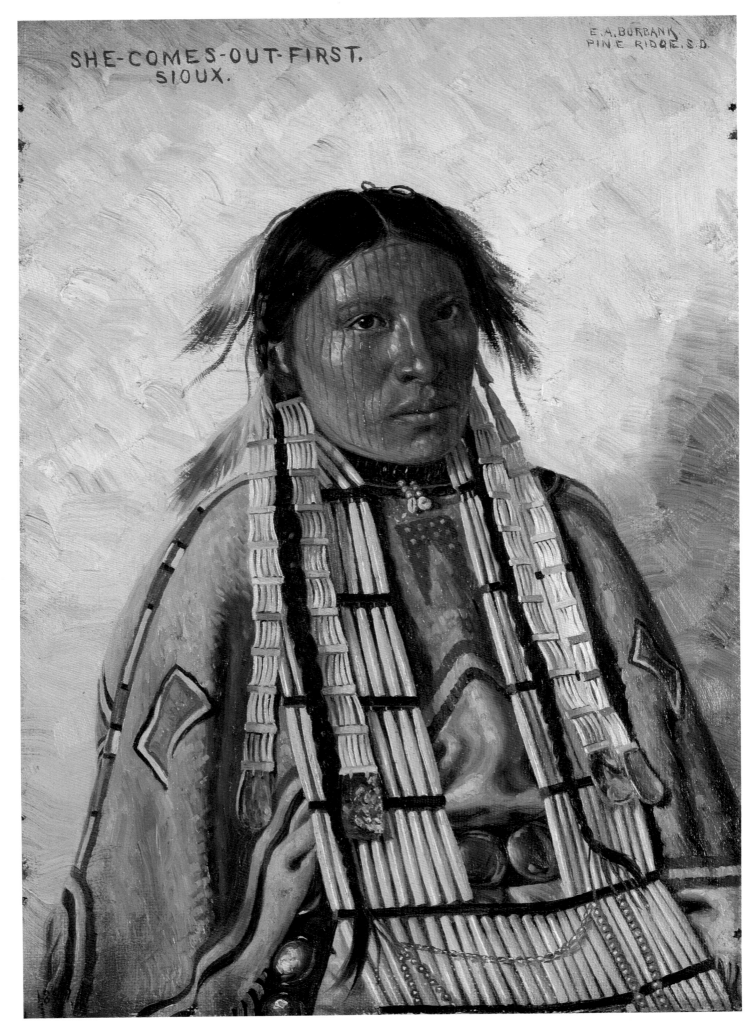

SHE-COMES-OUT-FIRST.
SIOUX.

E.A.BURBANK
PINE RIDGE S.D.

103

The Crow War Bonnet (c 1901)

The Buffalo Bill Historical Center, Cody, Wyoming

Joseph Sharp (1859-1953)

Born in Bridgeport, Connecticut, Sharp studied at the McKicken School of Design, later to become the Cincinnati Art Academy. At the age of 22 Sharp made his first of many trips to Europe to continue his studies. Two years later he travelled to Albuquerque and Santa Fe, New Mexico, where he became enthralled with the countryside and the Indians. It was during one of his return visits to Europe that he encouraged two young artists, Bert Phillips and Ernest Blumenschein, to journey to Taos and Santa Fe and paint the marvels of the Southwest.

Dividing his time between teaching at the Cincinnati Art Academy and spending his summers in Taos and Montana, Sharp painted his beloved Indians. Not until 1902 did he move to Taos, where he became one of the founders of the Taos Society of Artists.

The Crow War Bonnet is characteristic of Sharp's half-realistic, half-impressionistic style of portraiture, using reflected firelight to accentuate his modeling. Sharp always pictured his Indians as gentle, contemplative people, which is in keeping with his affectionate conception of them. In all matters of ethnographic detail he was faultless, and he recorded several aspects of Indian life known to few, if any, white men before him.

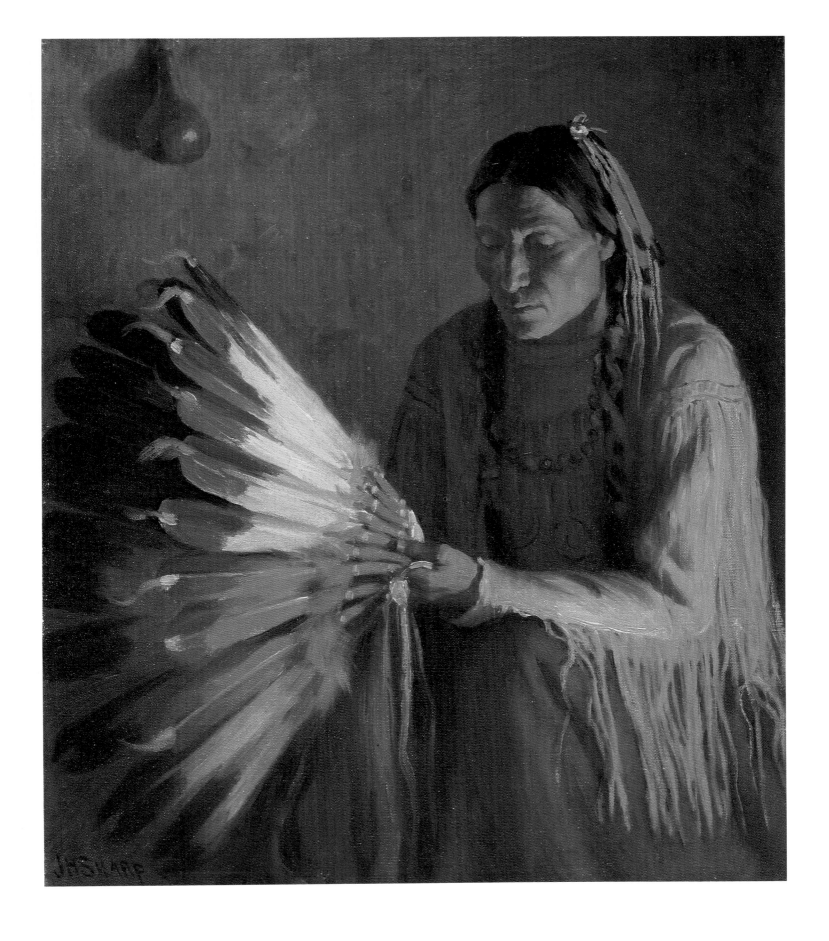

On the Southern Plains (1907)

The Metropolitan Museum of Art, New York City

The Scout: Friends or Enemies? (1890)

The Sterling and Francine Clark Institute, Williamstown, Massachusetts

The Emigrants (1904)

The Hogg Brothers Collection, Museum of Fine Arts, Houston, Texas

Frederic Remington (1861-1909)

Probably the most popular of all Western artists, Remington was born in Canton, New York. He loved the out-of-doors and horses, much to the expense of his schoolwork. As a disciplinary measure, his parents sent him to military school. After graduation, he decided to pursue a career in art and enrolled in Yale University's School of Fine Arts. The untimely death of his father was an excuse to quit Yale after only two years. With a small inheritance, he ventured west, where he travelled extensively, bought himself a mule ranch and promptly sold it. Eventually he brought his bride, Eva, to Kansas City, but this proved unsatisfactory, and she returned to New York. Remington had already sold a sketch to *Harper's* in 1881, but not until four years later did he begin to sell his illustrations regularly. Remington was in the West again in 1888, spent time scouting with the 10th Cavalry in Apache country and thoroughly enjoyed himself. Returning to his New York studio, he devoted himself to working up his sketches into finished paintings.

Remington's growing success as an illustrator, while financially rewarding, was not fully satisfying to him. His ambition was to be recognized as a painter. This desire was only partially met in 1891 with his election as an Associate in the National Academy of Design. And, in fact, the distinction between 'painting' and 'illustration' is difficult to make in his case, since all his work is narrative, is implicitly or explicitly dramatic and is usually bursting with action. His technique evolved steadily, his earlier sharp-edged realism giving way to looser brushwork (as a preferred means of conveying headlong movement) and finally to a kind of impressionism, most evident in his quiet nocturnes. He painted all sorts of Wild West subjects, but was particularly fond of cavalrymen. With good reason, he prided himself on his ability to paint horses.

A striking feature of his work is that it is essentially retrospective. He did not, like artists before him, paint the West as it was in his own time, but as it had been in the past – or perhaps, more accurately, as he believed it should have been. No one did more to give the semi-legendary Old West the graphic form most of us now accept as truth.

On the Southern Plains, painted two years before his death, is one of his most characteristic themes, done in his later, looser style. The scene depicted in *The Emigrants* is said to have been based on a real incident – a fact that is, in the face of such a violently self-explanatory piece of narrative, quite irrelevant. Narrative is no less present in *The Scout*, though here the emphasis is on suspense, rather than action. The picture's subtitle, *Friends or Enemies?* tells it all.

Between 1881 and 1907 Remington produced nearly 3000 drawings, paintings and sculptures, as well as two novels and five collections of stories and essays. The serious recognition he had always sought was perhaps most fully granted in 1900, when Yale University awarded him an honorary degree in Fine Arts.

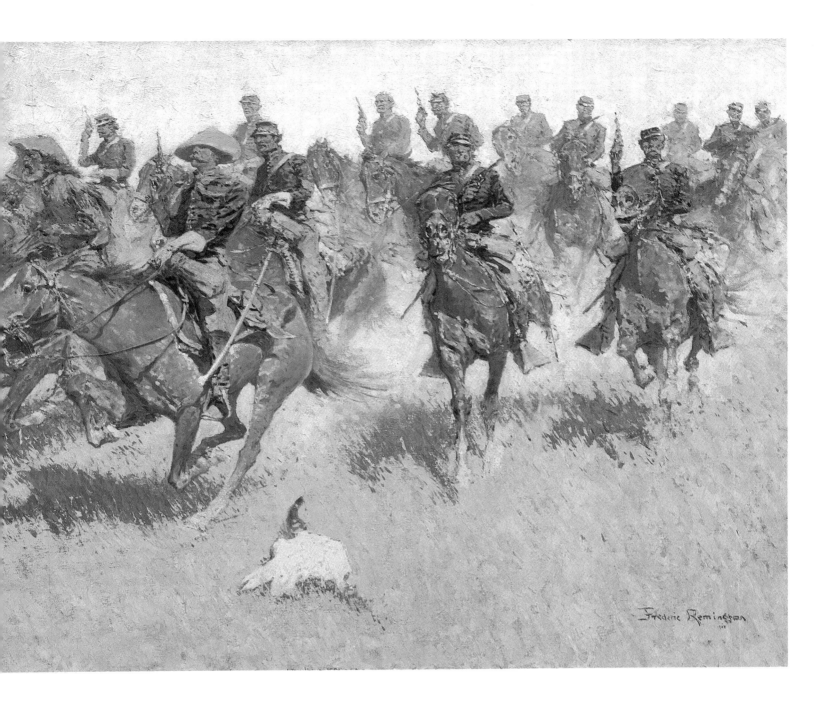

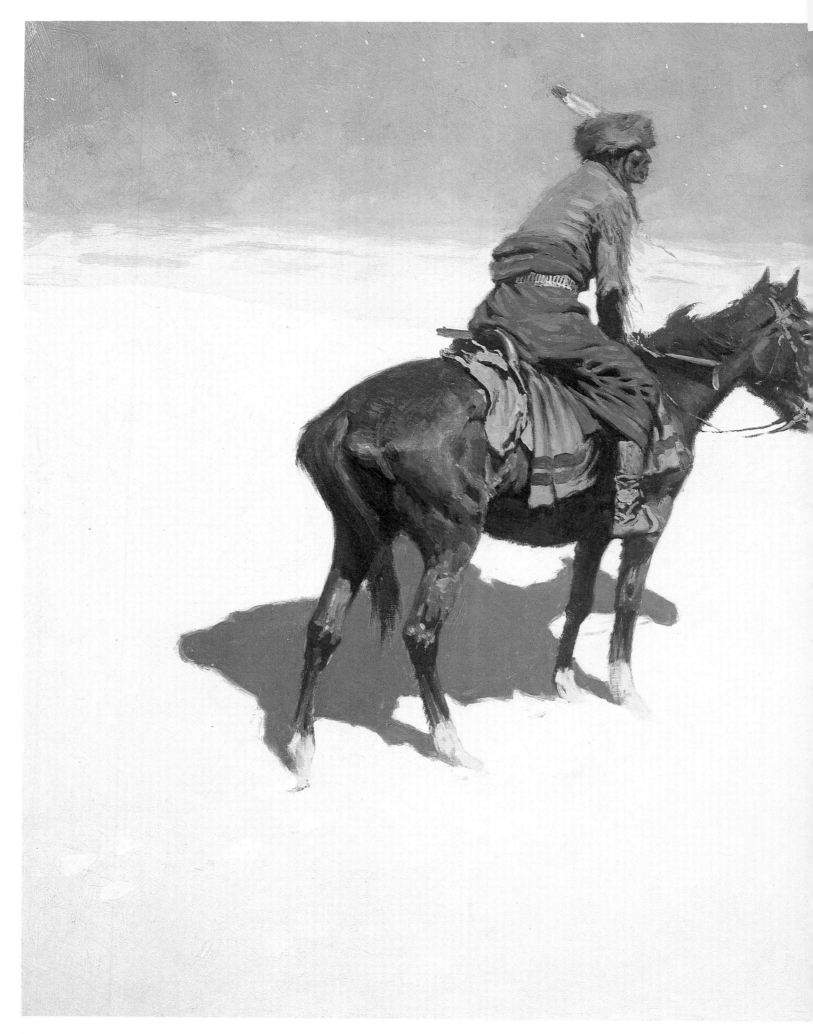

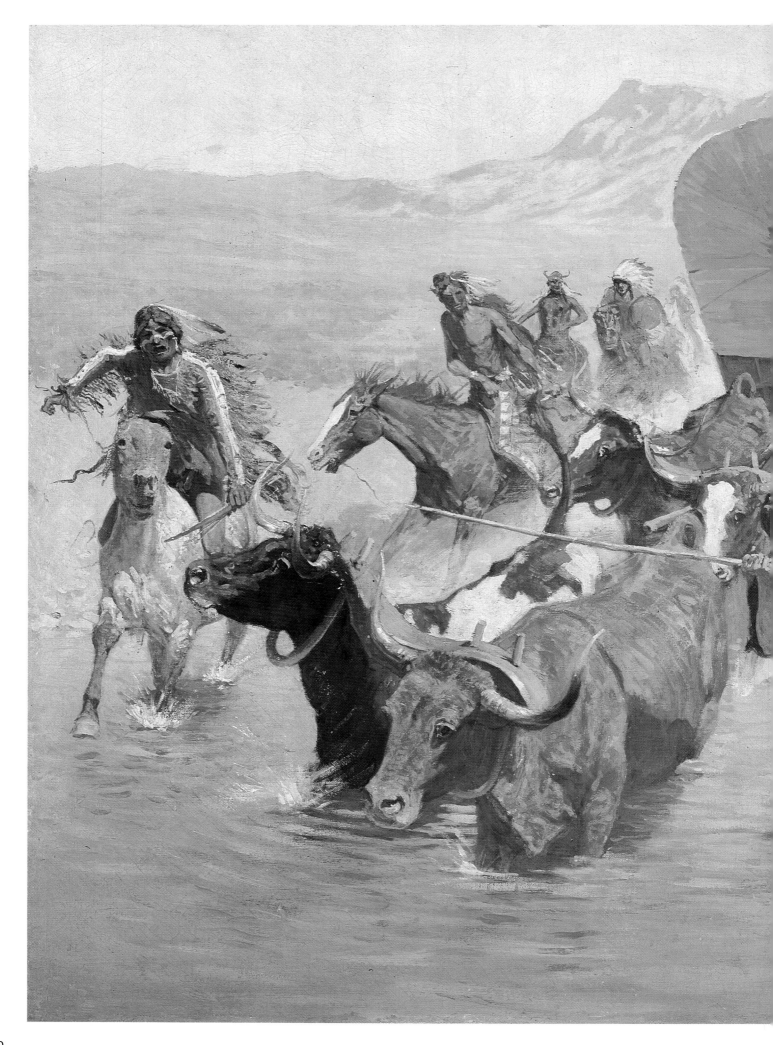

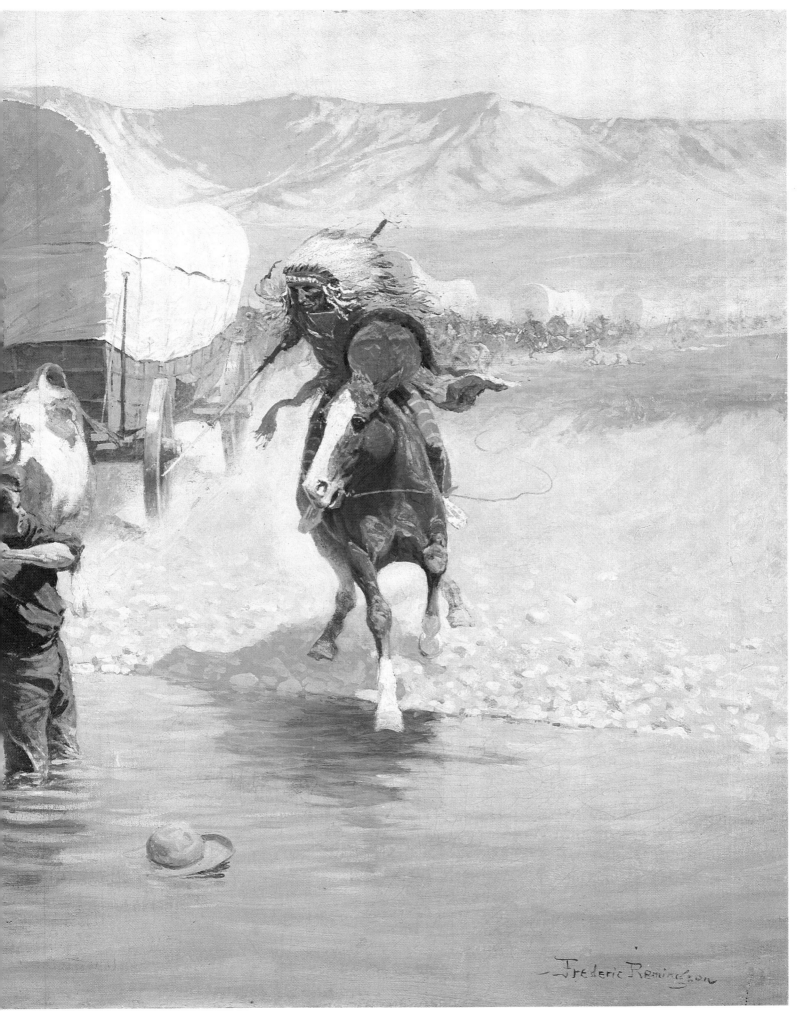

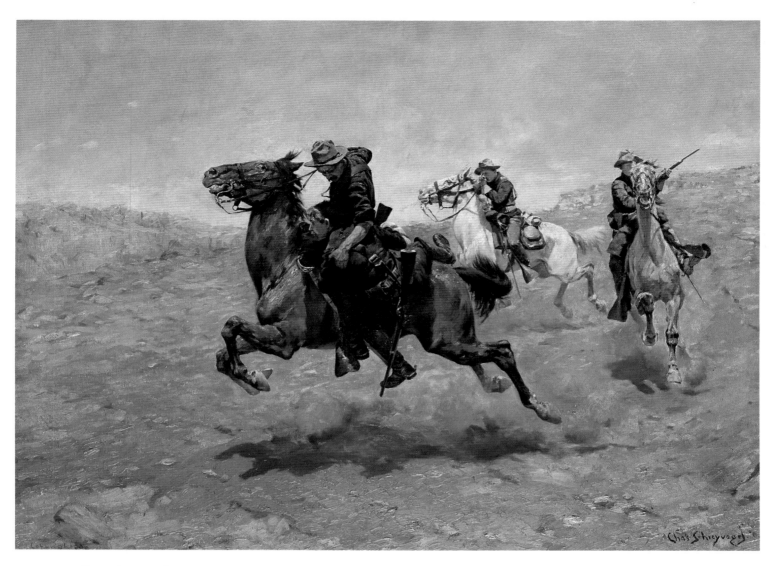

My Bunkie (1899)

The Metropolitan Museum of Art, New York City

Attack at Dawn (1904)

The Thomas Gilcrease Institute of American History and Art, Tulsa, Oklahoma

Charles Schreyvogel (1861-1912)

Schreyvogel was born of a poor family in New York City and earned money as a boy working for various artisans – a goldsmith, a lithographer, even a carver of meerschaum pipes. He taught himself to draw and at 19 found two patrons who sent him to Europe to study. Upon returning home, he was urged to go west for his health, but it took him three years to earn enough money to make the trip. Finally arriving in Colorado, he sketched Ute Indians at their reservation and later visited Arizona. Back in the East he managed to make a modest living painting portraits. Then, in 1900, he submitted a Western painting entitled *My Bunkie* to a major exhibition at the National Academy of Design. It won a first place for 'Figure Composition' and a $300 cash award. From then on Schreyvogel's career flourished.

Depicting an heroic action scene of a cavalryman rescuing a fellow trooper, *My Bunkie* was at first praised, but not long after it became the victim of an absurd whispering campaign that held that the subject implied a homo-sexual connotation.

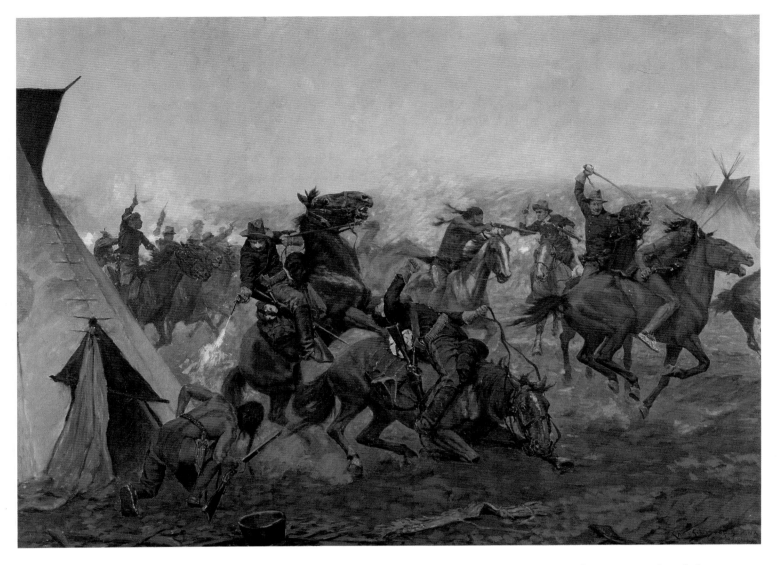

Schreyvogel's painting *Attack at Dawn* is a striking example of the artist's ability to convey violent action. There is an immediacy about this painting that somehow places the viewer so close to the action that he feels he will be overrun. The subject may derive from Colonel George Custer's dawn attack upon the Cheyenne villages in the Battle of the Washita.

Schreyvogel's popularity incurred the jealous wrath of Remington, who immoderately and unfairly attacked a Schreyvogel canvas, *Custer's Demand*, on grounds of historical accuracy. To Remington's embarrassment, both Mrs Custer and an eyewitness of the event depicted defended the painting, and Teddy Roosevelt later remarked to Schreyvogel, 'What a fool my friend Remington made of himself.' But fool or not, Schreyvogel had no illusions about their relative merits as artists. Speaking of Remington to a reporter, he said simply, 'He is the best of us.'

The Strenuous Life (1901)
The Thomas Gilcrease Institute of American History and Art, Tulsa, Oklahoma
When Shadows Hint Death (1915)
The Dunquesne Club, Pittsburgh, Pennsylvania
Salute to the Robe Trade (1920)
The Thomas Gilcrease Institute of American History and Art, Tulsa, Oklahoma

Charles M Russell (1864-1926)

Born in St Louis of a well-to-do family, young Charles Russell dreamed of the West and filled his schoolbooks with drawings of trappers and Indians. To cleanse his mind of Western adventure, his family sent him to a military school in New Jersey. He lasted a year. Giving in to Charlie's artistic bent, the family sent him to art school. He lasted three days. Succumbing to his ambition to go west, his parents made arrangements with one 'Pike' Miller to take the boy to Montana to work on Miller's sheep ranch. Charlie worked on the ranch for about a year, making a great many sketches and losing enough sheep to get him fired. A hunter named Jake Hoover took pity on him and invited Charlie to stay with him at his cabin. Charlie spent a year helping Jake and making sketches of wildlife. Leaving Jake, Charlie spent the better part of a year living with Blackfeet Indians. Next he found a job as a horse wrangler for a round-up. He was so good at this work he was given charge of 200 cow ponies.

Charlie worked for 11 years as a horse wrangler and cowboy, all the time sketching and doing watercolors of ranch life. These he gave away to friends or traded for a meal or a drink. Charlie was 39 when he was introduced to Nancy Cooper. She was only 17 but at once fell in love with this cowboy artist, and a year later they were married. Of the opinion that Charlie was not receiving a proper recompense for his paintings, she made arrangements with Eastern publishers, dealers and collectors to buy his works at higher prices. Furthermore, she convinced Charlie to spend only half his time at the bar drinking with his cronies. He was to paint in the mornings and have two drinks only in the afternoons.

In 1911 Charlie had his first one-man show in New York. Three years later he held two exhibitions in London. He also began working seriously in bronze. Nancy was increasingly successful in selling his pictures. By 1926 he was getting as much as $30,000 for single painting.

Like Remington's mature work, Russell's was mostly retrospective, filled with nostalgia for a vanished West. But Russell was memorializing a West he had known far more intimately than Remington. And for that reason, though he was not nearly as accomplished a technician as Remington, his paintings often communicate a deeper feeling. Not surprisingly, given Russell's background, this is particularly true of his cowboys. *The Strenuous Life* is a case in point. The surface action is tumultuous and dramatic, but there is nothing contrived about the actors. They are so evidently real, working cowboys that it is easy to imagine them all sitting around the bunkhouse later that evening, spinning tall (and probably hilarious) tales about the day's adventure.

When Shadows Hint Death is a suspense story somewhat in the manner favored by Remington. But here again, the two nervous hunters are anything but idealized, and the detail of their holding the ponies' noses to keep them from whinnying is as effective as it is realistic.

114

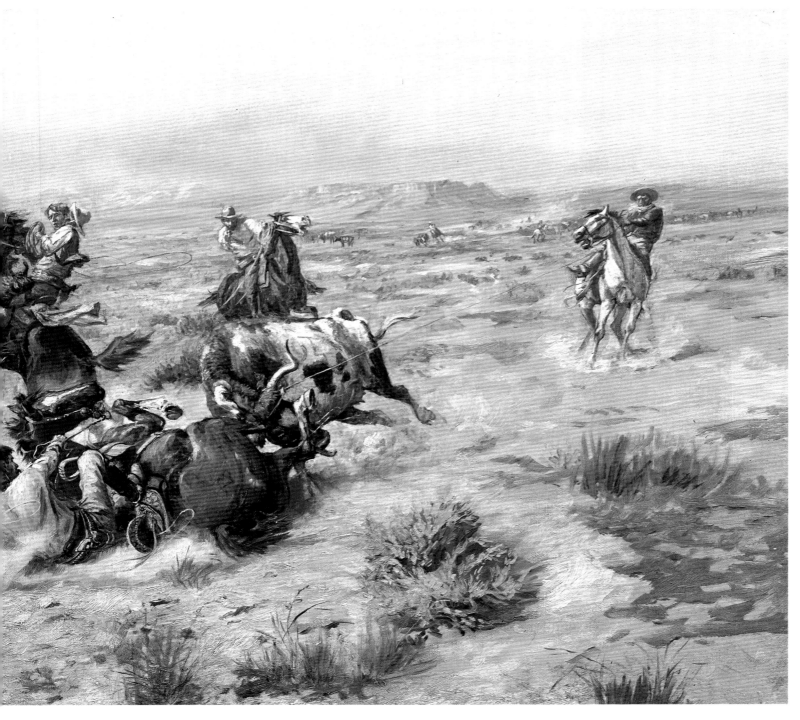

Next to cowboys, Indians were Russell's favorite subjects, and *Salute to the Robe Trade* is a good example of his typically human approach. Unlike most of his contemporary artists, he was seldom content just to cast Indians in the role of 'bad guys' in conflict narratives. Colorful, exotic and potentially dangerous they may have been, but he also found them admirable on their own terms, and he was always prepared to extend to them that same unsentimental sympathy that is the hallmark of all his painting.

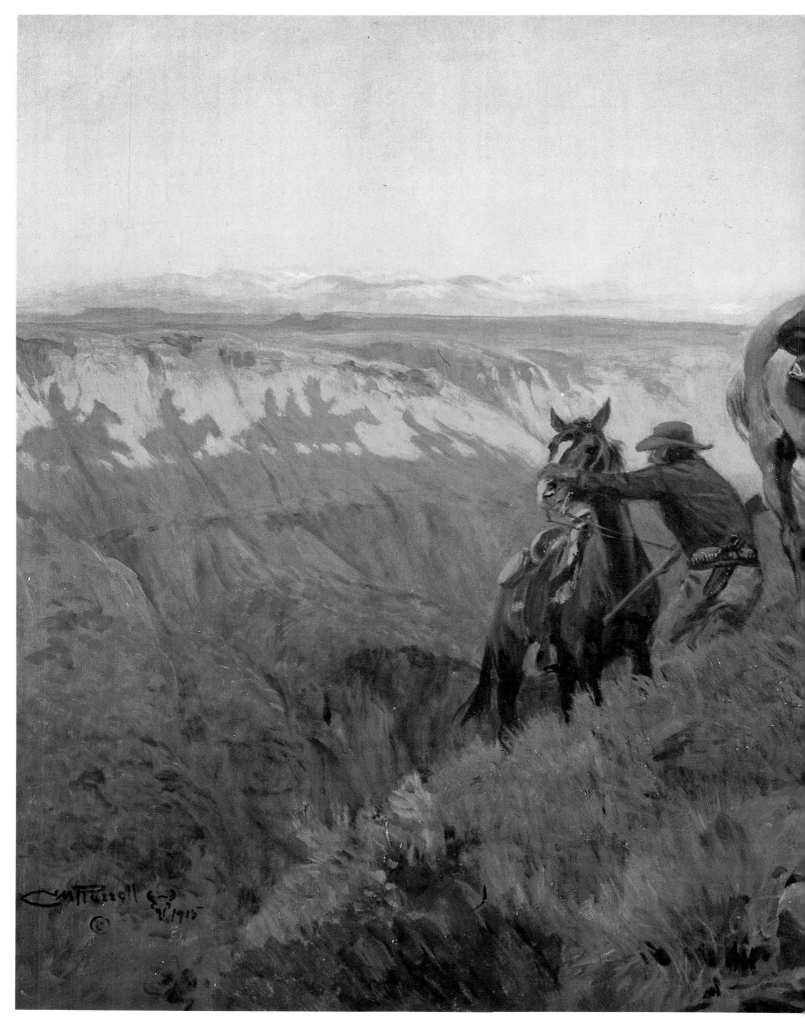

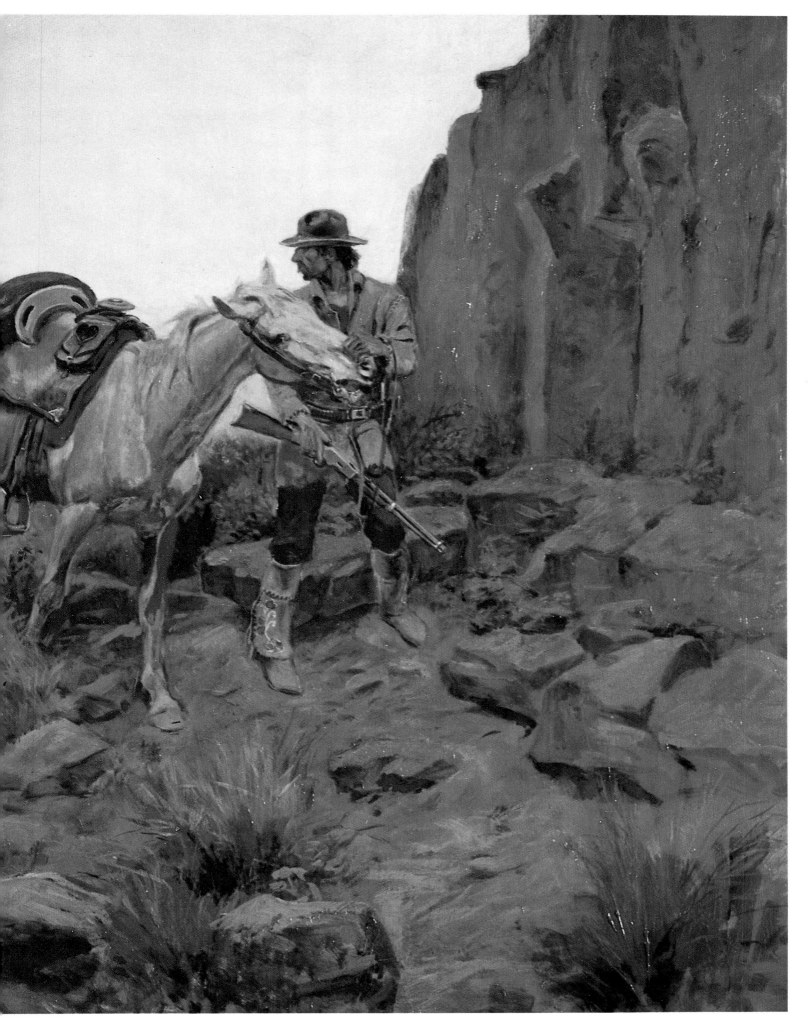

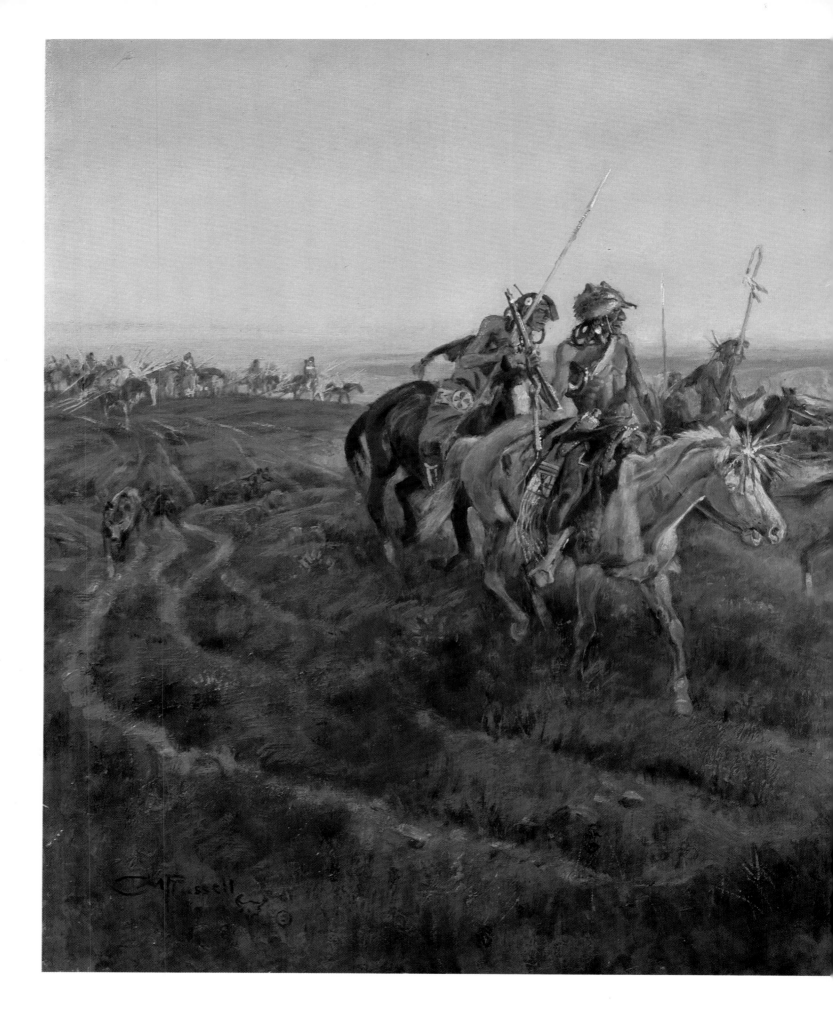

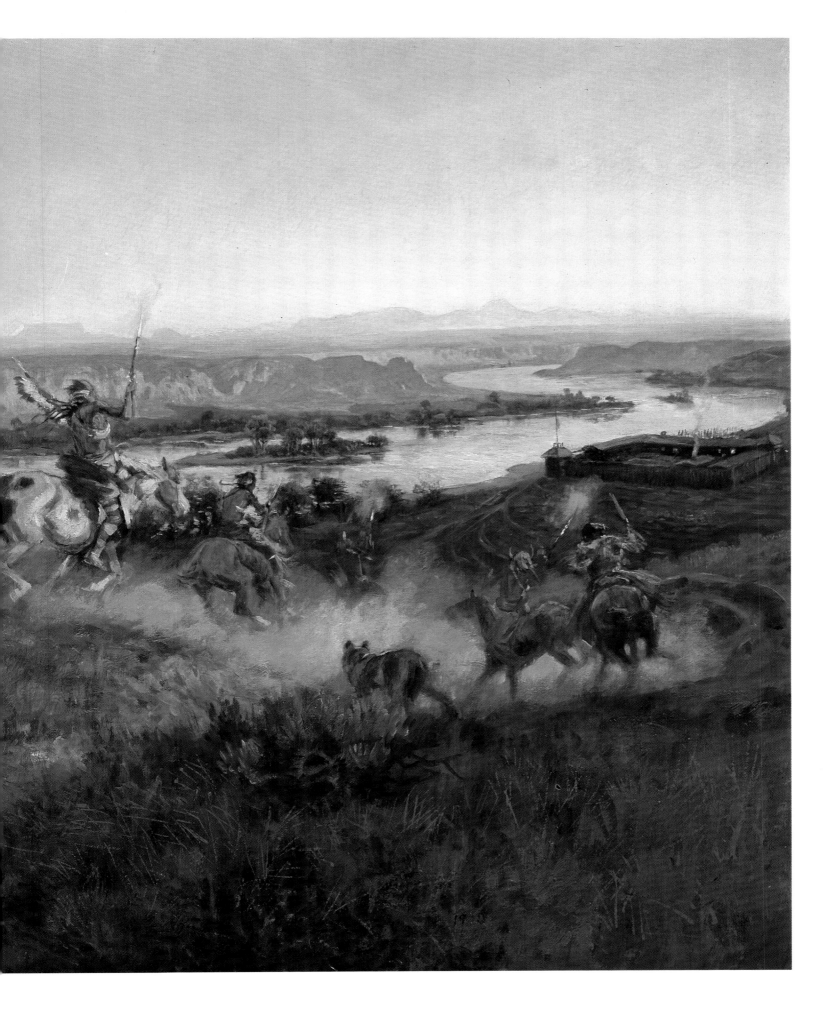

Indian Girl (1917)

The Indianapolis Museum of Art, Indianapolis, Indiana

Robert Henri (1865-1929)

As the leader of a revolt against the somewhat bloodless type of academic painting that had increasingly come to be represented by the National Academy of Design, Robert Henri was to be one of the most influential figures in the history of twentieth century American art. Born in Cincinnati, Ohio, he began his formal art training at the Pennsylvania Academy of Art. Two years later he went to Paris to study first at the Académie Julien and later at the Ecole des Beaux-Arts. After his return to America in 1891 he taught at the Philadelphia School of Design and at the New York School of Art. He was elected a member of the National Academy of Design in 1906 but broke with that body two years later on the grounds it encouraged self-conscious aestheticism at the expense of truth-telling about everyday life. He then became the leader of a group of young dissident artists known as 'The Eight' (and later, informally, as 'The Ashcan School'), which included George Luks, William Glackens and John Sloan. Henri only began to take up Western themes after his first trip to the West in 1916. His paintings from this period are mainly sensitive, semi-impressionistic portraits of his favorite Western subjects, the Pueblo Indians.

Indian Girl is typical of his Western pictures. The quick, free brushstrokes convey the wistfulness of his subject with astonishing immediacy. And although members of the 'Ashcan School' were popularly supposed to favor lugubrious colors, there is certainly no hint of that here – or, indeed, in much else of Henri's work, either before or after 1916.

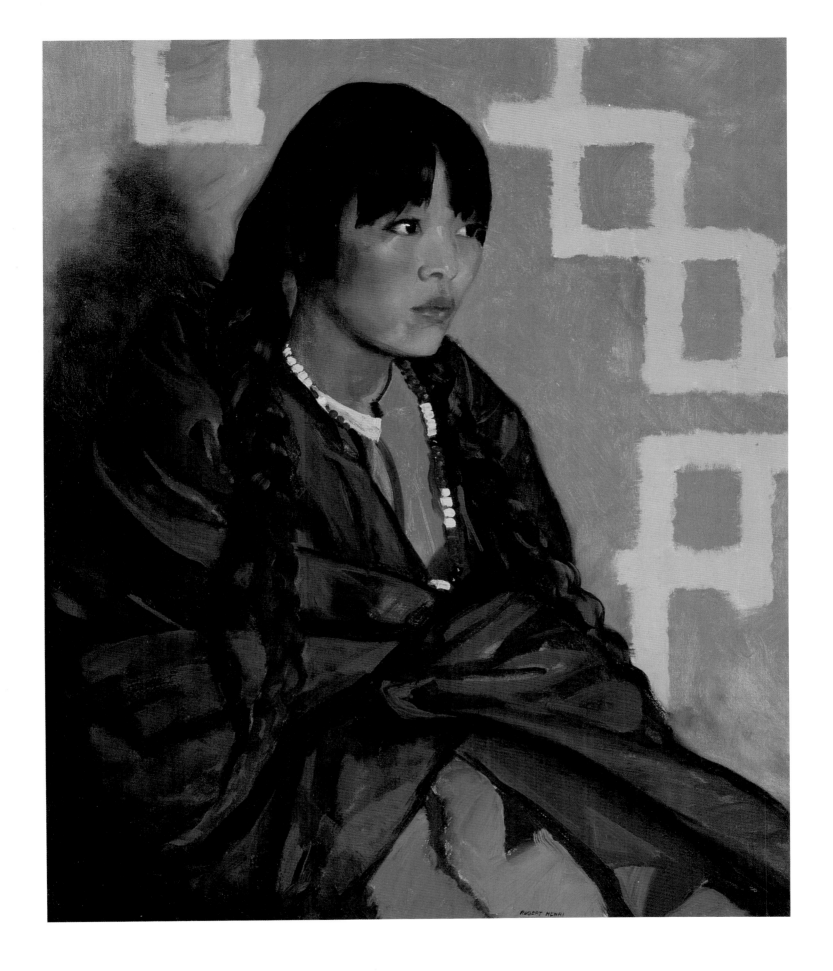

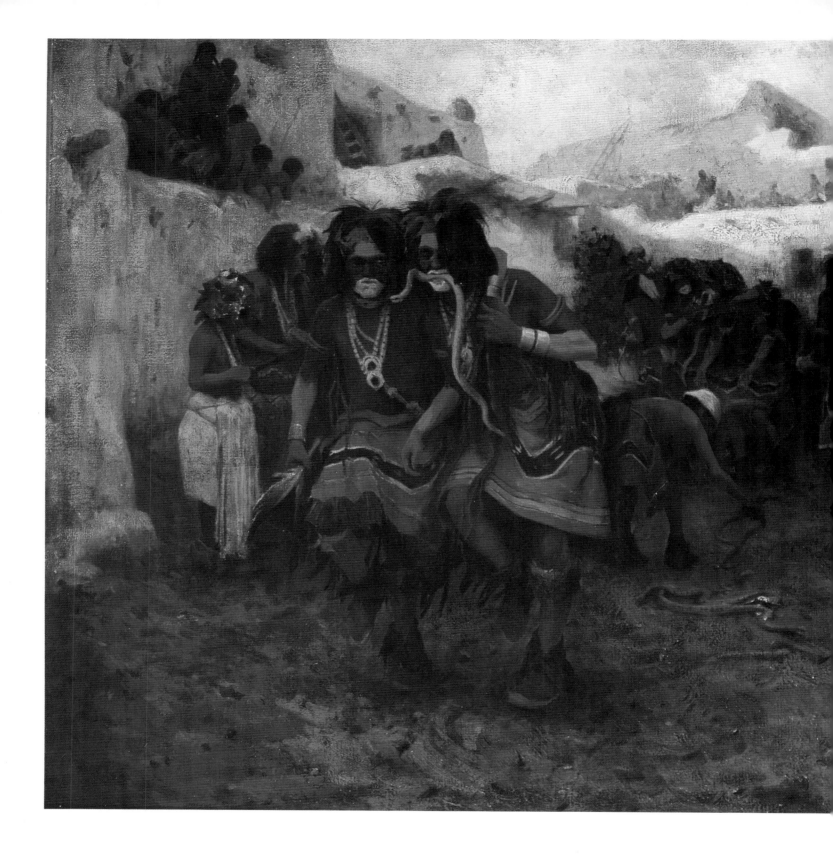

Moki Snake Dance (1904)

The Anschutz Collection

E. Irving Couse (1866-1936)

Couse was born in Saginaw, Michigan. He began his studies at the Art Institute in Chicago at the age of 17, and shortly thereafter he attended New York's National Academy of Design. Two years later he was in France studying under Bouguereau at the Académie Julien. He spent considerable time in France, where he sold landscapes to advantage. It was in Paris that he met Joseph Sharp and Ernest Blumenschein, who urged him to consider painting in the Southwest. Couse visited New Mexico in 1902 and four years later set up a studio in Taos. There he painted Indians, frequently posing them in squatting positions and bathing them in the reflected light of a campfire as they contemplated some object or performed some task. Most of these portraits are serene, idealized and, at worst, faintly saccharine.

Couse's *Moki Snake Dance*, however, is another kettle of fish entirely. In this darkly dramatic canvas he faithfully portrays the primitive midsummer ceremony in which men supplicate the rattlesnake, messenger to the underworld gods. One member of the Snake Society dances with a live rattler in his mouth, while another carries a feather with which to calm the deadly snake. Members of the Antelope Society, wearing white kilts, sing prayers. The ceremony concludes with the release of the snakes to their burrows. Thence they descend to the underworld to relay the people's prayers to the gods.

(page 124)

The Lookout (c 1902)

The Woolaroc Museum, Bartlesville, Oklahoma

William R Leigh (1866-1955)

Leigh, born in West Virginia, first studied art at the Maryland Institute of Art in Baltimore, after which he spent 12 years in Munich at the Royal Academy. First sent west by *Scribners* in 1897 to draw wheat harvesting scenes, Leigh returned again and again. Though he painted cowboys and Plains Indians in action-packed pictures, his favorite and best paintings were of the Southwest and the Pueblo Indians.

In his day, Leigh was compared by some to his famous contemporaries, Russell and Remington. But though his formal training had been far better than either of theirs, he somehow never quite achieved the poetic honesty of the one or the dazzling effectiveness of the other. Yet he was, in his way, very good, and perhaps no one has ever captured better than the odd, elusive coloration of the Southwestern landscape.

Lookout is a convincing re-creation of the cliff-dwellers' life in the pre-Columbian Southwest, displaying fine draftsmanship and a mastery of perspective. The women of the Anazazi, or Ancient Ones, are making pottery, while the lookout scans the distance, armed with a drum and beater to warn the men in the valley in case of danger. How authentic all this is is moot, but at least Leigh's guess is as good as any.

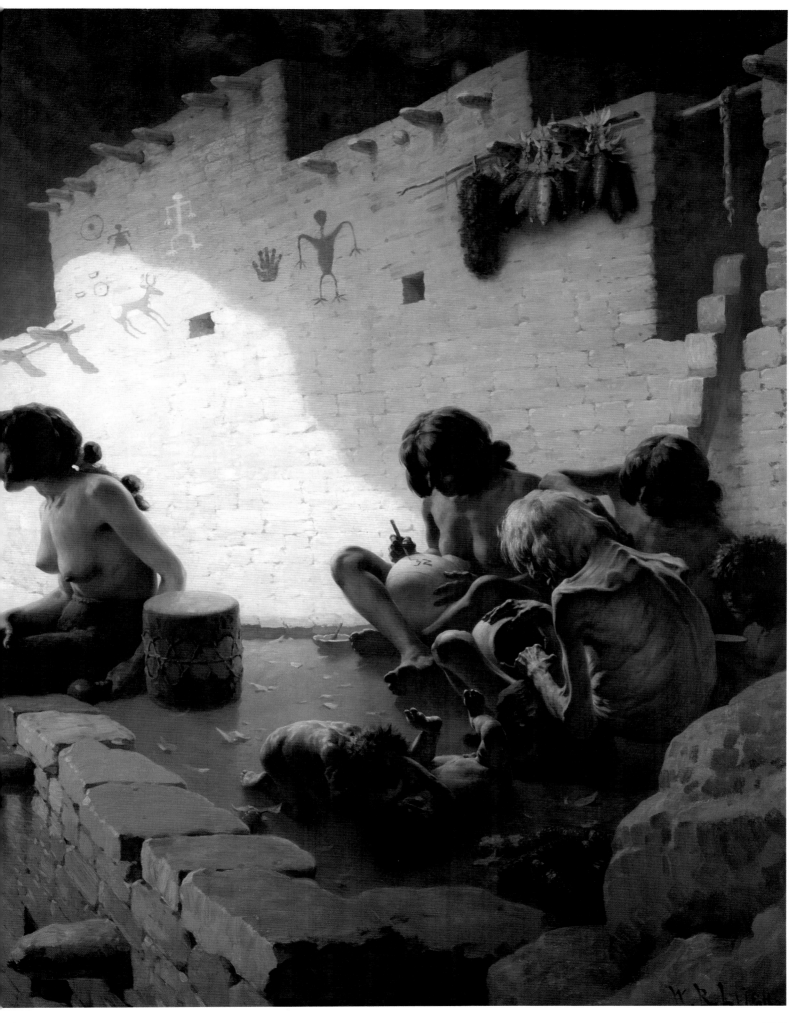

The Elk Hunter (c 1912)

The Anschutz Collection

Bert Phillips (1868-1956)

Phillips, born in Hudson, New York, left to study at the Art Students League in New York City and later at the National Academy of Design. At the age of 26 he went to France, where he studied at the Académie Julien and where, like Couse, he met Ernest Blumenschein and Joseph Sharp. It was Sharp who urged him to consider Taos, New Mexico, as a subject for his palette.

The fall of 1898 found Phillips and Blumenschein, with a team of horses and a wagon, heading from Denver, Colorado, to Mexico. Outside Taos the wagon broke down. While waiting for a blacksmith to repair the wheel, the two men found Taos and the area around it so delightful that they abandoned their trip and rented a studio forthwith.

Phillips spent the remainder of his life painting the people of the Southwest, both Indians and Spanish Americans. Phillips, no less than Sharp, was a moving force in creating the famous Taos Society of Artists.

The Elk Hunter is characteristic of Phillips's realistic-romantic approach to the 'gentle Indian.' Here a Taos hunter, garbed in a serape and wearing snow shoes, stalks an elk. Phillips's subjects are in general sober idealizations of the people of whom he was so fond.

(page 128)

Wyoming Elk in Timber (no date)

The Buffalo Bill Historical Center, Cody, Wyoming

Carl Rungius (1869-1959)

Born in Germany, Rungius attended the Berlin School of Art, the Academy of Fine Arts and later the School of Applied Arts. As his father was a minister concerned with conservation, and his grandfather was a taxidermist who enjoyed painting animals, Carl came by his interest in wildlife-painting naturally. He was 24 when he set up a studio in New York. A hunting trip in Wyoming in 1895 marked the beginning of his lifelong fascination with the West, to which he travelled repeatedly thereafter. At first he sold his works to magazines of the day, but after 1904 he painted for exhibition. His favorite subjects were big game – moose, elk, bear – and his works were considered among the very best. The National Academy of Design elected him an Associate Member in 1913. In 1920 he was made a full member.

Wyoming Elk shows the dominating figure in the foreground painted with the thick, bold strokes characteristic of Rungius's brushwork. Typically, Rungius highlights this figure less by lighting, or even by composition, than by setting it in a more loosely painted landscape.

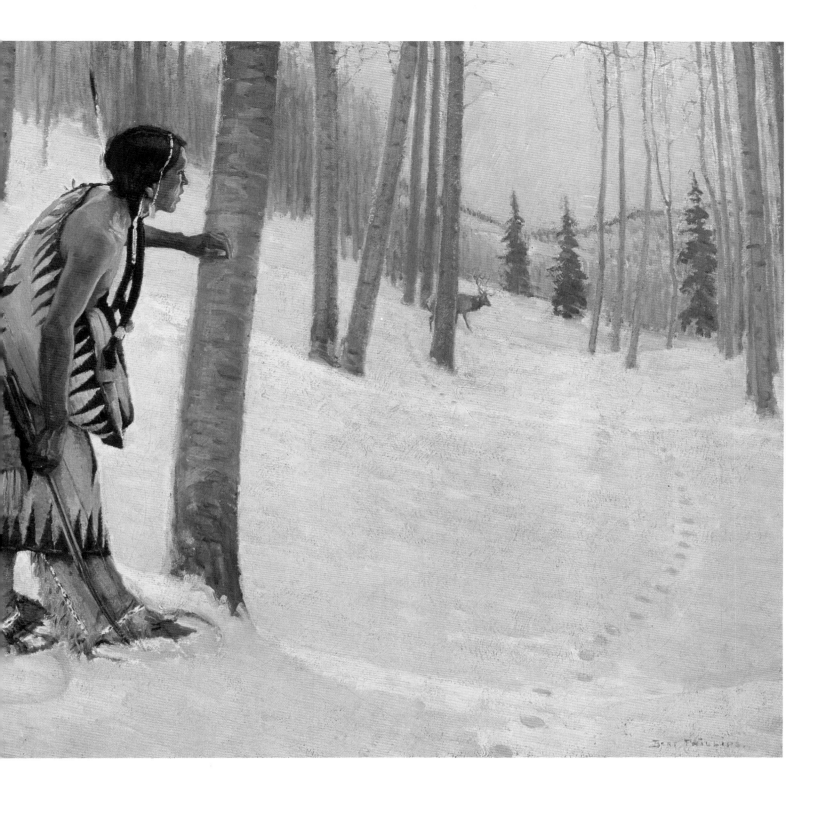

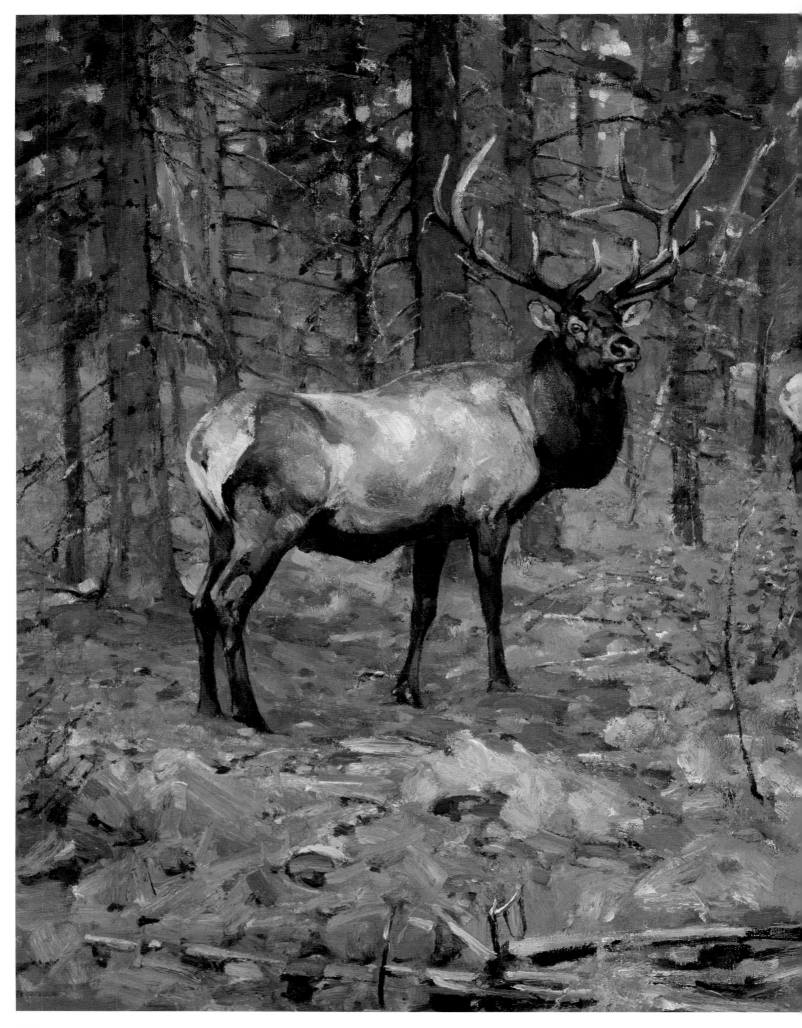

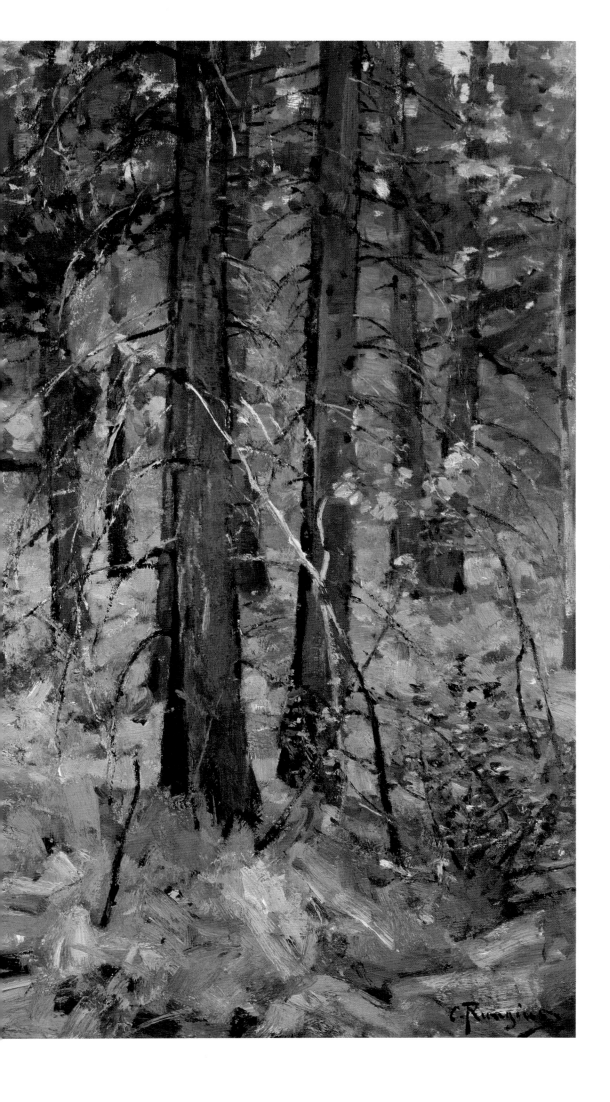

Sangre de Cristo Mountains (1925)

The Anschutz Collection

Ernest Blumenschein (1874-1960)

Born in Pittsburgh, Pennsylvania, of a musical family, Blumenschein was an accomplished violinist even before he took to the formal study of art. In New York he attended the Art Students League and later, in Paris, the Académie Julien. There he met Joseph Sharp and Bert Phillips, and it was Sharp who urged him to consider the Southwest as a source of fresh and exciting subject-matter for his painting. Blumenschein, together with Phillips, took Sharp's advice and went west.

Blumenschein was enchanted by the Southwest. He spent his summers in Taos and his winters in his New York studio, painting and teaching at the Art Students League. In 1919 Blumenschein decided to move permanently to Taos and devote himself to full-time painting. There he became an important force in the Taos Society of Artists.

As his *Sangre de Cristo Mountains* illustrates, Blumenschein liked to convey a sense of mass and volume in his paintings. He achieved this by use of rather broad, heavily-pigmented brushwork, by both simplifying the geometries of his shapes and modeling them very strongly and by de-emphasizing any secondary elements (sky, for example, or fine vertical details) that might detract from the feeling of solidity and weightiness he sought. In *Sangre* the almost organic forms of his mountains and village houses are reminiscent of elements that also appear in the work of Ufer, Wyeth, O'Keeffe and other Southwestern artists.

(page 132)

Peace and Plenty (1925)

The Saint Louis Art Museum, St Louis, Missouri

Oscar Berninghaus (1874-1952)

Berninghaus first found work in St Louis with a lithographer during the day, while studying art at the St Louis School of Fine Arts by night. He first saw the Southwest at the age of 25 when he was given a free trip to Colorado and New Mexico by the Denver and Rio Grand Railroad. While visiting in Taos he met Bert Phillips, who invited him to return. Year after year Berninghaus did just that, spending his summers in Taos and his winters in St Louis. In 1925 he left St Louis to devote full time to painting in Taos. As early as 1912 he was among the founders of the Taos Society of Artists. In 1926 the National Academy of Design elected him an Associate Member.

The loose brushwork that gives *Peace and Plenty* its lively surface texture — and to some extent obscures the professionalism of the underlying drafts-manship — is typical of Berninghaus's personal style. But in theme the painting is very much a product of the Taos school, at once colorful and faintly exotic and at the same time gentle, meditative and inescapably romantic. For all but the best of the Taos artists, the beguiling twin attractions of prettiness and sentiment stood firmly in the way of truly first class work.

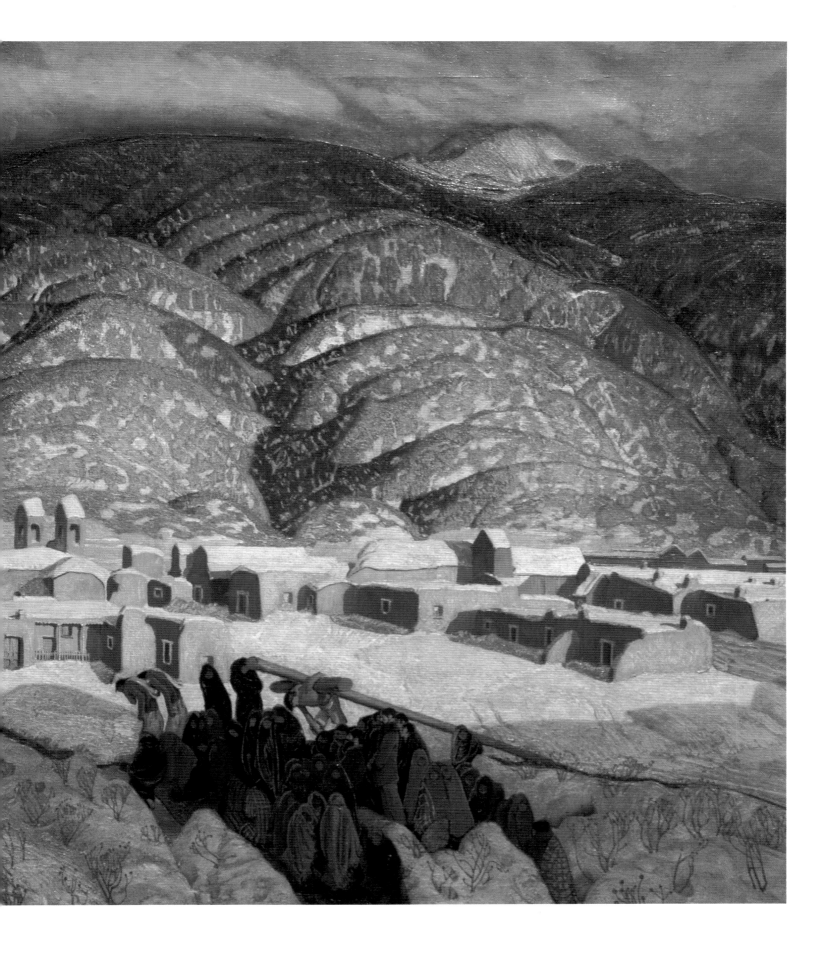

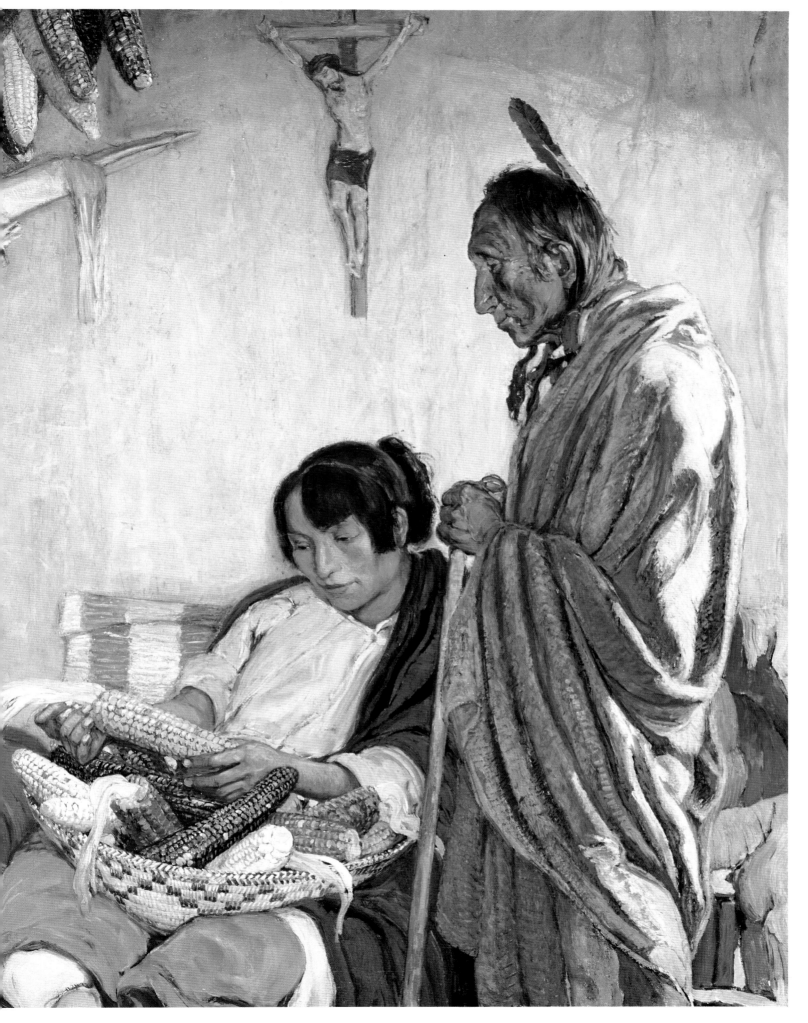

The Pony Express (1924)

The Thomas Gilcrease Institute of American History and Art, Tulsa, Oklahoma

Frank Tenney Johnson (1874-1939)

Born on a farm at Big Grove, Iowa, not far from the Oregon Trail, Johnson grew up in a frontier environment when prairie schooners were still moving west. The lure of the West made a lasting impression on him and became the subject-matter of a prolific and successful career. In 1884 his family moved to Milwaukee, where Johnson studied art, first under the horse painter F W Hein and later under Richard Lorenze. Johnson then studied at the Art Students League in New York, where he came in contact with such men as John Twachtman, Robert Henri and William Chase. In 1904 he was sent to the Southwest and Colorado as an illustrator for *Field and Stream*, a pattern of work he continued for many years. He finally moved to California, where his paintings became so popular that he could more or less forego his illustrating.

Johnson's *Pony Express* typifies his skill at painting nocturnal scenes, for which he achieved considerable renown. In fact, his painting of sky in all lights was remarkable, and he was always able to achieve a luminescence that gave his foregrounds a special snap and excitement. His use of quick, bold brushstrokes added an impressionistic aura to his works without diminishing the sense of reality. In technical terms, he is perhaps closer in spirit to the later Remington style than any other Western painter.

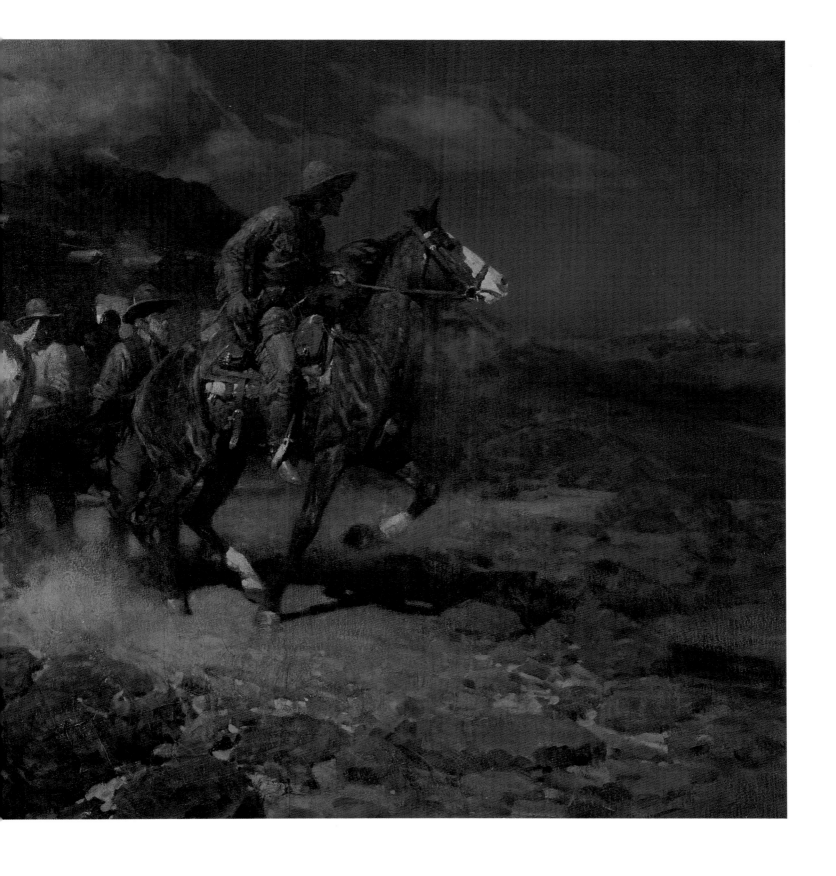

Where the Desert Meets the Mountain (before 1922)

The Anschutz Collection

Walter Ufer (1876-1937)

Born in Louisville, Kentucky, Ufer first worked as an apprentice to a German lithographer who shortly thereafter returned to Hamburg. Ufer followed and continued his apprenticeship. Upon completion, he studied at the Royal Applied Art School and later at the Royal Academy of Fine Arts in Dresden. After an extensive European tour of painting, he returned to the United States and settled in Chicago. The mayor of Chicago, a collector of the arts, was impressed by Ufer's work and urged him to visit Taos, even going so far as to pay his way.

Ufer was 38 when he arrived in New Mexico. So impressed by his work was the Taos Society of Artists that he was immediately asked to join. In 1920 he won a prize in the Carnegie International Exhibit, and this recognition launched him on a highly successful career.

Where the Desert Meets the Mountain is characteristic of Ufer's Landscapes. He boasted that he painted only in the open air because studio paintings lost their vitality. The bright tonal contrasts of this painting attest to his success. The sage-covered foreground cut by an arroyo, the cloud-darkened hills, the rain clouds with the distant sunlit sky, are a study in chiaroscuro. The covered wagon and the rain squalls, or virgas, add accents to this strong triangular composition.

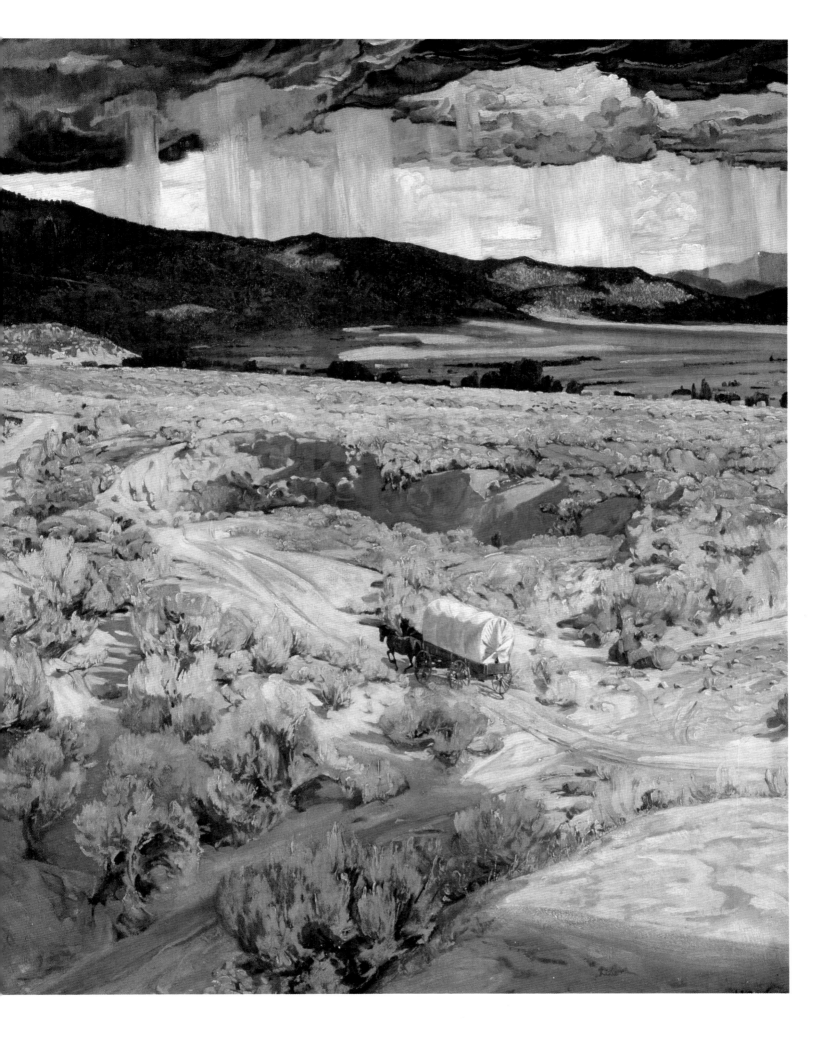

Medicine Robe (1915)

The Buffalo Bill Historical Center, Cody, Wyoming

Maynard Dixon (1875-1946)

Dixon, from Fresno, California, began drawing at the age of seven. Having sent two of his sketchbooks to Frederic Remington, he was encouraged to continue his art work by Remington's favorable comments. Except for a brief attendance at the San Francisco School of Design, Dixon was essentially self-taught. He travelled extensively throughout the West, sometimes working as a cowboy to support himself. At the age of 20 he held his first exhibition and launched his career as an illustrator, an occupation at which he was to become eminently successful. His works appeared in most of the popular magazines of the day – *Harper's, Collier's, Cosmopolitan*, among others. Dixon was 37 when he decided to abandon illustration and turn to painting in the West. In this he was aided by various commissions, both for paintings and for murals.

Dixon's *Medicine Robe* is typical of his simple, bold, rather imposing approach to composition. His commanding figure is executed with strong line, while his sage-covered foreground is handled in an impressionistic manner in which color and texture alone convey the idea of form.

(page 140)

The Custer Fight (no date)

The Buffalo Bill Historical Center, Cody, Wyoming

W Herbert Dunton (1878-1936)

Herbert Dunton grew up on a farm near Augusta, Maine. To encourage his proclivity for drawing, his family relieved him of farm work. He made his first trip to the West when he was 18 and followed this with many visits, during which he worked as a ranch hand and cowboy. Between trips Dunton studied under Ernest Blumenschein at the New York Art Students League, and it was there that Blumenschein persuaded Dunton that Taos was the place to paint. He was 34 when he moved to Taos and already a recognized illustrator. He joined the Taos Society of Artists and thereafter devoted himself mainly to painting technically excellent narrative scenes of the Old Southwest.

Most of his paintings are action-filled glimpses of cowboy life, but he also sometimes turned to broader historical subjects, as his *The Custer Fight* attests. In this spirited conception of the fateful battle, Indian horsemen are circling the remnants of Custer's troops. According to Indian participants, the warriors crept up under the protection of the hill, rather than surrounding the soldiers on horseback. Dunton was probably not aware of this, but there is no guarantee that he would have altered his painting, even if he had been. And perhaps rightly so, for by this time Custer's battle had become so mythologized as to make the facts almost irrelevant.

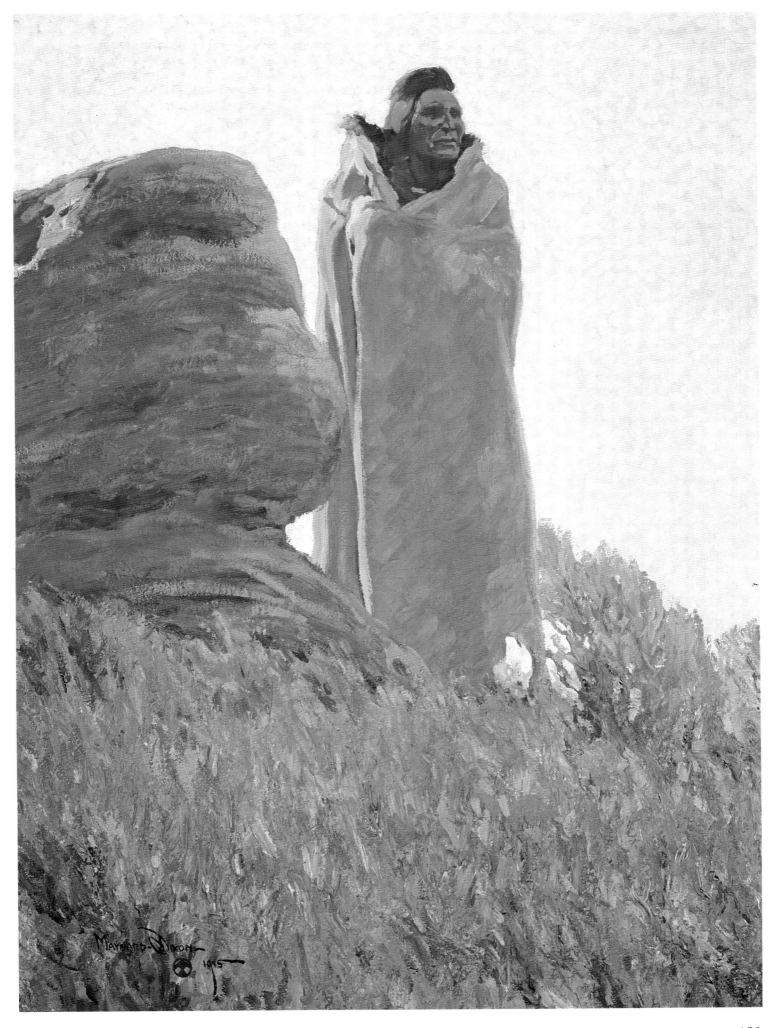

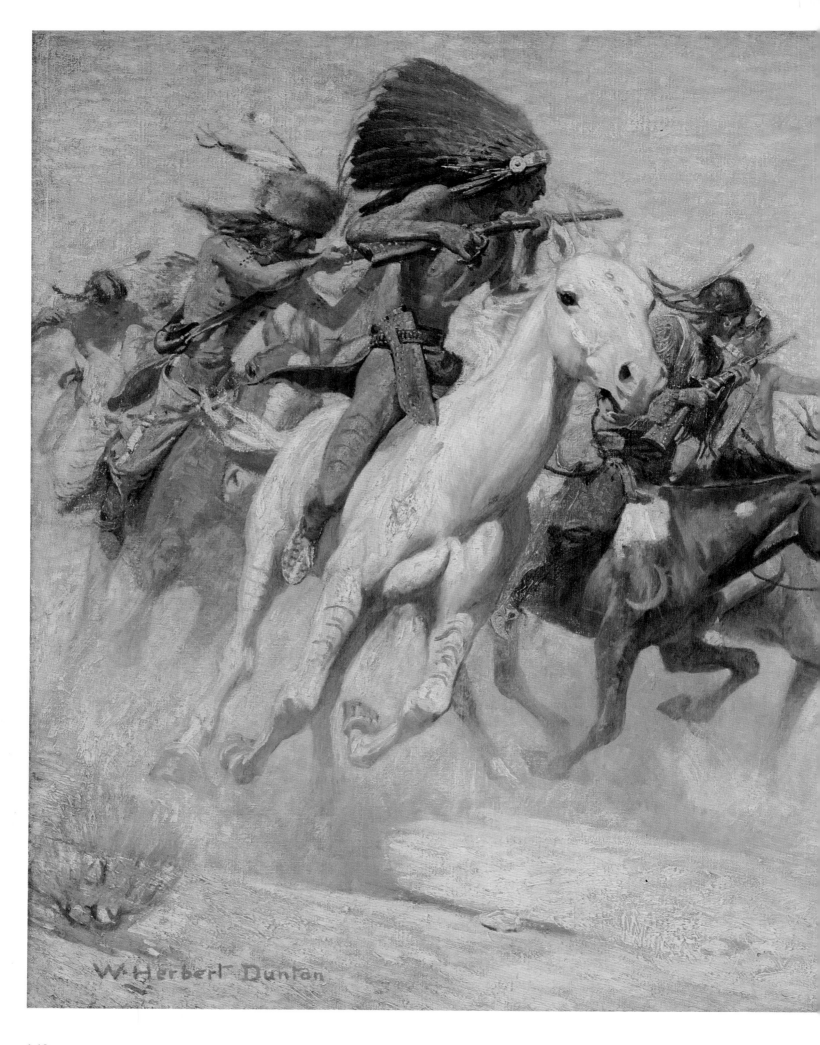

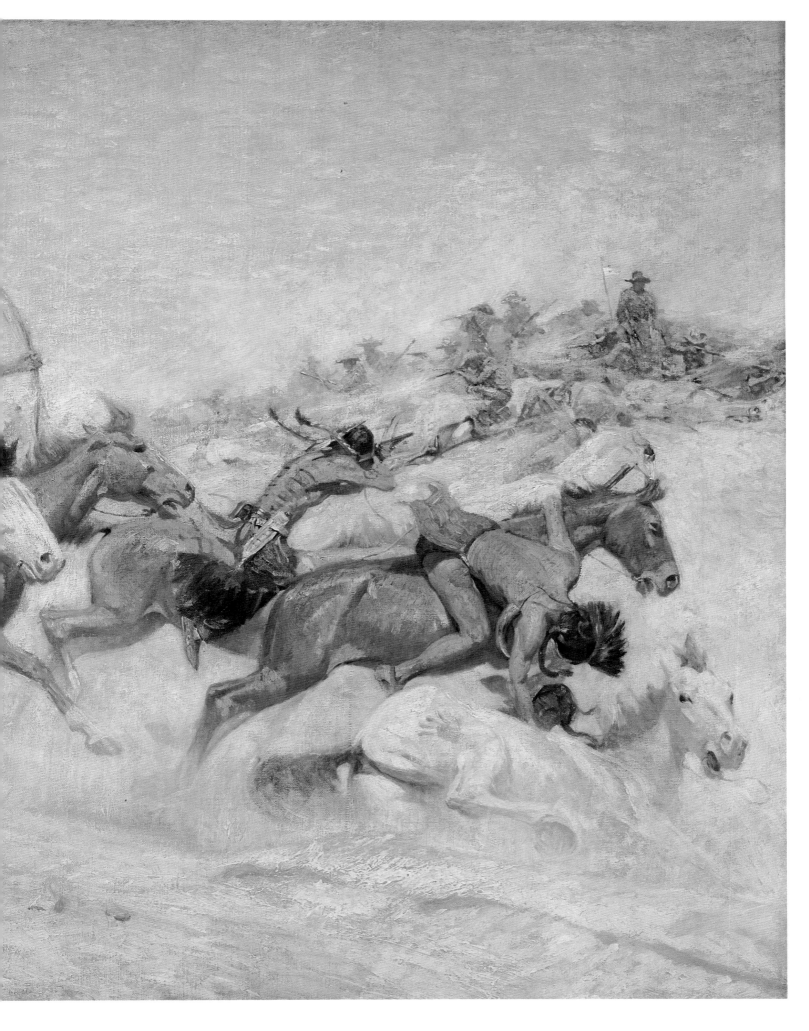

Buffalo Dancer (no date)

The Anschutz Collection

Gerald Cassidy (1879-1934)

Gerald Cassidy was born in Cincinnati, Ohio, where he attended the Institute of Mechanical Arts. In 1899 he was in New York with a lithographic firm, but due to a severe case of pneumonia he sought a cure in Albuquerque, New Mexico. Here he became acquainted with the Indians, with whom he worked and whose friendship he gained. Upon regaining his health he moved to Denver, where he earned a living doing stage sets. He left Denver for New York and took up studies at the Art Students League and the National Academy of Design. In 1912 he returned to the Southwest, making his home in Santa Fe, where he specialized in murals. He died while completing a mural of Canyon de Chelly for the Santa Fe Post Office.

Though Cassidy's themes are often similar to those favored by the Taos school, his work is usually less sentimental and – perhaps because of his muralist's training – simpler and stronger. His *Buffalo Dancer*, done with broad strokes in bold color, conveys the power and rhythm of the key figure dancing to the singing of the drummers. The ceremony, performed to insure a successful buffalo hunt, is held here in front of a great kiva, the sacred ceremonial chamber of the Pueblos. Cassidy has handsomely captured the pageantry of the dance.

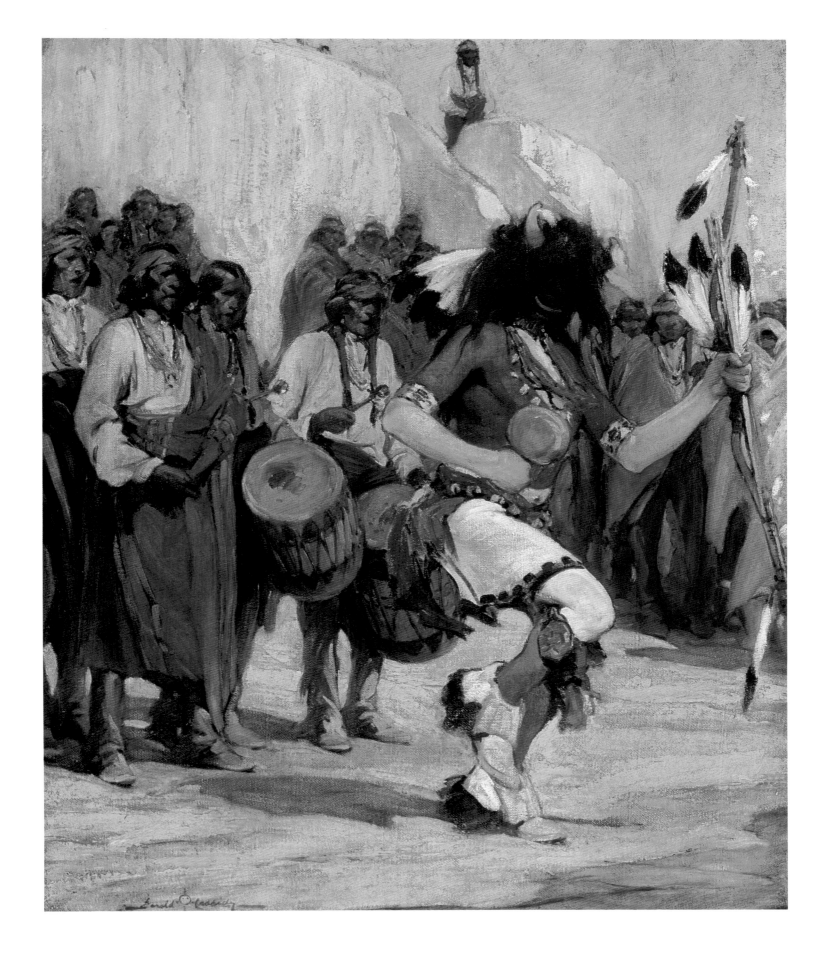

143

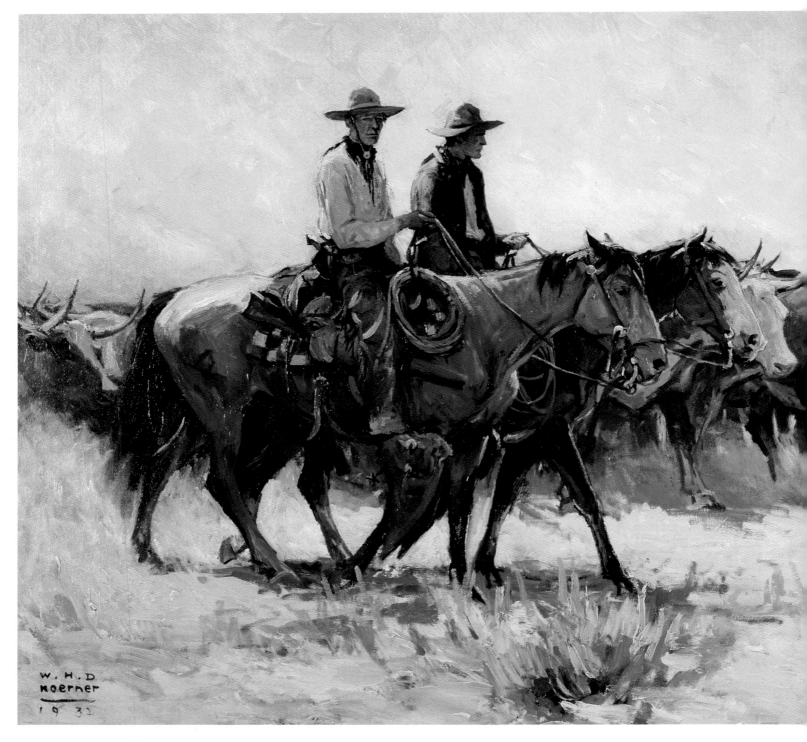

Moving the Herd (1923)

The Buffalo Bill Historical Center, Cody, Wyoming

W H D Koerner (1879-1938)

Koerner was born in Germany and grew up in Iowa. At 17 he got a job as an illustrator for the *Chicago Tribune* and took lessons at the Chicago Art Institute. In 1905 he studied at the Art Students League in New York, and two years later he went to Willmington, Delaware, to work under Howard Pyle, with whom he spent four years. Not until 1924 did Koerner first go west. He spent his time on Montana ranches, some of it near the Crow Indian Reservation. Later he travelled to California and the Southwest. All the while he was pursuing his commercial art, particularly as an illustrator for *The Saturday Evening Post.*

Moving the Herd authentically recreates a trail drive from Texas to the railheads in Kansas. Here Koerner shows the lead steer, an older animal that has made the trip before, as well as the 'point' riders, who guide the herd, and distant 'swing' riders, who keep the herd in line. Far to the rear and out of sight would be the 'drags', riders who push the cattle forward. These were usually younger, less experienced cowboys, assigned to eat dust all day long.

Indian Woman with Children (1926)

The Anschutz Collection

Nicolai Fechin (1881-1955)

Born in Russia in the town of Kazan, Fechin was a sickly child suffering from meningitis. His family encouraged his proclivity in art, and upon graduating from public school he entered the Art School of Kazan, a branch of the Imperial Academy of Art in St Petersburg. At the age of 16 he enrolled in the Academy itself. In 1919 he was awarded the degree of Artist and took up his post as State Teacher at the Kazan School of Art.

In 1923 he moved to New York City. Soon thereafter he received the Thomas Proctor prize from the National Academy of Design for his portrait *The Wood Engraver, Mr W G Watt.* As a portrait painter, he won wide acclaim. Suffering from tuberculosis, he moved to New Mexico for his health. There he built a house near the Taos pueblo and continued painting portraits, especially of Indians. He left Taos in 1934 and returned to New York, where he spent the remainder of his life.

Fechin's work hovers somewhere between impressionism and expressionism. *Indian Woman* illustrates how he habitually overlaid careful drawing with slashing, almost reckless brushstrokes and how he could extract a kind of eerie luminosity from his rather dark palette. It also has about it a hint of morbidity that is quite typical of Fechin's work and not at all characteristic of Western art as a whole.

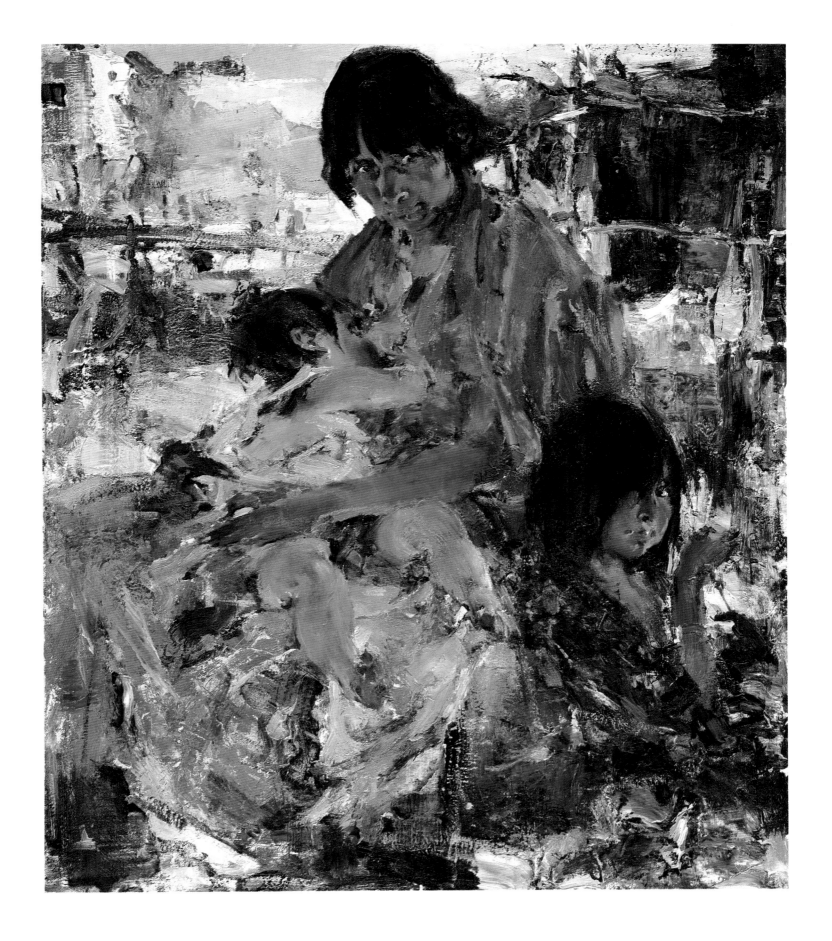

Pueblo Pottery (1917)

Museum of New Mexico, Santa Fe, New Mexico

Henry C Balink (1882-1963)

Balink was born in Amsterdam, Holland, and studied at the Royal Academy. He married at the age of 22 and went to New York City, where he was employed by the Metropolitan Museum. His first visit to Taos was in 1917, as a result of his seeing a travel poster. Thirteen years later he was to move to Santa Fe. There he became fascinated by the Indians, whom he painted with sympathetic understanding in a bright-hued, somehow rather 'Netherlandish' realist style.

Pueblo Pottery, while a sensitive portrait of a young woman of Taos, also shows Balink's Dutch adroitness at still-life painting. There is no question that the woman holds a San Ildefonso blackware pot. In the foreground is a characteristically Santo Domingo bowl, behind which stands a blackware olla. In the background hangs a Navaho Chief's blanket of the third phase, dating from about 1870. The porosity of large ollas, used as water jars, allowed moisture to reach the outside surface. In the arid Southwest climate, the quick evaporation cooled the water inside the jar. The highly polished effect was obtained by burnishing with a smooth stone.

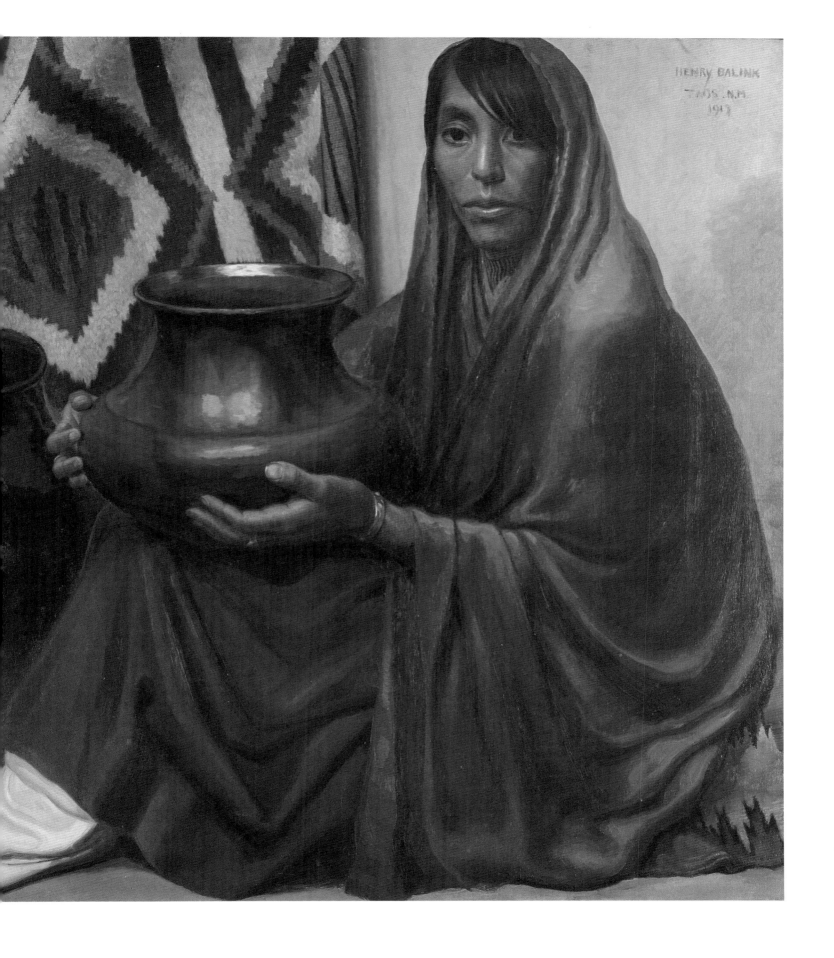

HENRY BALINK
TAOS. N.M.
1917

149

Cutting Out (1904)

The Buffalo Bill Historical Center, Cody, Wyoming

N C Wyeth (1882-1935)

Born in Needham, Massachusetts, Newell Convers Wyeth studied art both in high school and at the Eric Pape School of Art in Boston. At the age of 20 he moved to Wilmingon, Delaware, to study under Howard Pyle. The following year he sold his first painting – *Bronco Buster* – as a cover for *The Saturday Evening Post*. Wyeth made several trips to the West, where he participated in a variety of activities, including cowboying and even driving a stage. It was these trips that served as a basis for his many Western subjects, and by the time he was in his mid-20s his illustrations were in great demand. In 1906 he settled in Chadd's Ford, Pennsylvania, where he lived for the rest of his life.

Wyeth was, of course, one of America's greatest illustrators. His paintings for *Treasure Island, Robinson Crusoe, Drums, The Yearling* and many other children's and adult classics, as well as his magazine illustrations, murals and easel paintings, are all justly beloved. Yet many of his admirers still insist that he did his best work on Western subjects, and, indeed, his well-modeled, muscular style was ideally suited to Wild West themes.

Wyeth's *Cutting Out* shows one of his characteristic devices, a heroic, powerful central figure who serves as a focus for the violent action – here cowboys and horses in dangerous turmoil – swirling about him.

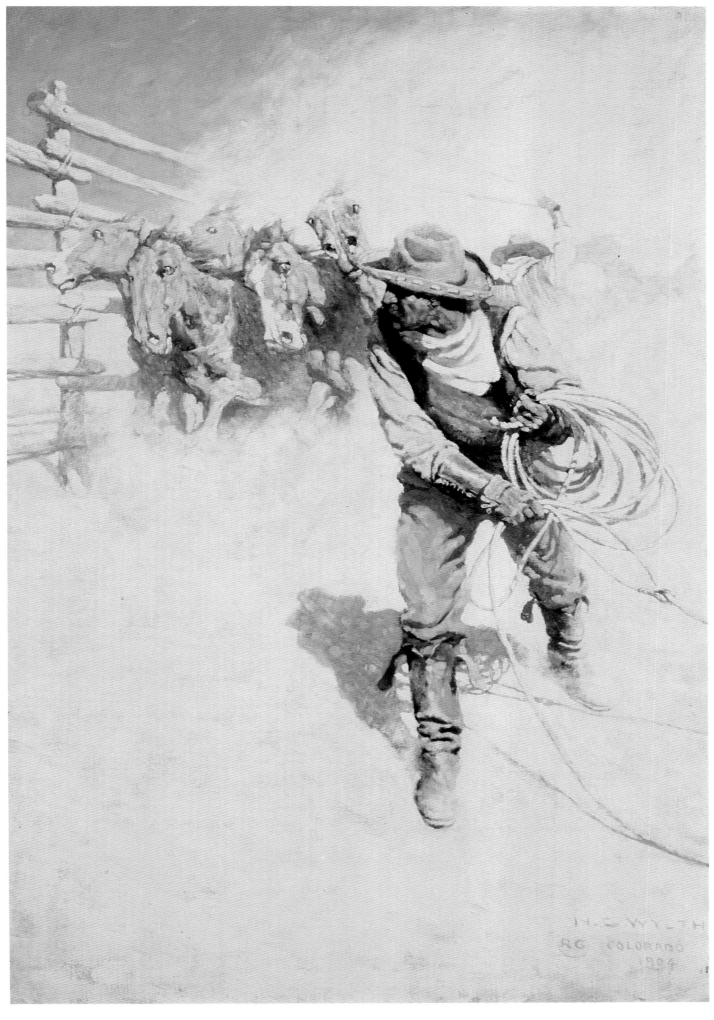

151

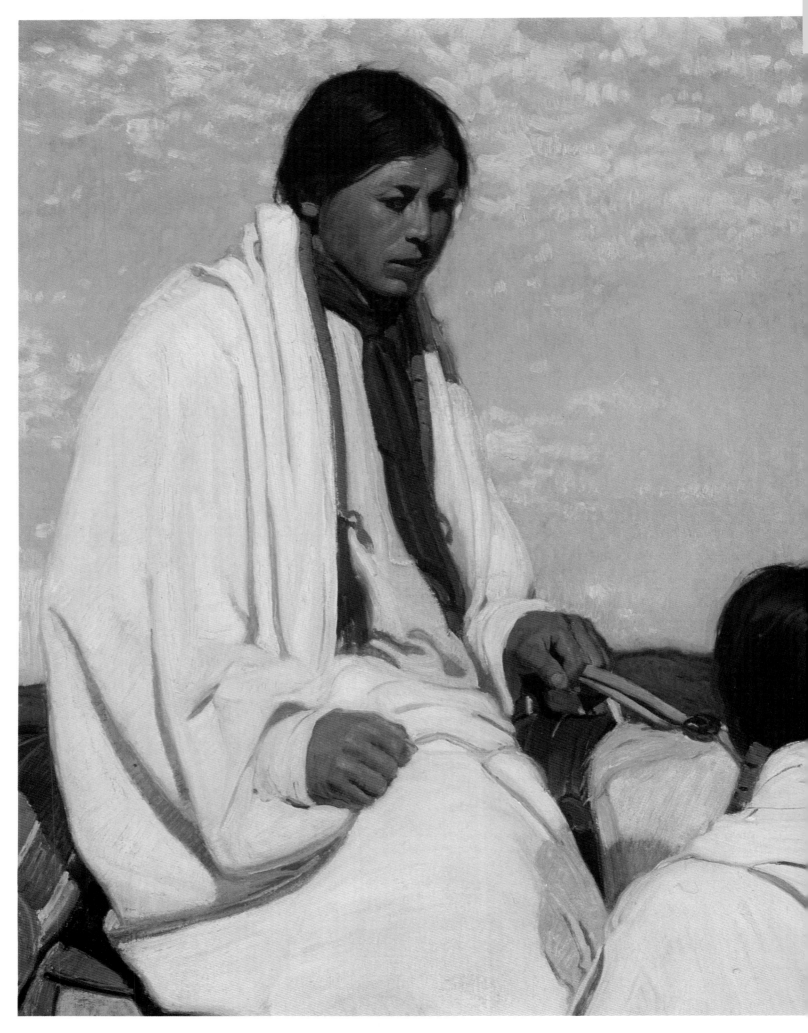

The Encounter (*c* 1920)

The Anschutz Collection

Ernest Martin Hennings (1886-1956)

From his home in Pennsgrove, New Jersey, Hennings went to Chicago to study at the Art Institute. The year 1914 found him in Germany, first at the Munich Academy and later at the Royal Academy. At the outbreak of World War I, he returned to Chicago, supporting himself by painting murals. Urged by a patron to visit Taos, he was so enamoured of the region and its people that two years later, in 1921, he made it his home. In 1924, by invitation, he became a member of the Taos Society of Artists.

The Encounter is typical of Hennings's style of placing figures in the immediate foreground, forgoing emphasis on perspective in order to achieve a sense of immediacy. Hennings's portraits of Indians express the quality of gentle peacefulness that he found in the people of Taos, and he conveys it with the romantic idealism so common among the artists of the Taos school.

Hennings also painted landscapes and Taos street scenes. Although the latter are often well populated with people doing various things, the effect is always subdued and tranquil.

Angry Bull (no date)

Courtesy of Burlington, Inc

Winold Reiss (1888-1953)

Born in Karlsruhe, Germany, Reiss studied art at the Royal Academy and later at the School for Applied Arts in Munich. It was James Fenimore Cooper's *Leather Stocking Tales* that whetted Reiss's interest in Indians, and at the age of 25 he headed for the American West. Short of funds, he got only as far as New York. There he painted for a living and, with his brother Hans, established himself as an interior architect of considerable note. It was not until 1919, six years after his arrival in New York, that Reiss reached the Blackfeet Indian Reservation near Glacier Park, Montana. From that time on he made many visits to the Blackfeet, making scores of pastel portraits. In 1927 the Great Northern Railroad commissioned him to do portraits for their 'Art Calendar.' Reiss continued to produce portraits for the Calendar for 31 years, until it was finally discontinued in 1958.

Angry Bull is characteristic of Reiss's technique of pastel portraiture, combining hard lines and soft tones to bring strength of character to his subjects. Here the sitter is shown wearing a 'Straight-up Bonnet,' an eagle feather headdress decorated with ermine tails that was favored by the Blackfeet. Angry Bull holds a small gourd rattle in his hand.

Reiss so endeared himself to the Blackfeet that they named him Beaver Child in honor of his industry. After his death, his ashes were scattered over the Reservation.

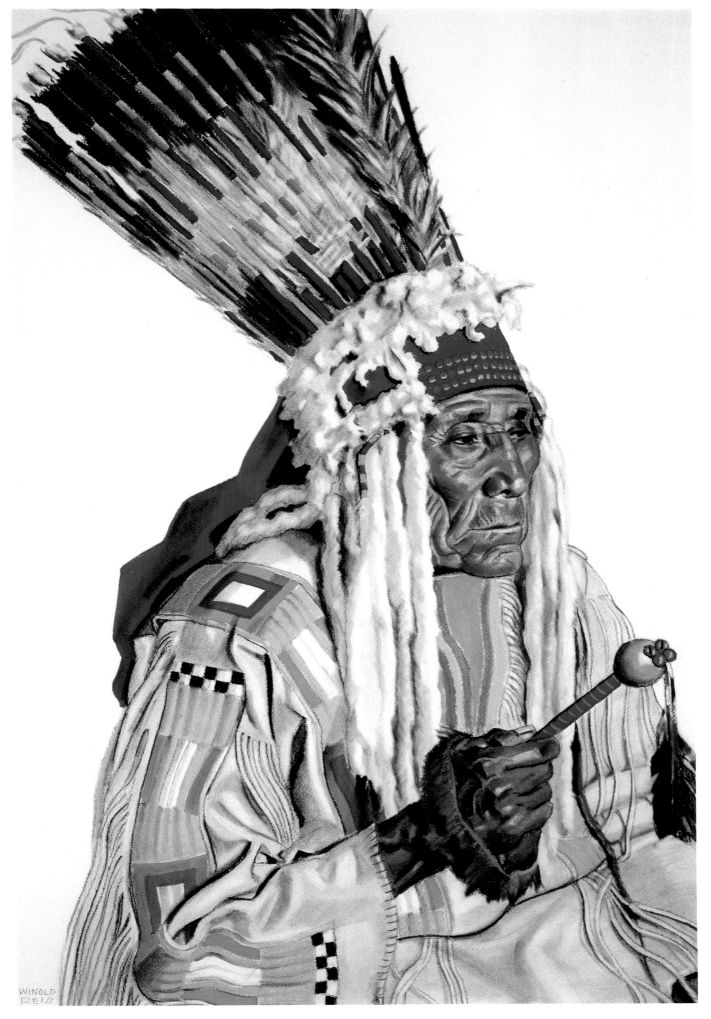

Black Cross, New Mexico (1929)
The Art Institute of Chicago, Chicago, Illinois

Red Hills, Grey Sky (1935)
The Anschutz Collection

Georgia O'Keeffe (1887-1986)

Born in Wisconsin, O'Keeffe first attended the Art Institute of Chicago at the age of 17. Two years later she was studying at the New York Art Students League. Discouraged, she gave up art, and not until 1912 did she take a position in the Art Department of the Amarillo, Texas, school system. Later she taught at the University of Virginia. In the meantime she was struggling to develop an art form which was expressive of her subjective, abstract viewpoint of nature. Alfred Stieglitz, unbeknown to O'Keeffe, showed her work in his Gallery 29. Her paintings were well received, and she began to enjoy a modicum of success.

In 1924 she married Stieglitz, who continued his support of her work until his death in 1946. O'Keeffe divided her time between summers in New Mexico and winters in New York. After her husband's death, she moved permanently to Abiquiu, New Mexico.

O'Keeffe was surely one of the most highly personal and strangely effective painters in the history of Western art. Like some medieval philosopher, she seemed to view the phenomenal world as a screen behind which another reality lay hidden. To pierce the veil she employed a battery of techniques – abstraction, hard-edged realism, symbolism, neo-cubism, surrealistic juxtapositions – sometimes all at once, but always in her own severe, unmistakable style. Whether she found what she was looking for is hard to say, but the sense of its mysterious immanence in her painting is always haunting and sometimes overwhelming.

Black Cross, New Mexico is an imposing work that combines a blackened cross, perhaps symbolic of the somber influence of the Catholic church, against a stylized Southwestern landscape composed of undulating hills reminiscent of body forms. That this is meant to be more than just an exercise in powerful composition or some sort of comment on religion is obvious, but as in all O'Keeffe's work – as in, for example, the beautiful but strangely disturbing *Red Hills, Grey Sky* – its true meaning defies verbal expression.

In addition to her conception of the organic quality of the curvilineal hills of the Southwest, O'Keeffe had a penchant for enormous flowers done with grace and a marvelous sense of texture. Probably most like a trademark were her paintings of animal skulls, always done without morbidity, but rather with a cool symmetrical grace expressive of their affinity with the eternal.

156

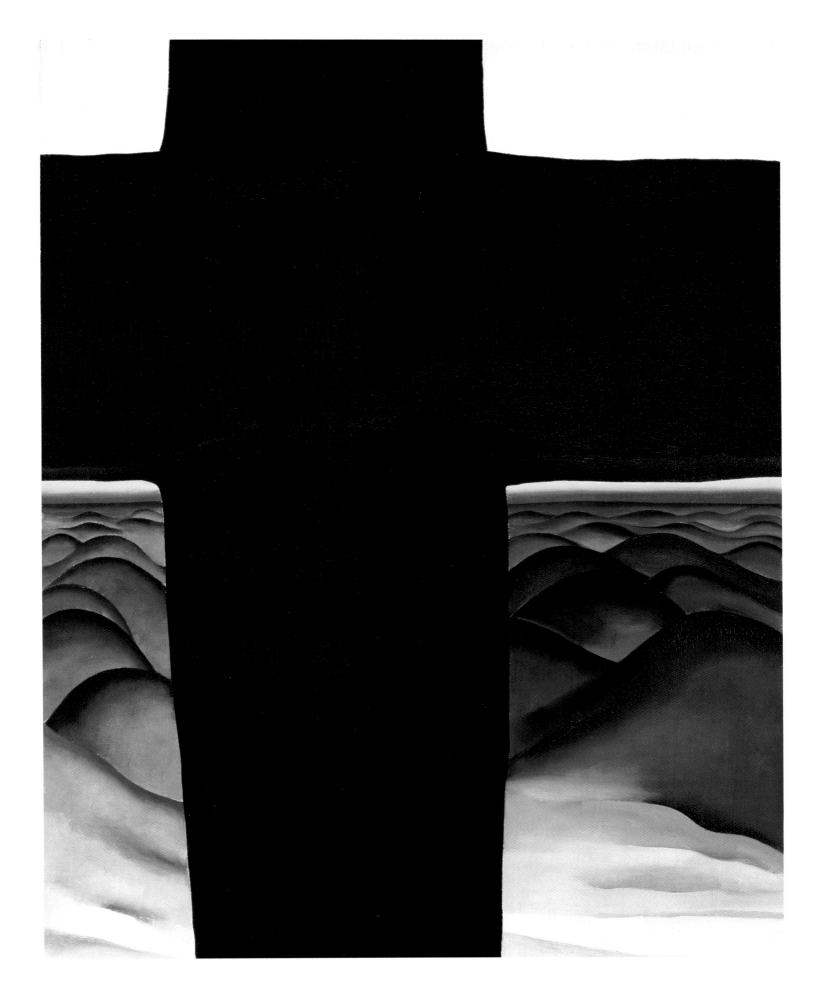

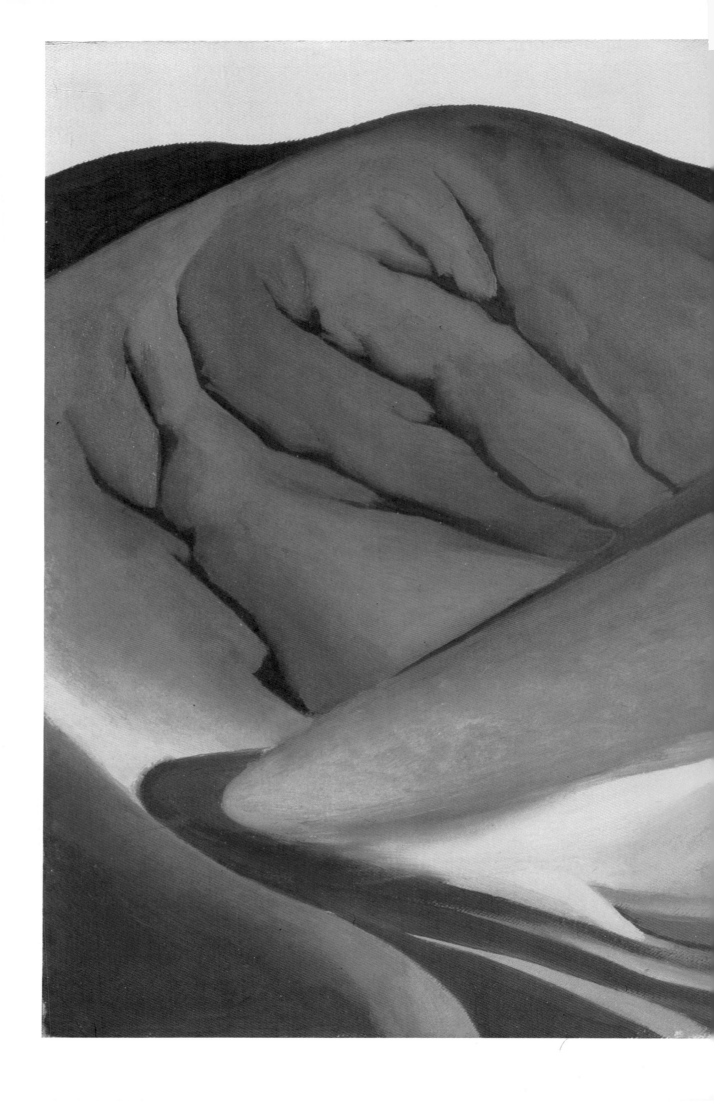

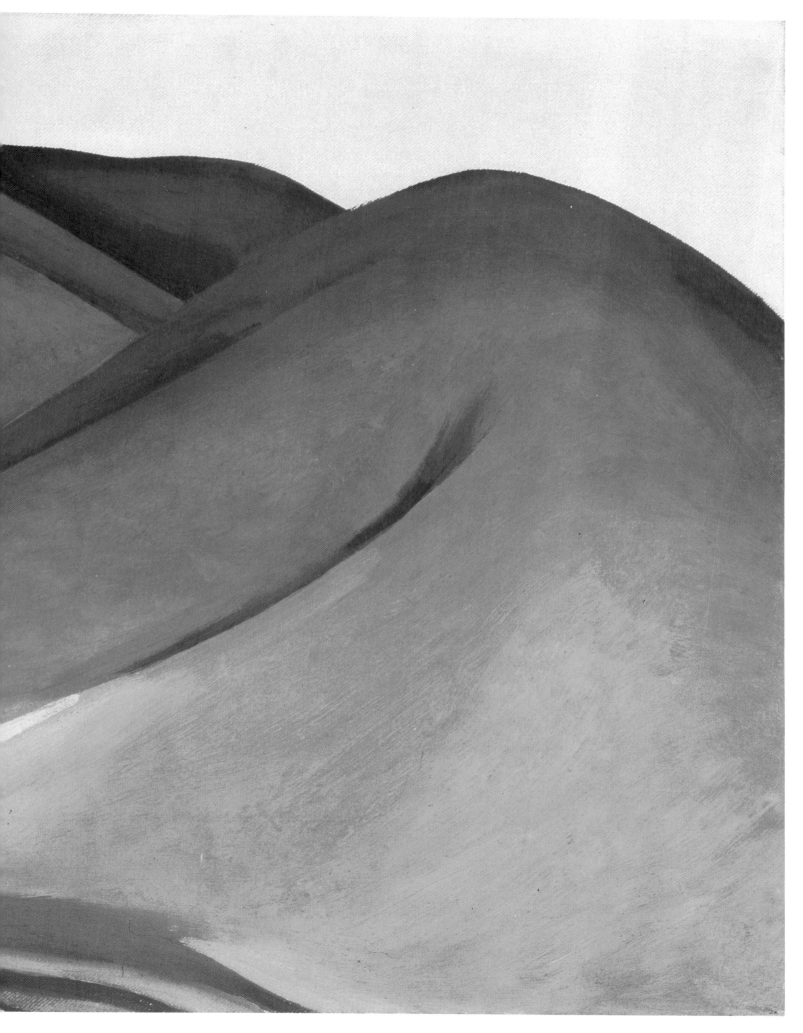

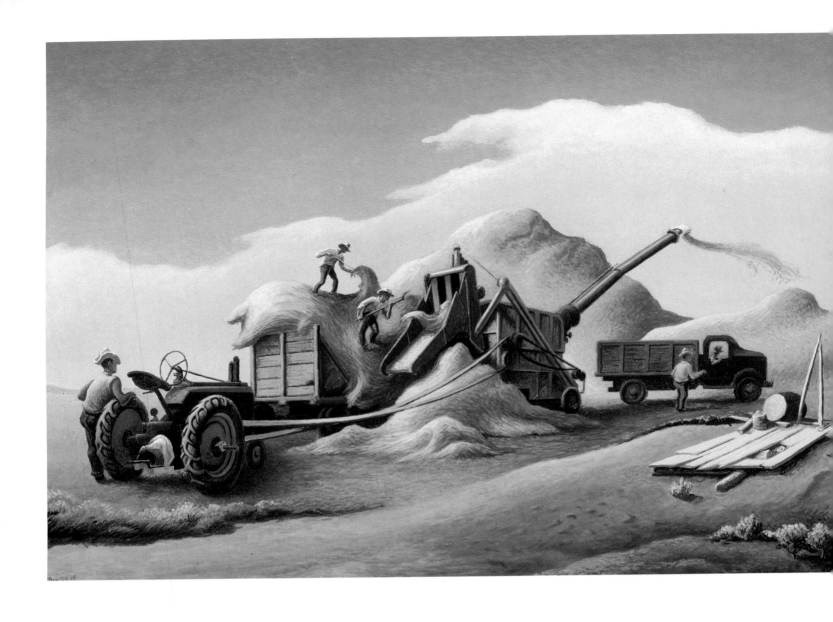

Threshing on the High Plains (1969)

The Anschutz Collection

Thomas Hart Benton (1889-1975)

Benton was born in Neosho, Missouri. He first tried his hand at professional cartooning, but after three months he gave it up in favor of a year at the Chicago Art Institute and three years in Paris at the Académie Julien. He later complained that he had been subjected to every kind of 'ism' from synchronism to cubism, all a waste of time. Benton was determined to create a wholly American style of art, one devoted to folksy American subjects and expressed in a uniquely American way. He devoted the rest of his life in America to the pursuit of this vision.

Benton was not specifically a Western artist, but rather one who included Western subjects in a larger body of work devoted mostly to depicting rural and backwoods American scenes. He was at heart a fabulist, intent on converting most of his scenes, however commonplace, into a kind of instant folklore, an effect he most often achieved through a subtle distortion of forms crowded into sinuously writhing, rather hermetic compositions. Some critics before World War II hailed him as a genius who had created a wholly new style of American art, but the prevailing opinion today is that he did no more than create an idiosyncratic personal style.

In *Threshing on the High Plains*, a late work, almost all the famous Benton tics are muted or absent. The painting implies no more than it states, the composition is open and uncluttered and caricature is held to a perfectly acceptable minimum. If Benton had painted this gracefully all his life, his reputation might be more secure today.

Indian Scouting Party (1940)

The Anschutz Collection

Harold von Schmidt (1893-1982)

Von Schmidt, from Alameda, California, early showed an interest in art. At the age of 19 he entered the California College of Arts and Crafts. Later he studied under Maynard Dixon, and in 1924, under Harvey Dunn, whose dictum that illustrators should always strive to paint the epic, and not the incident, von Schmidt called the best advice he ever got. Soon he began receiving commissions from national magazines such as *The Saturday Evening Post* and *Cosmopolitan*, and over the years he enjoyed a successful career as an illustrator and painter.

His *Indian Scouting Party* demonstrates both his characteristically muscular style and his attention to accurate detail. The white pony in the foreground is probably the 'war horse' belonging to the man carrying the feather banner. War horses were the fastest runners and were saved for battle and for the buffalo chase. The feathered banner was the emblem of a particular warrior society, and the man entitled to carry it was the leader. In some cases such an honor bore with it the obligation of staking oneself to the banner in battle and remaining so until a comrade removed the stake.

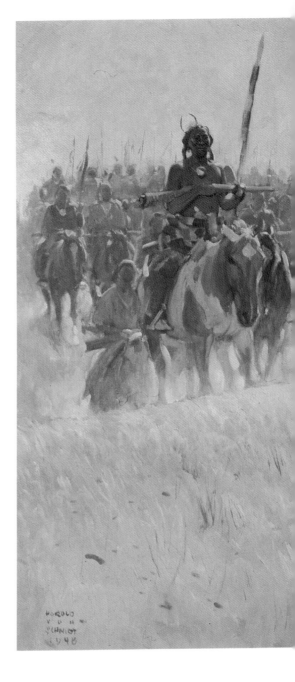

(page 164)

Letter from Home (no date)

The National Cowboy Hall of Fame, Oklahoma City, Oklahoma

Olaf Wieghorst (1899-)

Born in Jutland, Denmark, Wieghorst grew up with horses and a drawing pad. He sold his first painting at the age of 12. Still in his teens, he became a trick rider with a circus. At the age of 19 he embarked for New York, where he enlisted in the 5th Cavalry, then patrolling the Mexican border. After a three-year stint, Wieghorst travelled west, where he got work as a cowboy on the Quarter Circle 2 C Ranch in New Mexico. Three years later he was in New York to marry his girl, Mabel. He then joined the New York City Mounted Police. Upon retirement, he moved to California.

Wieghorst is a genre painter who devotes his skills to portraying the life of the cowboy and Indian. Many of his paintings are action-filled, but others display tranquil moments, and such is *Letter from Home*. Here Wieghorst plays with light and shadow to create a nostalgic scene. Many of the early cowboys were, in fact, far from home, having come from such eastern seaboard states as Pennsylvania, Connecticut and Virginia.

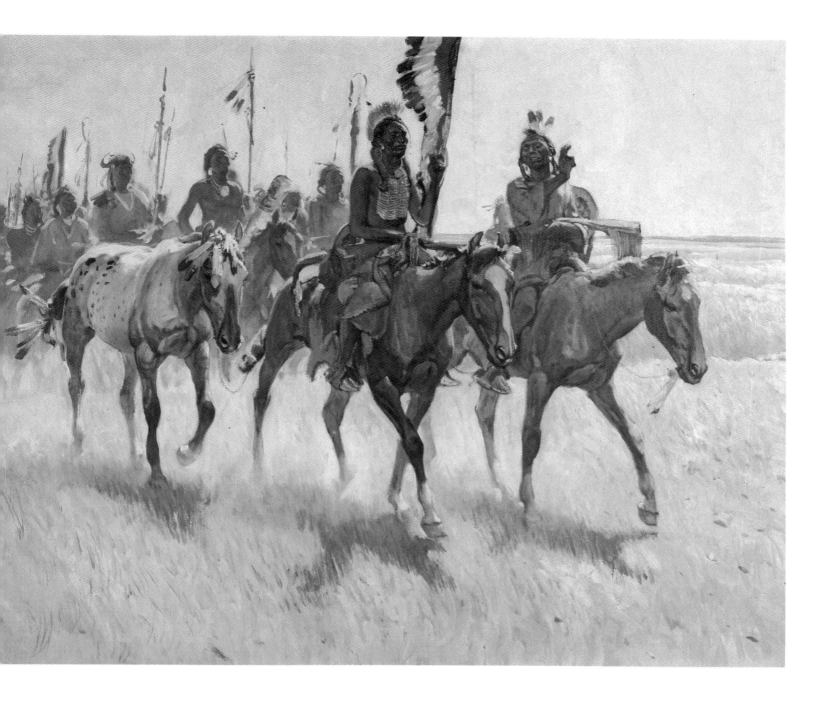

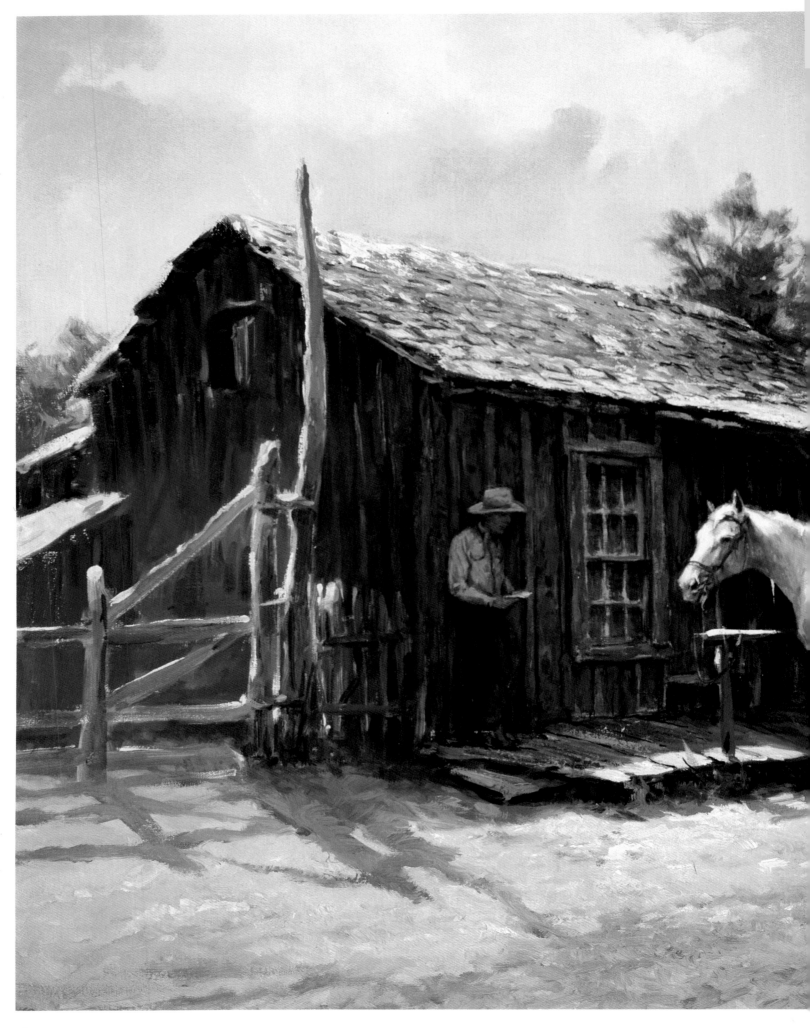

Coe Ranch (no date)

Santa Ana Editions, New Mexico

Peter Hurd (1904-1984)

A native of Roswell, New Mexico, Hurd studied under N C Wyeth (whose daughter he married), as well as at the Pennsylvania Academy of Fine Arts. The recipient of many awards for his illustrations, portraits and murals, Hurd was especially acclaimed for his portrayal of the Southwestern landscape and its people. The shimmering quality he imparts to the New Mexican mountains and plains adds a note of vibrancy to scenes that might otherwise be monotonous. Perhaps because he often worked in tempora, his paintings achieve an atmospheric quality typical of the Southwest's light and color.

Coe Ranch is unusual for Hurd in that he has employed the autumn foliage and a red barn to bring color to what might be a somber landscape. The sheer white ranch house stands amidst a kaleidoscope of fall coloring, the whole being framed by the background of a dark and somewhat ominous piñon-studded mountain. The very fact that this is such an 'untypical' Western scene somehow makes it seem all the more authentic.

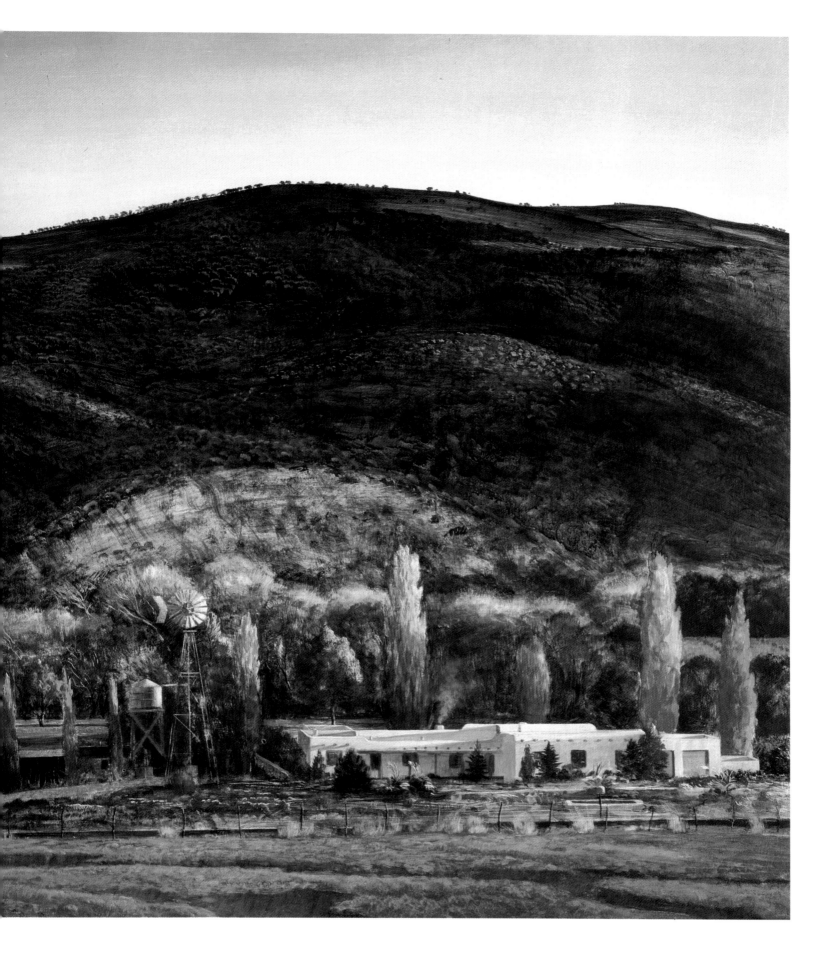

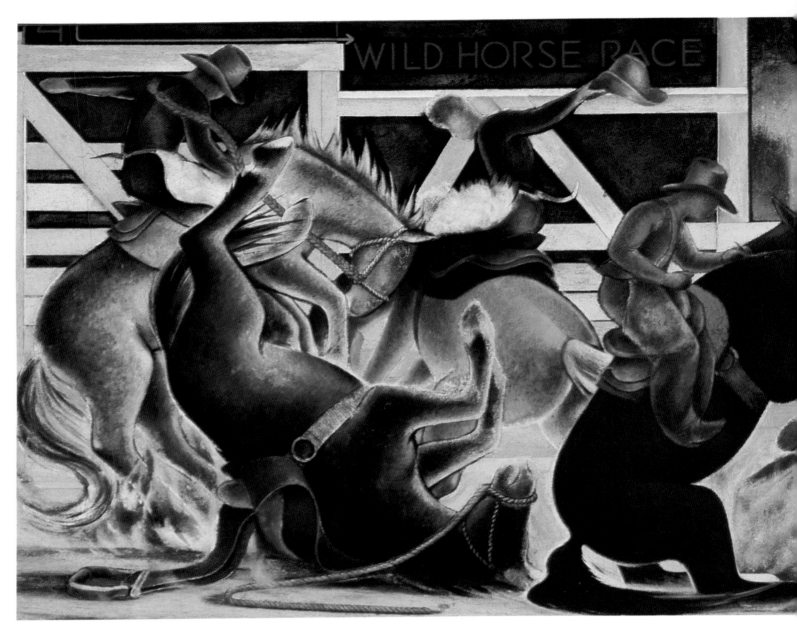

Wild Horse Race (c 1935)

The Anschutz Collection

Frank Mechau (1904-1946)

Mechau, born in Glenwood Springs, Colorado, first supported himself by working on a railroad and by professional boxing. Eventually he earned enough money to spend a year of study at the Chicago Art Institute. Moving to New York, he found he was able to make a living by selling his paintings, and by the age of 25 he had accumulated enough money to visit Paris. There he studied the works of the cubists, but undertook no formal training. He returned to Colorado in 1931. Under the Works Progress Administration Mechau secured commissions to paint murals in several public buildings, including Post Offices in Washington, DC, and Fort Worth, Texas, and in the Denver Public Library.

His mural-sized *Wild Horse Race* is a swirl of action so stylized as to border on abstraction. By drawing his horses in every conceivable position, he has created a saw-toothed composition that is a kaleidoscope of color and movement. The wild horse race is an uncommon rodeo event wherein cowboys must rope, saddle and ride unbroken horses from one point in the arena to another. It is considered exceptionally dangerous.

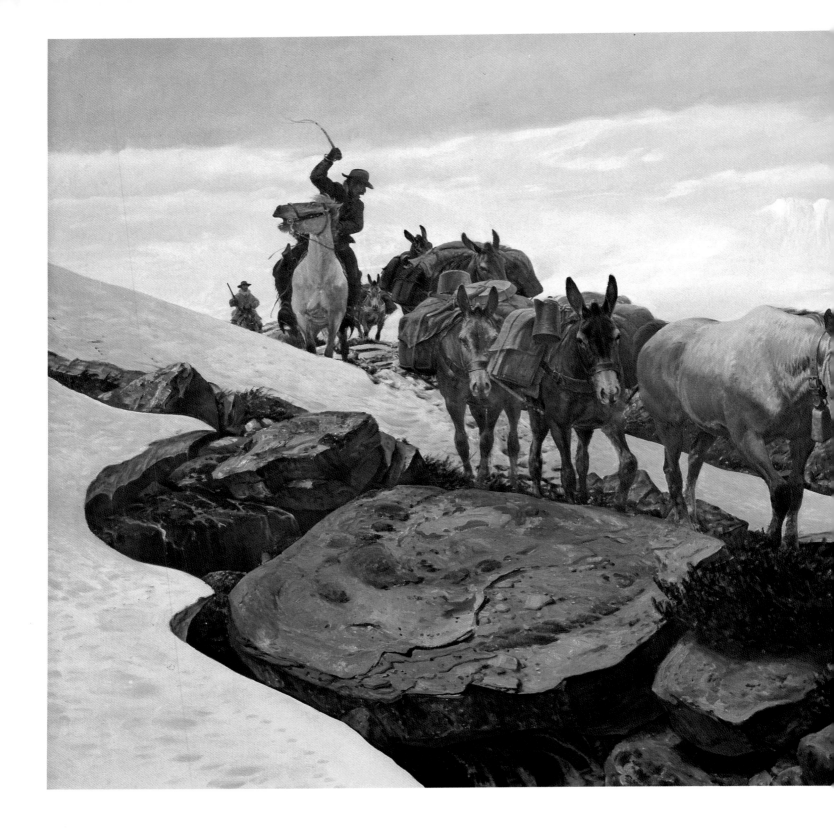

The Gold Train (1970)

The Buffalo Bill Historical Center, Cody, Wyoming

John Clymer (1907-)

A native of Ellensburg, Washington, Clymer studied art at various schools, including the Wilmington Society of Fine Arts, where he was taught by N C Wyeth, and Grand Central School of Art, where he was taught by Harvey Dunn. As a freelance artist he has won many gold medals, and his works have been exhibited in many galleries. These include the Royal Canadian Academy, the Montana Historical Society, the Whitney Gallery of Western Art and the National Cowboy Hall of Fame. His special interest is the Western scene, with particular reference to historic incidents.

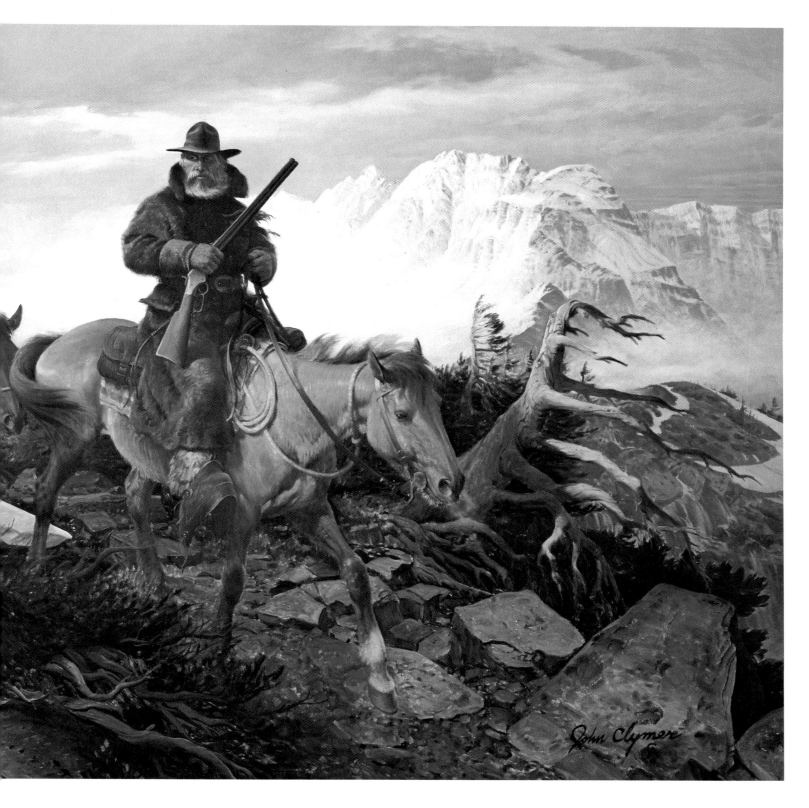

Clymer is an unabashed, nearly photographic realist, and his attention to authentic detail is legendary even among illustrators who pride themselves on the quality of their research. *The Gold Train*, one panel of a Western triptych that also includes *The Cattle Drive* and *The Homesteaders*, is typical of his work. It would have to be a rash critic who would challenge the accuracy of his rendition of such items as the bell mare or the mining pan or the coffee pot or the buffalo coat. Even the firearm is identifiable as a .44 lever-action Henry carbine.

The Hand Warmer (1973)

The National Cowboy Hall of Fame, Oklahoma City, Oklahoma

Tom Lovell (1909-)

Lovell, from New York City, was graduated from Syracuse University with a BFA. He began selling his illustrations to magazines while still in college, and during the course of his life his work has appeared in virtually every major American periodical. Winner of several gold medal awards, his paintings are included in the collections of the United States Capitol and the National Cowboy Hall of Fame. His particular interest is the American Indian as he appeared in the historic West. Lovell's sympathetic treatment of his subjects is often expressed in imagined, anecdotal incidents.

The *Hand Warmer* is just such a painting. That Indians should take advantage of the heat from the chimney of a nester's dugout is quite within the realm of possibility, and Lovell has conveyed his hypothesis with imagination and a touch of humor. Like Clymer he is a dedicated realist, and like Clymer he is famous for his perfectionism in the matter of documentary research.

(page 174)

Dakota Pipe Clan Magic (c 1950)

Courtesy of Mr and Mrs Peter H Hassrick

Oscar Howe (1915-)

Born on the Crow Creek Sioux Reservation in South Dakora, Howe first studied art at the US Indian School at Santa Fe, New Mexico. Later he attended various schools and colleges and received a Master of Fine Arts degree from the University of Oklahoma. Presently he is Professor of Fine Arts and Artist in Residence at the University of South Dakota. Over the years Howe has held one-man shows and has received many awards, including the honor of being named Artist Laureate of South Dakota.

In the poster-like *Dakota Pipe Clan Magic* Howe has extracted all non-essentials in portraying his figures as abstract elements in a forceful composition. His contrasting use of reds and blues imparts to the scene a sense of its ceremonial dignity. For many Indian tribes, smoking the pipe served both to open negotiations and to seal agreements between individuals and nations. Tobacco smoke was pleasing to the gods, who looked with favor upon the affairs of men when they initiated and concluded them with the pipe of peace.

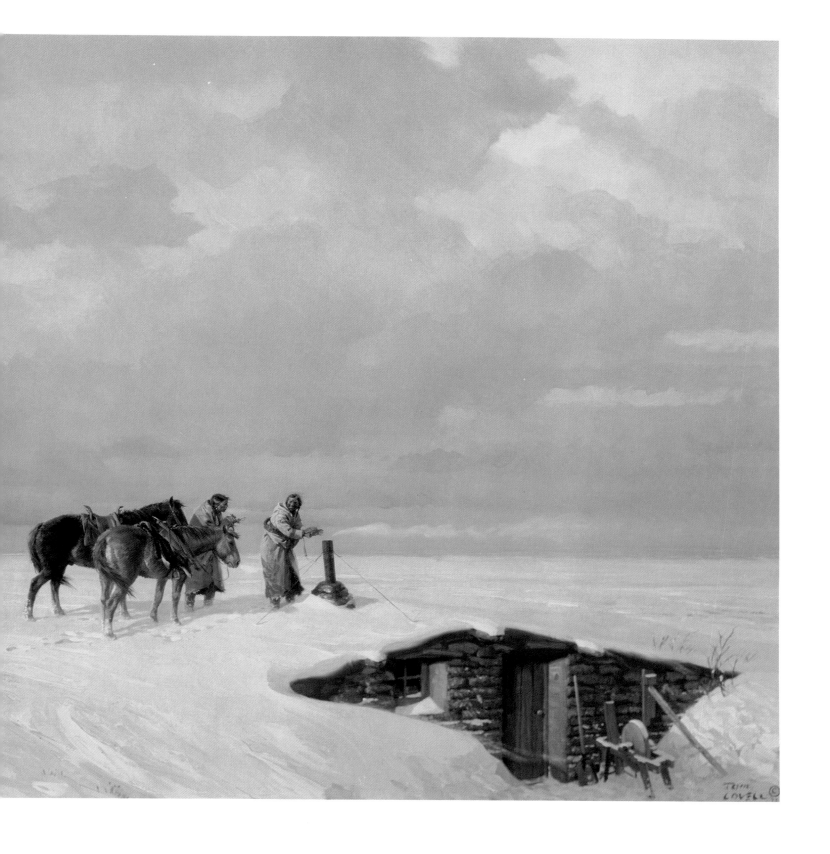

At the Sing (no date)

The Anschutz Collection

R Brownell McGrew (1916-)

Born in Columbus, Ohio, McGrew's speciality is the Navaho Indians. Rather than being a Western painter, McGrew considers himself a classical artist whose choice of subject mater is simply a function of where he happens to be living. McGrew paints both portraits and genre, and in each he displays a remarkable ability to impart a bright luminescence to his already colorful palette.

At the Sing is a representative McGrew canvas because, though it is neither strictly genre nor portraiture, it contains strong elements of both. There is no particular story being told in this large 36- by 60-inch picture of a Navajo gathering, but the overall ambience and the various activities of the participants are nevertheless vividly conveyed. Action is supplied less by the figures themselves than by a sparkling interplay of light, shadow and color that follow a jagged compositional line from the right foreground into the left distance. And every individual face and posture is so fully realized that the painting could almost qualify as a group portrait.

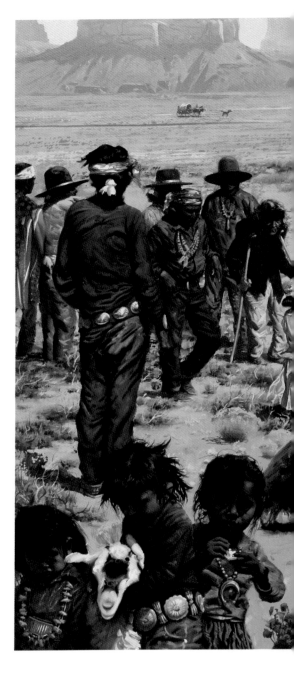

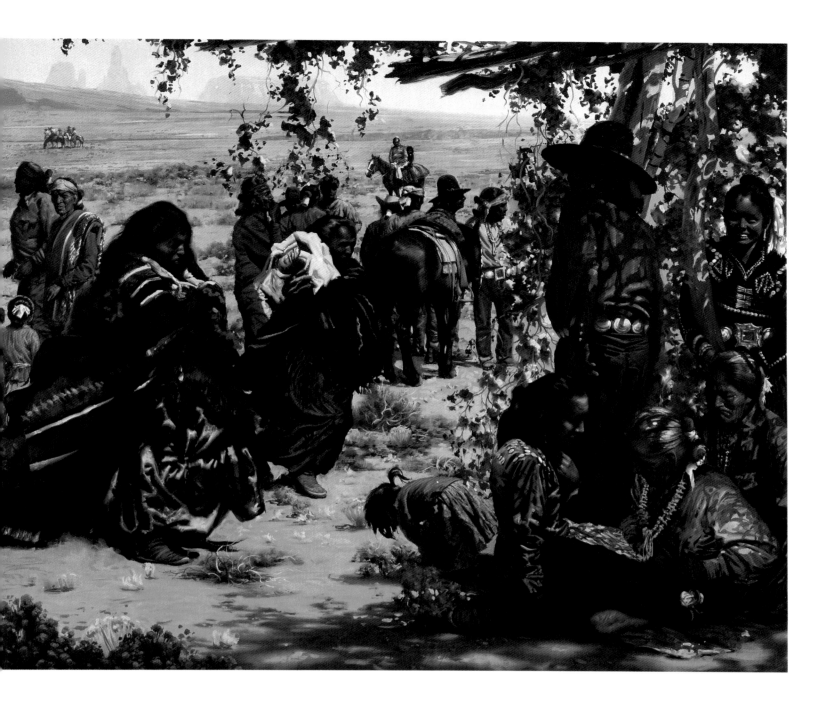

Trail to a Lost Freedom – Chief Joseph (no date)

Courtesy of the Artist

Newman Myrah (1921-)

Myrah was born in Holdfast, Canada, and grew up in Deer Lodge, Montana. After a stint as a squad leader of infantry in World War II, Myrah took up studies at the Art Institute of Pittsburg and later at Carnegie Tech. In 1949 he joined an advertising agency in Portland, Oregon, where he now resides. His work has appeared in many national magazines including *Time, Life* and *The Saturday Evening Post.* Myrah enjoys conveying action, especially through the horse, and whether it be cowboys, Indians or cavalrymen, his figures move with grace and assurance.

Trail to a Lost Freedom is an impressive panoramic view of the Bear Tooth range, showing a procession of Nez Perce Indians led by their great chief, Joseph. As a result of conflicts with the white men in northeast Oregon and a refusal to be confined to reservation life, Chief Joseph led some 430 men, women and children on a 1000-mile trek toward Canada. All the while he was obliged either to elude or beat off converging Army forces led by Colonel Sturgis on his flank, General Howard at his rear and General Miles at his front. Finally, within 50 miles of the Canadian border, he was cut off by fresh troops and forced to surrender on 5 October 1877. Even in those bellicose times he was perceived by the public as a man of heroic stature.

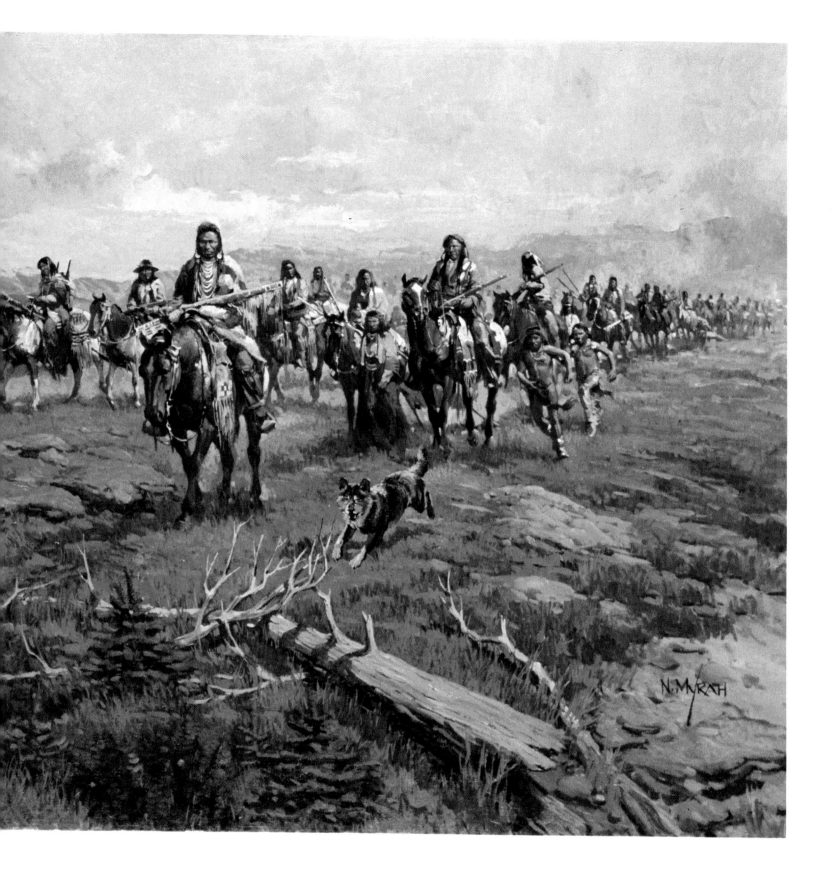

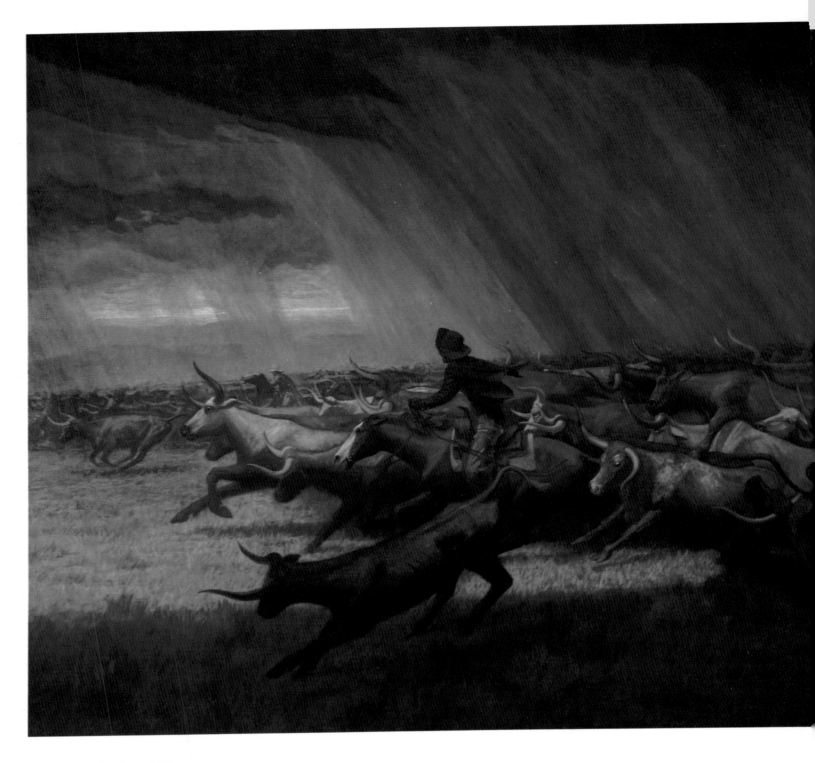

Stampede (1963)

Wyoming Foundry Studios, Inc

Harry Jackson (1921-)

As a young child in Chicago growing up near the stockyards, Jackson began drawing horses. While still in his teens he attended the Chicago Art Institute's Saturday morning classes. Then, at 14, he ran away from home to find work as a cowhand. He got a job at Meeteetse, Wyoming, on the Pitchfork Ranch. In 1942 he joined the Marines and was twice wounded in the Pacific before he was made a Combat Artist. After the war he moved to New York. He was at first an abstract artist, but as time passed he gravitated steadily towards realism. After receiving a commission from the Whitney Gallery of Western Art in Cody, Wyoming, to paint *Stampede* and *Range Burial*, Jackson from then on devoted himself to Western subjects in the round, and his sculptured figures of Indians, cowboys and scouts have won much praise.

Stampede is a dramatic portrayal of the uncontrolled power generated by the headlong rush of frightened cattle. Here Jackson has conveyed the horror of imminent death, for it is clear that the cowboy, dragged by his horse toward the gulch, will soon be trampled by the herd – no uncommon fate in the days of the great cattle drives.

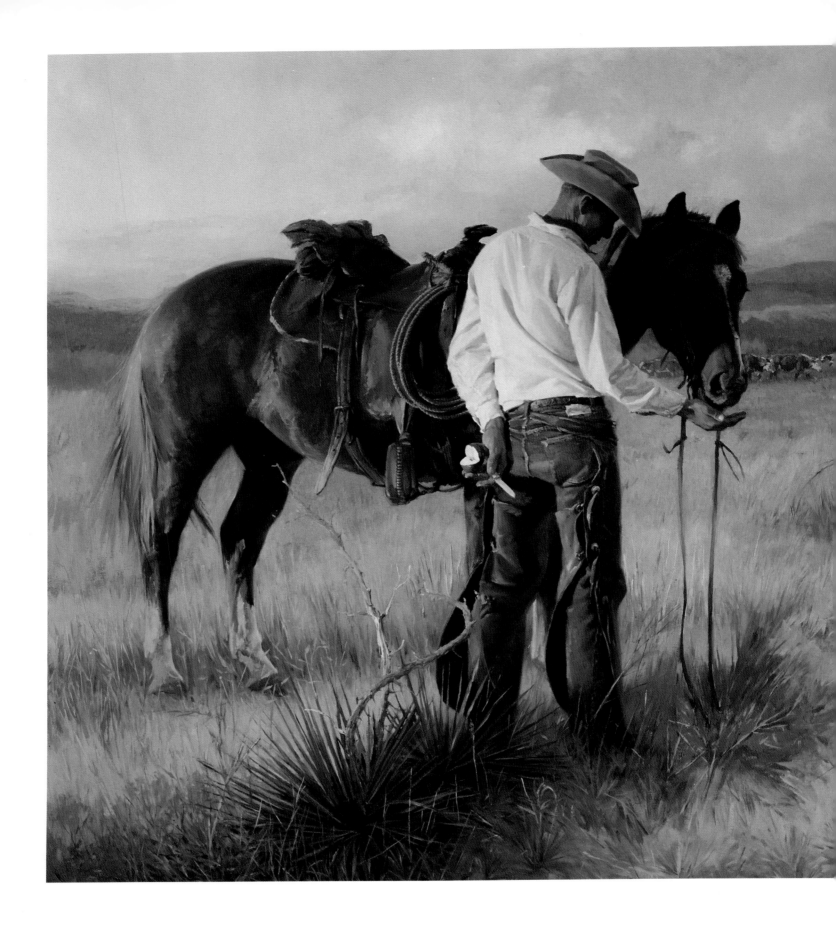

Sharing an Apple (1969)

The National Cowboy Hall of Fame, Oklahoma City, Oklahoma

Tom Ryan (1922-)

Born in Springfield, Illinois, Ryan studied at the Art Students League and has continued a career as a free-lance artist since that time. A former president of the Cowboy Artists of America, his works have been shown at the Franklin Mint in Philadelphia, the Whitney Gallery of Western Art in Cody, Wyoming, and at the Phoenix Art Museum, to mention a few. He has won numerous silver and gold medals for his work.

That Ryan is both a realist and something of a genre painter is obvious from *Sharing an Apple.* If the narrative point of this scene manages to escape sentimentality, it is only because of its authenticity. The affection and mutual trust that wranglers shared — indeed, had to share — with their mounts was less a matter of sentiment than of survival, and Ryan has done no more than illustrate a representative aspect of this interdependence. The compositional technique he has used to tell his story is simple and direct: a decisive focus on the main actors in the foreground, with the detail of the white shirt serving as the visual center of the whole.

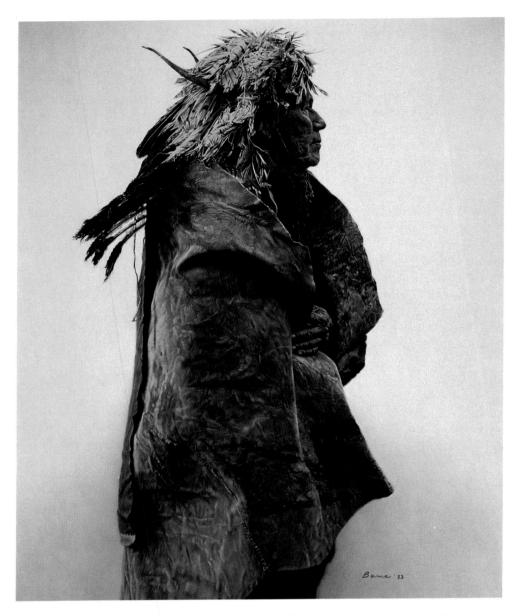

Crow Indian Wearing 1860 Medicine Bonnet (1983)

Courtesy of the Artist

James Bama (1926-)

Bama was born in New York City and studied at the Art Students League. After 20 years as a successful commercial illustrator, Bama moved to Wyoming to devote himself to portraiture. Here he paints Westerners as they are today, not as they might have been, and his models include such types as Sioux Indians, trappers, rodeo cowboys and hunting guides. With photo-realistic precision Bama makes his people sharply individual, each expressing his particular role in the Western milieu. Frequently they are portrayed with the acoutrements of their occupations, these being rendered with almost *trompe l'oeil* realism. Bama's portraits, which almost always seek to convey a sense both of gentle composure and of inner strength, are highly regarded.

Crow Indian Wearing 1860 Medicine Bonnet is a particularly interesting study, for it shows a patriarch proudly donning an heirloom. Only the bravest of warriors were entitled to wear such split-horn bonnets, which were believed to endow the wearer with impunity from harm in battle. Such headdresses are now so rare as to be seldom found outside museum collections.

184

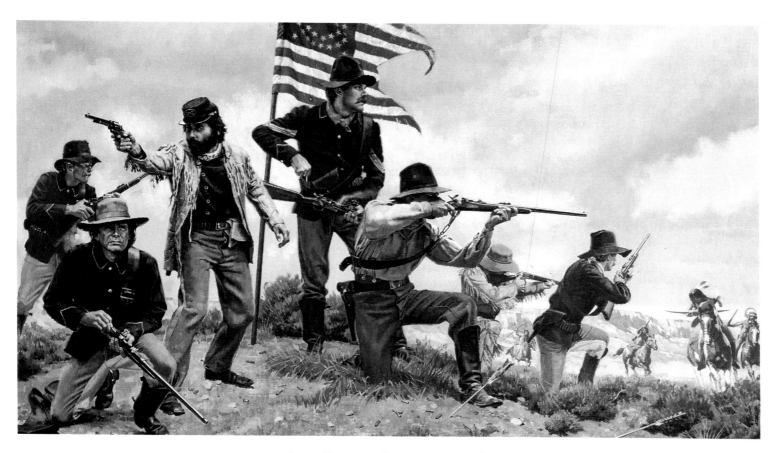

The Skirmish Line (no date)

Courtesy of the Artist

Don Spaulding (1926-)

Born in Brooklyn, Spaulding first took up his study of art at the Art Students League in New York. Later he worked under Norman Rockwell. It was while he was in New York that he saw the movie *She Wore a Yellow Ribbon*, and from that moment on the United States Cavalry became his passion. As a commercial artist, Spaulding specialized in Western military scenes, all the while amassing an enviable collection of cavalry items. This collection, combined with reference books and museum visits, is largely responsible for the extraordinary historical accuracy of his paintings.

In *The Skirmish Line*, Spaulding shows his skill as a realist in an action-filled composition. The scene is imaginary but totally convincing. Among the myriad authentic details shown here perhaps the matter of costume deserves some added comment. In the field, cavalrymen were permitted considerable latitude as to what uniforms they might wear, and Spaulding is entirely correct in showing them dressed in several variants of the regulation field kit. The belief cherished by many nineteenth century painters (and some twentieth century moviemakers) that cavalrymen normally wore dress uniforms while on campaign is, of course, nonsensical.

An American Portrait (1979)

The Anschutz Collection

Fritz Scholder (1937-)

Scholder was born in Breckenridge, Minnesota, and began his studies of art at the age of 13. He first worked under Oscar Howe in Pierre, South Dakota, and later studied at Sacramento State College in California. In 1964 he received a Master of Fine Arts degree at the University of Arizona and soon thereafter began teaching at the Institute of American Indian Art in Santa Fe, New Mexico. It was then that his own Indian heritage (his father was part Indian) began to come into play, as he turned ever more exclusively to Indian subjects, both in his own paintings and the subject-matter he recommended to his students.

An American Portrait, a good example of Scholder's expressionistic style, clearly shows the influence of the British painter Francis Bacon, whom Scholder admires. Here the harsh, slashing brushwork and ironic distortion are perfectly in tune with the bitter theme of ancient dignity decaying under the weight of military and cultural defeat. Interestingly, Scholder is by no means simply a pro-Indian polemicist. He can, on occasion, handle his Indian subjects extremely roughly. But if his view of them is sometimes critical, it is nevertheless always full of understanding.

(page 188)

Dream Shirt (1981)

The Anschutz Collection

Ned Jacob (1938-)

Although Jacob was born in Tennessee, he early moved to New Jersey. When he was 18 his wish to see Indians was satisfied by a $50 gift from his father to travel to the Blackfeet Reservation in Montana. For the next four years Jacob painted Indians, lived with them and joined in their ceremonies. At the age of 22 he moved to Taos, where he came under the guidance of several artists, including Robert Lougheed and Bettina Steinke. In 1966 Jacob moved to Denver and in the same year held his first exhibition at the Kennedy Galleries in New York. His paintings have won him silver and gold medals at the Cowboy Hall of Fame in Oklahoma City.

Dream Shirt shows his skill at figure painting. Here a Jicarilla Apache wears a magical shirt, the designs of which he has received in a vision. Some supernatural helper has thus given him power to achieve success in battle and to be protected from harm. This pastel is typical not only of Jacob's sensitive portraits of native Americans, but of an attention to authentic detail that makes all his work ethnographically valuable.

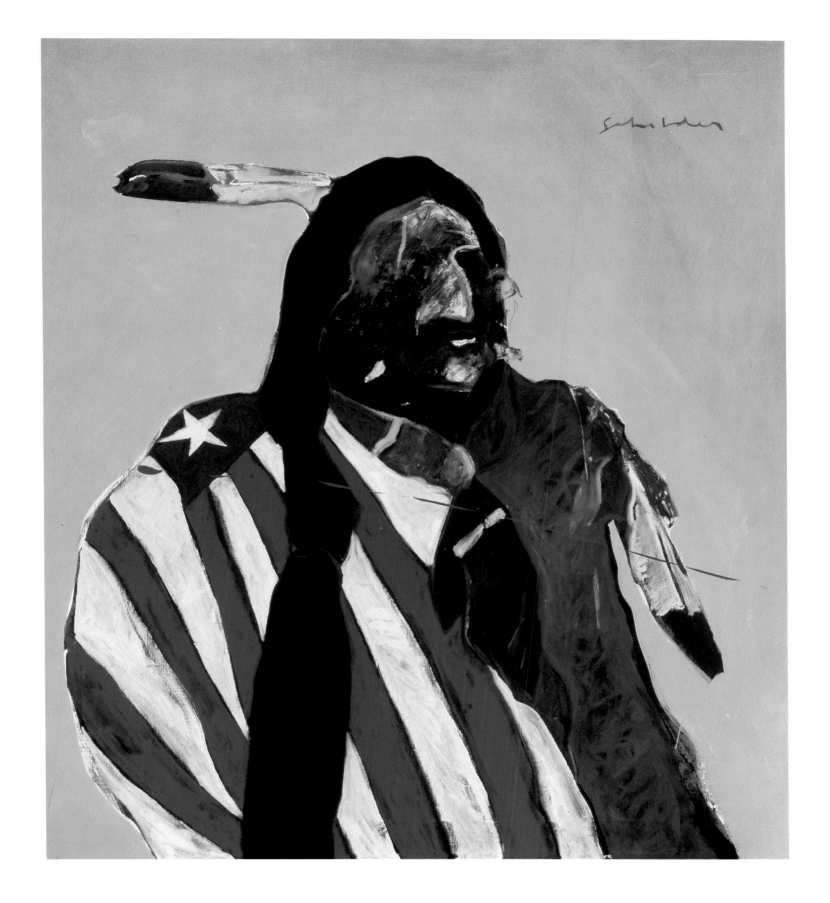

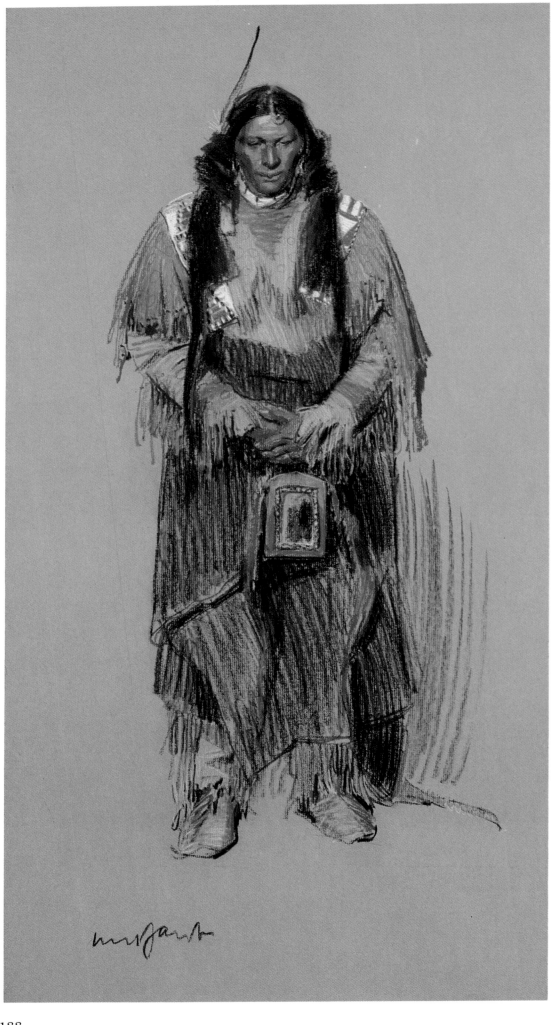

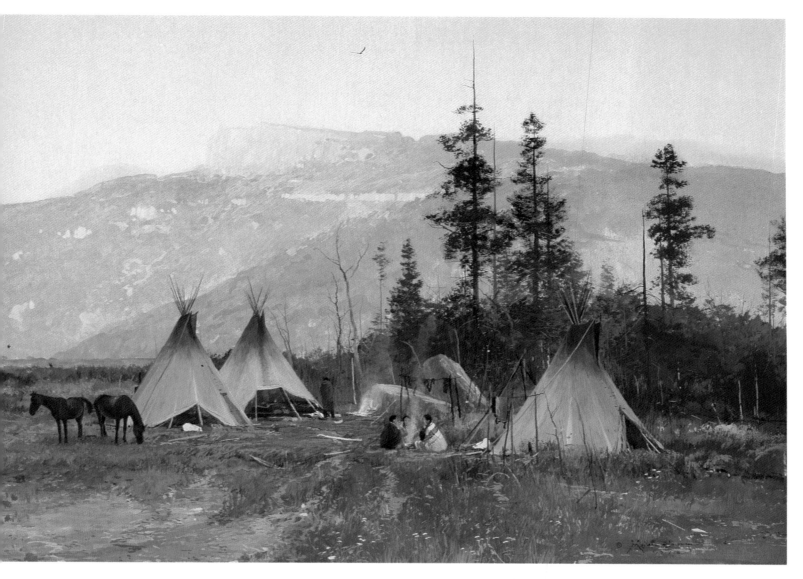

Popo Aggie River Camp (1976)
The Buffalo Bill Historical Center, Cody, Wyoming
Michael Coleman (1946-)

Coleman, a native of Utah, studied art at Brigham Young University in Provo. Always attracted to Western subjects, he began as an animal painter. In time, however, he gravitated to human subjects and eventually settled on a realistic semi-genre style devoted to recreating bygone Indian folkways. Although his paintings often imply some degree of narrative, they seldom allude either to violence or high drama. Whether he is dealing with a solitary hunter or life in an encampment, Coleman's Indians always seem to be going about their daily business calmly and competently, and Coleman fortifies this tranquil impression by avoiding the more flamboyant compositional tricks dear to many illustrators.

Popo Aggie River Camp displays these qualities well. The serene horizontal composition and remote point of view are reminiscent of Henry Farny's style, and the somewhat murky atmosphere in which the scene is displayed lends it an added dimension of peace and quiet. The Popo Aggie River, it may be noted, flows into the Big Horn River at the foot of the Wind River range. It was a favored site for trappers' rendezvous, the three greatest of which occurred in 1829, 1830 and 1838.

INDEX